humus

CARAF Books

Caribbean and African Literature
Translated from French

Renée Larrier and Mildred Mortimer, Editors

humus

Fabienne Kanor

Translated by Lynn E. Palermo

University of Virginia Press

Charlottesville and London

Publication of this translation was assisted by a grant from the French Ministry of Culture, Centre national du livre. The author also thanks the Centre national du livre, which provided a creation grant to support the writing of this work.

Originally published in French, © Éditions Gallimard, Paris, 2006

University of Virginia Press
Translation © 2020 by Lynn E. Palermo
Afterword © 2020 by the Rector and Visitors of the University of Virginia
Printed in the United States of America on acid-free paper

First published 2020

9 8 7 6 5 4 3 2 1

Library of Congress Cataloging-in-Publication Data
Names: Kanor, Fabienne, author. | Palermo, Lynn E., translator.
Title: Humus / Fabienne Kanor ; translated by Lynn E. Palermo.
Other titles: Humus. English | CARAF books.
Description: Charlottesville : University of Virginia Press, 2020. | Series: CARAF books: Caribbean and African literature translated from French | "Originally published in French, © Éditions Gallimard, 2006." | Includes bibliographical references.
Identifiers: LCCN 2019057920 (print) | LCCN 2019057921 (ebook) | ISBN 9780813944685 (hardcover) | ISBN 9780813944692 (paperback) | ISBN 9780813944708 (ebook)
Subjects: LCSH: Slave ships—Fiction. | Fugitive slaves—Fiction. | Women slaves—Fiction. | LCGFT: Novels.
Classification: LCC PQ3949.3.K36 H8613 2019 (print) | LCC PQ3949.3. K36 (ebook) | DDC 843.92—dc23
LC record available at https://lccn.loc.gov/2019057920
LC ebook record available at https://lccn.loc.gov/2019057921

contents

translator's acknowledgments

My thanks to the National Endowment for the Arts for support-
ing this project with a 2019 Literature Translation Fellowship, to
Susquehanna University for ongoing support, and to the CITL and
the 2017 Atelier ViceVersa in Arles, France.

Thanks to Carine Gendrey for her expertise.

Thanks to Gladys Francis and Fabienne Kanor for their friend-
ship and guidance.

Thanks to my family for always being there.

humus

Aux chers miens.
À mon bon capitaine.

Where are your monuments, your battles, martyrs?
Where is your tribal memory? Sirs,
in that gray vault. The sea. The sea
has locked them up. The sea is History.
 —Derek Walcott

On the 23rd of March last, fourteen black women apparently leaped overboard, from the poop deck into the sea, all together and in one movement . . . Despite all possible diligence, with the sea extremely choppy and the wind blowing a gale, sharks had already eaten several of them before any could be hauled back on board, yet seven were saved, one of whom died that evening at seven o'clock, being in very bad shape when rescued, so in the end, eight were lost in this incident.

—Excerpt from the logbook of Louis Mosnier, captain of the slave ship *Le Soleil*

It all started there. With this incident reported by the captain of a slave ship in 1774, and found in the archives of the city of Nantes. It all started there. From a desire to swap. Trade away technical discourse for the spoken word. The cant of the seaman for the scream of the captives. It all started with a question. How to tell, how to retell this story told by men? Without fuss or artifice. Otherwise. Upend the reader's expectations.

Abandon all hope, you who think a story of slavery will be a novel of adventure. An epic tale, a heroic, tragic story filled with rape, pillaging, brawls, and death. Running in all directions. And we're never bored because something is always going on. Inevitably.

Abandon all hope, you who think I'm going to tell such a tale. Grandiose. Exotic. Unimaginable. Unheard of, crammed with details, numbers, twists and turns. Action. Vivid description to move you, make you see it, as if I'd been there. I wasn't there, that's all I can say for sure. But any one of us could have been there, so universal are the ordeals. Familiar and familial, by our very existence.

Turn back, you who dream of setting off on this path. You will be taken captive. Chained to the words against your will. Locked up in this story that repeats itself like a chant, prefers new chapters to endings, the surest stammers to sharp conclusions.

This story is not a story, but a poem. This story is not a story, but an attempt at a shift in a space where there are no longer witnesses to speak, where the human being, plunged into the darkness of a bottomless blue-black sea, must confront the cruelest trials that exist: aporia and the death of the spoken word.

Like these shadowy figures put in chains long ago, the reader is condemned not to move from this moment on. Just listen with no other distraction to this chorus of women. At the risk of losing your bearings, hear once more these hearts beating.

Big Jehan of Nantes, topman on Le Soleil
Set out for hot climes, with good winds and God
With forty Jack Tars unfurled sails on the tub
That far-off fall eve in '73

Adieu to Maman, beurre blanc and sharp cider
Our route to the south will take a long time
I'll tell you this now, without pretense or lie
It pained my young heart to see us away

Hoist up now the canvas, hoist up now the sails
We'll shoot off the cannons and ring out the bells
Let's raise high a glass, Lads, to life and our health
We'll drink down our grog for France and our King

the mute woman

In the beginning was absence. Say nothing, be nothing. Nothing but a thing they use. Use up until its insides break.

I saw everything. Don't ask me what. Lost words are lost forever. To speak all that is in my mind, I'd have to invent. Words for laughing, words for forgetting words, words for acting as if. Who still cares about the details?

The sea is blue. A ship sits upon it. So heavy, you think it will never hold. It holds. It even moves. White magic.

(The sea can be seen in the distance. Nothing extraordinary. The girl squints into the sun, squats on her heels, begins her story.)

I no longer know the name of the country. I was too young when they came to take me. I have forgotten the woman who rocked me in her arms. Only the husky voice has stayed, the voice of a crazy sky. Around the village, I can still see the trees, haunting at nightfall, their heavy oblong fruits dangling from branches like human bodies. They are called spirit houses because they shelter the souls of the dead. Not all. Only those still alive.

In the country, suspended like a dream, I hear the river flow and swell. Taking earth, men, and beasts by force. Nothing can resist it. Overhead, birds glide past. They look like the head ties worn by women on feast days. Down below, children take aim and shriek with joy when their prey drops to the ground. Beneath the generous sun, I watch the children until a voice calls them in. The huts close up. Sleep burrows in, stinging eyes like red ants.

In the country, men don't know what it means to cry. In their language there's no word for it. But there are plenty of other words: eat, dance, cook, hunt, fish, sow.

In the country, women are always happy. Every task puts a song in their mouth and they suck on it all day, like a sweet. Late at

night, the song sometimes refuses to melt. Runs through their head until morning. Always the same story playing on their lips. The same doing repeated. Eat, dance, cook . . .

In the hut where I was born, an old woman is sleeping. It seems that she's always been there like that, and her old age, over one hundred years, lets her read the sky and see what the stars hold for tomorrow. Usually, she foresees rains or lightning. Sometimes she sees war, but then no one believes her. Where we live, this wicked word does not exist. Or rifle, or ship-hold, or master, or sea.

Like my people, I am short. The sun in the sky is so huge, it shrinks the bodies of people. In my village, the grown-ups are like children. Only their face shows age. The oldest of our old have wrinkled skin, cotton on their head, and blue in their eyes. The oldest of our old sometimes rise in the night. Walking stick in hand, they penetrate deep into the forest. It is said that death hides out there, a hyena so fast it can pierce dreams. No one has seen it but the trees. Humans can no longer hear it.

I was too young to learn and too small to climb up to the branches or remember how to reach the huts where those who are not dead keep their vigil. I knew nothing of the world when they took me. Because I knew nothing of crying, I screamed when water fell from my eyes. So much water behind my eyelids, how was that possible? I gazed at the sky, studied the clouds. In vain. Looked for the river. Searched the landscape. Nothing. Inside my body the rain had started. From my wide-open eyes this stream flowed, dragging me far from the village to the sea where the river came to lose itself each day. With no mouth to name them, the words fell away. Joy, smile, childhood, grasshoppers, baobabs . . . the words sank, unspoken. Only much later did I realize it. When nothing was left, and I opened my mouth. Emptiness. Silence.

One night, they ate my belly. The man was alone but felt like a hundred. I had run out of tears when he came in. I thought only of my finger in my throat. The finger that would never be enough to get rid of it all. I would need two, my whole hand, my arm. Until this man's water was gone. He never tried again, no doubt knew about my finger.

Now, I hurt when I look at my hand. My legs tremble. I bleed, clench my fists and try hard to think of something beautiful.

On the road to oblivion, the men who are shouting look just like us. Same dark skin, same coiling hair, same feet accustomed to the night. No one knows where they come from, some claim they're from here. How to believe it? How to think the unthinkable? To avoid sinking into madness, a few of us take the opposite view. Surely, those Black men are shams, White men made to look like us, so we'll let down our defenses. White magic.

Today, a man has collapsed. His eyes are yellow, his ribs heave. From his lips dribbles a milky liquid. It foams. Like a dying fish. There's no time to pray, a hand raises a club. Strikes, then breaks the iron chain that attaches the corpse to the rest of the group. Without a word, without a backward glance, we move on. Understand that only dead, will we be free. Fully.

I no longer recall the date. Or the place. We'll just say it was an ordinary day. Some African town wedged between forest and water. Upon arrival the night before with a group of ten (five of us had perished during the long trek), I had immediately been sold. My new masters paid the asking price, pressed to set sail after long months of waiting. It had all happened quickly, the hot iron on my skin, the descent below deck, the cries in the hold as the ship weighed anchor. An hour passed, an entire night. A lifetime it seemed, we were so sure we'd end our days down there, slapped about by the waves. Forgotten, forgetting who we'd been.

Call them whatever you want, I no longer hold their names in my head. Barely even their faces, turned toward the ocean, facing it, laughing. So was I.

I did.

I.

We jumped.

Together. We.

Jumped. Sea. Jump!

We

Did it.

UNDER THE SEA, haunted by death, the immobile triumphs. Long life to those who made it. Down there, reality has taken over. The bodies, their verticality. Through the fog woven by nightmares, I see them stir. I open my mouth, spit up salt and water. Want to

speak but I've lost my words. How many, how many lives remain?
The sailor counts how many. He scans the horizon, willing answers
to appear. White magic.

They say that the earth won't emerge from the sea for another
four hundred years. That when it does, a new day will dawn.
We will return, neither ghosts nor beasts, our memory emptied,
washed clean.

I have more to tell. There's also the woman badly chewed up,
bled by the sharks, but refusing to leave us. Like an animal, she
hangs on. From the hold where we huddle, we follow her battle in
silence. For hours she clings; the dead woman will not die. When
day breaks, we are only six bodies who remain. I spit. I have thou-
sands of words in my mouth. A story, what I saw down there, under
the water. The beast bearing down on us. And I, just escaping its
fangs, look ahead-behind. Ahead-behind, believing nothing more
can be done. Nothing more to hope when the little one screams
for help. Too late. The beast swallows her whole. Only then, if my
memory is right, do the White men toss their nets out onto the
water—surely, they were in league with the sharks—and haul us
out of the water like a catch of fish.

The hatch slams shut. Like a period in a sentence, the period in a
sentence. End. This is where we will die, with no family to see us off
or earth to cover us. The last hope has faded from our faces. Where
will our souls go when our bodies depart? As the day unravels, a
song rises. Song of a thousand tongues, all saying the same, accom-
panying the rising of friends' souls.

*

When land disappeared behind the line, I began keeping count.
With my thumbnail, I scratched lines into the wood. One stick =
one day. That's how I proceeded. Every day, in the wood, afraid of
forgetting one. Slicing up time . . . I'd never done that before. So I
scrape and count twenty-seven scars.

> *(One. Close-up of the girl's mouth. On three, the lips tremble.*
> *Let a tear escape. A comma trailed by a word traced in fine ink.*
> *No emotion in the girl's eyes. She must be used to telling this*

story. Unless she's making it up, like the name she claims to have
forgotten but which she must have put somewhere, right?)

In my mouth, there is a word that refuses to be said. Weighs me
down like these irons that chain us to the sea. The day my tongue
started moving again, I prayed for the word to fall from my mouth.
But it didn't come. My finger was too short. *Ohé!* Has anyone seen
my name? *Ohé!* That's the one I'm looking for. I had one before
coming here, all people have one. Lying on my back, I inspect every
bit of me. It's like a game, my hand walks all over my body, across
my legs, my hips, goes around my belly. Not there! Not since they
broke it. One time, it happened. By that, I mean the man entered
me and spoiled the music that cradles childhood.

I hate men!

I don't think that will change.

With all the sticks I've scratched into the wood, I could rebuild
my village. Top the huts with pointed roofs, draw granaries, trace
paths, and outline trees so tall, their leaves would mingle with the
clouds. At the center of the village would be all the lost words.
Dream-words with weight only for those who can speak them. Just
saying them aloud would make the world exist and once again be
as it was before.

I thought that time had come the day the sea stopped. I have no
idea when; I had long since stopped counting. At the end of a night
of storms and prayers, the ship suddenly went silent, not daring
to believe the miracle: land, almost there, a few leagues off. Our
throats tight, we, the women of the ship's hold, pressed against
the railing up on deck. Could it be that the earth was round? That
after sailing all the way around, we had arrived back home? Others
said so. Others built it up, until the land lay before us in plain sight.
Nothing but an island. A place with no name.

I would not be staying long.

(A woman, white head kerchief, pleated dress, watches the sea go
past. Is she dreaming? Unless she's hoping that a wave, higher
than usual, will carry her away.
Hands clutching her flapping headscarf, the woman turns
abruptly. Stares into the distance at a gull, or perhaps a gather-
ing storm.

*The girl is familiar. Despite the dress. Straight hair with two
white strands.*
*In all directions lies the sea. Much less blue than two days
before. The Atlantic Ocean, I assume. The captain nods, then
takes a nap. The same two, later, look at each other. The man
watches the young woman study the sea that is the measure of
man. They talk, though neither understands. The white head-
scarf fades. Night falls.*
*The following days are almost the same. Only the light has
changed. Comes early and slips away fast. Looks like the young
woman has dry skin and a runny nose. Never goes out without
shawls.)*

Until the ship docked, I never thought we'd arrive. Would have bet
it on my forgotten mother's head. By what miracle have I survived?
I don't know how I held out. Remember only that night when, after
searching for my words a hundred times, I stumbled on my reflec-
tion and my name came back to me.

The-one-who-walks-the-world.

It helps me to know that. In this land where everything moves
fast, I am the one who comes from afar, no longer resides but
passes through. I am the-one-who-walks-the-world.

Falling into step behind my new master, I climb into a coach and
press my forehead against the glass. For a long time on the left: the
galloping water transports spices, sugar, and salt, floats between
land and sea under a fuming, fishnet sky. Everywhere crowds, thou-
sands of bodies moving, hanging around the docks, walking along
the edge of the water that rises. Then. Falls. Rises-falls until night
falls just beyond the Pirmil Bridge. The city takes shape, lights its
lanterns. Its stones. Its contours. Its Negroes. Free to wander at
will. Go everywhere. Are everywhere, even laughing on the stone
facades of the houses. Booming, explosive laughter!

Some of them live at my master's house, over the doors and
windows. Cut leg, cut tongue hasn't made them lose all sense of
hospitality. They welcome me as if feting their own kin after a long
voyage.

*(It is a house of distinction. That's what is usually said when
they don't want to think any further. A house of rich people,*

where you worry about tracking in mud on your feet. Because it's raining out. It's dark inside, despite the windows. The cold is penetrating, the embers in the fireplace have died. The furniture is draped with white sheets. Like animal pelts. White sheets masking the furnishings, it's as if the house has never existed.

Down the hall is the bedroom. Bed unmade. Parquet floor strewn with seashells, so many, a hundred slaves couldn't pick them all up.

A mirror is swaying on the dressing table. A few hours earlier, reflected the image of a woman, hollow cheeks, blond, though most of her hair has fallen out.

Close-up of a man's face. The man on the ship, but older and sadder . . . Drawing close to the bed, it is clear that the sheets are wet. "Soaked," to be precise.

At this moment, the man, hands clasped behind his back, is standing in front of a watercolor. A seascape with a woman in silhouette running along the shore in the foreground. An angel with her golden curls flying in the breeze.)

The staircase leading up to the attic is steep. I almost fall when my foot catches in my dress. The stairs bring back memories of the open sea. The ship where I died, in the time before I walked the world. The enormous blue-black flies tracing circles in the room, usually announce death. They are not wrong. Death is present. In her disemboweled body.

"Marie, Ma . . ." stammers the captain, before crumpling to the floor at his wife's feet.

LATER, I, too, will go in. I will go to wash the body.

Cast off the ropes fore, Lads, and cast them off aft,
Stay wide of the reef lines, the Captain will snap,
Hey, sailor, hey, sailor, oh what is your worth?
All night and all day, to hell with your rest

Those sailing wide seas are men stout of heart
They've sailed 'cross the ocean, are no more just lads
We've now left the coastline so far at our back
Saint Pierre, hear our prayers, Saint Pierre, hear our prayers

My gullet is thirsty, Kill-Devil it craves
My dish is now empty, so serve up my lard
Come serve me my beans and my share of dry bread
Lads, drink to his health, to the King of France!

the old woman

We should have known.

Well, don't put words in my mouth, but in life, there are things you know without ever having tasted them. It's in the very nature of human beings to imagine. When a man can no longer imagine, he is already no longer a man.

When thinking of that time, for some reason, it comes back like a laugh in your throat. You have to spit it out fast if you don't want it to choke you.

This evening, the rain spirit is in my hut, spreads healing water on my raw wounds. The laugh is gone now, and I feel good. Smile, thinking of our victory.

We survived. In spite of the deaths, the shame, the hunger. In spite of the ship's hold.

The day it all began.

IT'S THE RAINY SEASON, the earth is hoping for rain. Inside, life is drowsy, sleep is seeping in. Beneath the hut's roof with its central hole, we're lying on a mat, my husband's head pressed against my shoulder. Pain is at work on the floor of beaten earth. Once again, my lower back has grown stiff, presaging the coming rains. Soon, drops. Rain patters on the straw. Outside, bodies are up. Women pounding, scrubbing, carping. Flames blazing under large cauldrons with lids dancing. A hand comes close to the fire. It's Afi. That girl is always sticking her nose where she shouldn't. Not even six years old and she wants to know everything about the world. Why are stars smaller than grains of rice? Where does the rain go when the earth drinks it in?

I was just like her at that age, it's not for nothing that I'm her grandmother. My Little Sweet, she calls me. Because I can refuse

her nothing, and all I need is one of her smiles to boil my oil and prepare my dough. She's wild about the long snakes of honey. Claims that eating them will protect her from real snakes. I believe it, too.

One hour more and the millet will be ready.

Even here, I sometimes hear her voice. At first, I thought I was losing my mind, but now I know it's not that at all. Nothing has happened back there: the women are still pounding their grain, the millet is still cooking, the old women are still tossing animal flesh into the oil. All has remained. You can't kill life. I learned that when they emptied the ship. My word! What a stench! It was the first time I'd really taken it in. But in a way, it was good. Smelling meant not seeing. Forgetting the corpses we were leaving behind. Before us stood tomorrow. The other country, with its trees, huts, flowers. Just enough to nourish my heart. Wipe away the sea, never again fear its fury, the angry jaws that closed around us one mid-morning in the dry season.

Inside the hut with its roof open to the sky, I hear the voice of Akissi. She's after Afiba. Why won't her six-year-old daughter listen? A hundred times, she's told her to stay away from the fire. One of these days, she's going to hurt herself and too bad for her. The little one pulls away from her mother and runs outside to play in the rain. Of my five children, Akissi is the most hardheaded. Stubborn as a mule, that one! I sometimes think there are too many stones in her body. It will take more water to make her a woman. The man who married her showed up too late; some things should not be delayed.

I was thirteen when I met the man who is sleeping. He taught me all and I gave him all. That's why the children came quickly. Abla, Totou, Afoué, Akissi, I won't name the last one. The dead don't belong to us.

I have been a good mother. I am proud of my children, even if I don't always agree with them and Kissi sometimes worries me. My mother says that we must let nature take its course, that we're nothing much, and that only the gods know. I do as she says, but still think my daughter should be more gentle.

Until blood flowed onto the mat that morning, I swear I felt nothing. Just another day, the women were doing. It was the silence

that woke me, then suddenly a shout, my name. Someone outside, screaming.

Despite all the red on the mat—the man sleeping was dead—I find the strength to raise my old body and go see what Akissi wants. Who has brought death into my hut this morning?

I was the last to be captured. Work had begun at dawn. I was sleeping. There are things that must be done early.

<p style="text-align:center">*</p>

I didn't think I could hold out. Drag my body all day long, keep it clear of the whip that lashes out because we have to move quickly, they have no time to waste on the weak. The worst is not knowing where to go. All my life I've known where to set down my feet, which path, of all the paths to take, was the right one, the one that leads back to the village. I was the mother of five, I knew how to avoid getting lost. The trail of pebbles you leave behind you, the bits of loincloth you hook on branches. The wind rustling through the grass tells you what you need to know: the direction. Before, there was always a path. What your eyes can't see, your heart knows. So I stopped searching. Stored my country in my head and continued forward. At the end was Badagry. A small town with nothing around it. In town, a wide plaza. Noise. Never seen so many people! Black people but also Red people, men whose skin was so thin, it showed their blue veins. The way they acted was also curious. Strange words fell from their mouth. Sharp angles sunken in their faces made them look angry all the time. And they were angry, for sure. They were, when they started shouting at us and then threw us into the hole.

<p style="text-align:center">*</p>

In the beginning, we were only ten, women from all parts of Africa, packed on top of one another in this room where just closing your eyes made you think death had come for you. With the pain that coursed through my bones, being unable to lie down in the cramped space tore cries of pain from me, it took all the tenderness of another one's hands to loosen my knotted muscles and stop the tears. Morning came, thank god. A new day when, busy with tasks, the body forgot the soul. Stored it somewhere far off, secretly

hoping it would lose its way. Outside was so vast and inside so small it would surely forget to return. When there were too many of us, we heard sounds. Coming from outside. Filling the night. The whole universe seemed to be pounding. Pounding so hard that one woman said they were digging our graves.

From that moment on, we stood guard. Each night, in turn, we kept watch, so that when the noise ceased, the door opened, we would be ready to leave. We'd have to act fast, like the wind. Push far, all the way to the great silence.

We never got there.

One evening, everything stopped. The door opened. Armed with firesticks, the men drove us out of the hole and into a barn. Some kind of hut, reminded me of the pen where we kept our animals. So, this was our new house! From there, we would set off for the great land called TheSea.

TheSea, a thousand times, I'd heard the name. Dreamed of it for entire nights. The end of the journey. How could I have known that after TheSea would come the land? That on this land grew water. Water that emptied into the sea, and that this would never end?

The new cage never stopped filling, either. From ten we grew to twenty, then forty, until we could no longer count, until the weary eyes stopped looking up each time the door creaked open. I never dared meet the gaze of the other women. Even at the end, I couldn't. Afraid to see in their eyes my own decay, the shame of still being here, I, the useless old woman, *wrinkled skin, hanging breasts, sagging buttocks,* captured weeks ago, whose life would likely end here.

NIGHT FALLS.

Inside our cells in Badagry, the women have started talking. In all directions. Searching for truths to exchange.

Some come from nearby, others have made a great journey. Many are silent, don't trust memory. To the one at my side, struggling against death, I feel the need to tell all. Where I'm from, what kind of woman I am, what I know of life after, beyond the shore, on that land they call TheSea.

The colors of the country come back to me. Straw-yellow noon.

Red dawn. Tawny sunset. At these words, the woman sobs, fingers digging at her head, desperate to unearth her own story. The suffering has taken up so much space inside her that she has to search, dig deeper to find its source.

"I don't deserve to live," she says at last. "What mother can be cruel enough to watch and do nothing as her child dies?"

"We don't always have a choice," I say. "I was a mother, five children I had. I understand."

"My son was so beautiful," she says, when . . .

When a pounding on the door. Angry guard. Fall silent. If he catches us scheming, we'll have him to deal with. We can tell what they're saying from their face and their eyes. Their face, it's like a mouth.

My hand rubs the mother's back and belly, just like it used to stroke Afi. She won't let me stop, cries again. "Again!" Squeezes her eyes shut to hold onto the pleasure. A smile crosses her lips. A voice speaks in my head. A question: "Is this like love with a husband?" I have to laugh. At age six, Afi talks like a grown-up. Has more water in her body than any of us.

In our cell, where night is taking hold, the little mother eases, rests her head on my thighs, listens to me tell her my stories.

"My people, the Baules, were not always known by this name. In times long ago, they called themselves Ashanti, people of a fabulously rich kingdom far away, to the east of the river, where the sun is born each day. After conflicts split the family, they fled their kingdom, taking with them their cattle, their gold, and their children."

The mother's eyes open wide, as if watching the convoy pass.

"At the head of the procession is a mother. Unquestionably, the queen. Firm stride and proud eyes that never look back at this people of blind followers. Does she know where she is leading them? She walks. Her young son on one side and an old sorcerer on the other. Time slows. The sun presses down. Bodies collapse. From thirst or impatience. When will we arrive? The queen is now no more than a seed rolling along the ground. A tiny black dot that people's feet struggle to follow. Lose sight of, each time a yellow ray dazzles their eyes. Slices through their attention. Does she know it, she who advances in silence? Without fear, dreams of the new kingdom, the still-hostile land to be taken.

"Day has broken. Once more. Already on her feet, the queen studies the horizon. On her right, the sorcerer relates his dream telling that their journey will soon come to an end. The queen looks worried. Her lips tremble, tears in her eyes. 'It is time to move on!' she calls to her troops, 'Today, we will find our country.' All rise, the able and the infirm, faithful to this mother queen who has promised to guide them. The sun is blazing high in the sky when a river appears before them, so wide, so turbulent that, short of a miracle, no one will be able to cross.

"'Oh queen, the gods require of you a sacrifice. Your most precious possession, you must give.' The queen pulls out her strongbox, but the old man halts her. 'Mother Abla, you must offer your son. That is what the gods seek. I was told in my dream.'"

In the Badagry jail, the young mother trembles. Her hand grips mine. Her mouth says no. No!

"The gods have spoken and the queen obeys. Pitches her child into the river, as a tree leans over the water, joining the paths on the two riverbanks. 'Baule people, a few hours more and we shall be home,' she declares, finally, in muted voice, before leading the way."

The young mother sits up straight and stares at me, her face bathed in tears.

"Komwé. This is also what my people call the sacred river," she murmurs.

Silence takes us. Emotion. We come from the same land. And this discovery, as paradoxical as it seems, shakes us to the core.

What, now, is left of the land? How much longer before we're swallowed up by history? Are we nothing more than a small mouthful?

In this unthinkable saga, I had hoped to be alone. The only Baule captured. The exception. The error. But I was wrong in my thinking, there were many coming from where I lived. An entire people placed in irons and chased from their land.

Our voices hang in the air; we avoid each other's eyes. I lower my head and think of that morning in the hut. The day Akissi's breasts moved freely in the wind.

The thought that my dead might not be dead haunts me. Have they also been torn from their roots? Driven by force, chains at the

ankles, and spiked collars at the neck, all the way to the shacks rumored to lie along the flowing blue waters? Even here, even all these years later, I sometimes think I'll see them again. One day, I was surprised to find myself following a woman. Akissi's spitting image. The untidy hair, the backside that shifts right and left when she walks or when she's annoyed. "Kiki!" I whispered, "Kissi!" The girl turned around, but it wasn't Kiki. Just some black woman who declared her name to be Marie-France, lived on this or that estate.

*

The fear of falling even further is really what led me to go through with the plan.

It was morning. The sky had a white skin, like warm breast milk. It was the day of our departure. We knew it; some woman had announced it. We would board this large wooden boat, which stalked its prey like a vulture. Soon, we would be no more than carrion. Bones. Nothing.

On my own, I likely wouldn't have dared, but the women had started talking. Hope had returned to haunt us. Anything was better than slavery.

What would happen after we jumped? The question never came up. You have to be free to see the horizon.

The day has arrived.

In single file, we walk, climb into the dugout canoe that takes us to the ship. Heckled by the waves, the boat wobbles. The sea spits. I taste. Who could have put so much salt into so much water?

In the country of TheSea, the whole village is in a state of activity. Shouting, rushing about. My old body grows still. The wrinkles are a second skin. Armor. Everywhere young people protest their innocence. What have they done to deserve this? Deaf to the pleas of the Negroes, the Red men get our attention and sort us like grains of rice.

Males with males, females together. Pregnant Negro women and children in one corner. Everyone to the middle deck, a chaotic space, where the hatch beats like a heart. For a long time it goes on.

*

The water had left me when the boat touched earth.

Like a sponge, the sea had sucked everything, our tears, my blood, the water that discharges to express and take pleasure. Turned me into an old stick, the sea. A mute-breasted shadow that no one could have said for sure if it was a woman, a man, or a dog.

That first night at my new masters' house, I remember bleeding. It was the first and only time. A scrap of red cloth between my thighs, I lay like that for hours. Retracing from memory the path of the ancestors.

For a long time, I kept the red rag under my pallet. At the time of the moons, I pulled it out, smiling at the memory of what I had been. Girl, woman, mother. That wasn't nothing, I had reason to be proud. I touched it for a long time, until my masters caught me with it and grew angry with me.

A few years later, I left that estate and began my service with Madame.

It was not out of goodwill that she purchased me. Those people have no blood. It was because of my advanced age. What master would be crazy enough to ride an old woman?

And yet, on certain nights he'd end up at my door, three sheets to the wind. "Knock, knock!" he'd bray before turning away, unsatisfied, to empty himself wherever the wind took him. I never opened the door. I had too much hate and no desire to lock horns with their law.

*

The world has changed. I am different because of the evil that resides within me and, since the time it found me, has refused to leave. Evil. We think it's far away, and then one day, there it is. Everything started on the island after Jason, son of Maripo, made his escape. Jazz, that's what we called him, was a wonderful boy. Not a braggart. Always a smile. Never a harsh word. And yet, I can tell you, the child had been through so much! Hardly out of his mother's belly, he had to be taken to the hospital. For weeks lay there because of a problem with his jaw, that cursed illness that eats the heart of little people. On the thirtieth day, the illness had been turned away. Jazz was saved.

But bad luck took root again. At two years, the child started

spitting up blood, coughing like the devil and vomiting worms. He was bathed, fed herbal teas, given massages, purged. *Tchip.* Poor thing. The other science was consulted. Prayers, sacrifices. Vice versa, *tchip*, before calling for Balba, the strongest *papa-feuille* on the island.

The child survived but a melancholy shadow hung in his eyes, nostalgia for a country from before, imagined but unknowable. Who would have been able to talk to him about it?

Time took its time and he grew. Jazz had just reached the age of twelve. One Saturday, right after evening roll call, he left the hut. The country was dark, but he could see well enough to take the mountain path, the road he'd taken so many times in his mind. We all dream of the mountain.

For a month, they hunted him. Long nights shaking up the island, until dust rained down, turning our headscarves red.

On the thirty-first day, while we were cutting cane, a gunshot echoed in the sky. The machetes trembled. All eyes fell on the horses galloping across the plain, dragging behind them the corpse of a boy.

That's not all. The master, crazy with fury, makes the mother come identify the body. She runs over, looks at the White man, tells him this is not her child, this supposed son, this is not Jason. The master loses patience. Twenty-five lashes of the whip. The woman continues her denials. Fifty. He orders her to finish off this Maccabean, since he is not her son.

I was there, I saw it all. She did everything and returned to the field with a light step. I even think she was whistling.

Ten days later, she cracked. A madness that had danced about her like a top, before coursing through her body. When the steel thread snapped, we knew nothing could be done. Soon would come death.

It wasn't content just to strike, it hung around. Roamed about. One morning, sat down right in the middle of the field, right out there, I'm telling you, as if it had been invited!

Nothing was ever the same after that. The cane, the dogs, the men, all seemed to be haunted. Seized with a desire to sing. A melody unlike anything here. Put dark thoughts in your head.

IT WAS LATE. Already pitch-black in the hut when it came over me. Because I couldn't keep my mouth shut, I got up. Silently, I crept away from the Black people's huts and walked toward the light.

The master's house lies at the end of a path lit with torches. It's a long, light-colored wooden structure surrounded by a veranda with floors scrubbed clean.

Upstairs, two large bedrooms. The White woman's room separated from Monsieur's by the toilets. Downstairs, the children are sleeping. A little brother and his sister. Redheads, both of them, with spots scattered all over their skin, which makes them look sick or dull.

Because of the sweltering heat, they've left open the door. Up close, the little girl looks like her mother. Same softness in her features, same complacency, as if the whole universe were her due. The skin is so white, I taste. Smells of soap and bright-colored flowers. Sugar with nothing, sunlight without cane. I think of the whip that this skin has never felt, and this thought, though idiotic, is more than I can stand.

My hand draws close, brushes the cheek, pauses, hovering over the neck.

I'm going to do my best, wring as hard as possible. Clap a hand over her mouth to smother the scream. If it's the same as with animals, should be over soon. I know how to slit a throat.

But something has broken inside my head.

The song is gone now, I back away to the railing, race back to my hut, as if the devil were at my heels.

In the morning, I went to see Madame and asked her to change my duties. I preferred the cane fields, my sick old body needed fresh air, was beginning to stiffen. A young Negro girl like Sabine would be of more use to her. An old woman couldn't be depended on to keep a clean house.

She lifted her eyes to the sky, just like each time she was irritated, and with smothered anger declared that she would not tolerate a slave interfering in the organization of household work. What should or should not be done.

"Do I make myself clear?"

"For three years, I've done what I was told. But today . . ."

"Today will be like yesterday. Nothing has changed. I will not

have a slave revolutionizing anything here. If you have a bad back, it is no doubt from spending too much time dancing. You all think of nothing but your feasts."

The evil song takes over again, but I act as if I hear nothing. Not the right time. Wait a little longer. Soon.

*

The sun has gone down. Passions, life itself. I have more than a century behind me and every morning, at the same hour, heat my water for coffee. It's here that I caught this habit. I drink it without sugar, better for the heart. With a loaf of bread on Sundays, the only day I have an afternoon to myself. Off work, I bustle about, tidying up my hut from top to bottom. Crush a dozen cockroaches and get rid of them, quick. Horrible things! They stink. Remind me of the old days, that woman in the ship hold, who fed on them.

The other time, I encountered the girl. On the path that leads to the river, she was running through the cool night. Butterfly wings attached above her bottom.

I would have followed her, but I had an errand to run, it was late. The *mambo* had told me seven o'clock.

The *mambo* claimed she was from Benin. There, she'd acquired her science from a priest, in a place far from people. Ageless, she seemed to have lived the whole history of humanity. Knew the position of the stars, the depth of the seas, the color of a man's heart. "The end of the Negro's ordeal draws nigh," she was always saying. "Will come a time when you all walk as you did in the past, with light step, your body straight and tall as a silk-cotton tree. A rifle cannot kill a rifle, we must arm ourselves from within."

Her body bent over, she was tracing strange symbols on the ground in her hut. Paid me no mind, she was engaged in conversation with the invisible, spitting her saliva from time to time, moaning with pleasure whenever the spirit made its presence known to her. Water began flowing from under the white dress hastily slipped on, forming a puddle, a lake, a sea. Swelled, emptied herself, pouring out thousands of bodies. I was tempted to slip away, but the priestess's gaze dissuaded me, and instead, I approached her, humble and submissive, holding out a flask of my own urine. The water of a very old woman is what the spirit required.

"The great day is coming," murmured the *mambo*. "The cere-
mony will soon take place." She said no more about it, but wished
me a good trip back, then disappeared into the sea.

MY FAULTY old memory fails me. Yet, I swear that I'm making
none of this up. It all happened just as I've told you, the hut, the
water, the *mambo* . . . It happened, like so many other things.

The day after my visit to the priestess, it was as if the weather
had decided to change. It was hard to believe, *Diantre!* Roaring
waves of swollen drops rushing down from the sky, pounding and
pulling down banana trees and sugarcane. Every day, downpours
somewhere, swallowing the earth and tearing the roofs off huts.
Riverbeds shifted, cattle washed away. The roads? No more roads!
The paths? Furrows where bodies got stuck and foundered. When
downpours come, I'm warning you in the name of all that is sa-
cred, do not leave your hut and venture beyond the gate!

ONE MORNING, the day after the Artibonite River had receded,
we saw bits of cloud falling from the sky. Working in the kitchen, I
saw Madame grow pale, call to Monsieur three times, telling him
to come see. "It's snowing! Look at the snow!" they stammered,
terrified as if they'd seen a ghost. And it fell. Morning, noon, and
night. So much that all the green disappeared from the country.
Everything turned white. Gray, mud.

A week later, the sun shone again. The master gave orders. The
church bells rang. Back to work! In that month, there was plenty to
go around. The big hut empty, I was left to myself. I was old. They
didn't dare put me down.

In the garden, partly destroyed, labored all kinds of Negroes. The
wheelwright sweated, the infirm wore themselves out, the children,
usually excused from heavy tasks, stumbled along, hoeing rows,
tearing up roots, gathering cane into small bundles for shipping.

Hard at their labor, the men no longer kept their eye on the
sun. Gave up hoping they'd be able to rest their hoes and machetes
with the sun's last rays. Night fell on their backs. Under a late af-
ternoon runaway sun, the Negroes toiled on in the cane under the
threat of the whip, marking each gesture with a grunt. A collective,
muted *unh hunh,* which far from the result of the effort expended,

voiced all the power contained in these men, the violent strength they would soon put to use.

Certain events had to unfold before that day arrived.

One morning, when the slaves, called by the bell, were lining up in the courtyard, a flash like lightning lit the sky, thick, dark clouds boiled up, and the earth trembled under their feet. By noon, the wind seemed to have taken its leave. The air was dry, nature stock still. Not a hint of a breeze, nothing that could cool. The White men turned their gaze to the sky, but the great dryness triumphed. Cane stalks dropped their arrow-shaped leaves, supply deliveries lagged. No new life. Everything was dry, even the big river, so deep in the past, lay dry with its bed exposed.

More arid mornings, more nights followed, inflicting all sorts of ailments on people. It hit you all at once, the malady, gave you worms, scabs, vertigo, whitened your tongue and swelled your feet. It was slow to leave. Sent you to the hospital. To take herbal teas, camphor rubs, tar-water, hot baths. Sometimes stayed at work to avoid too much scratching.

With most of its Negroes down, the estate fell quiet. Only the furnaces rumbled on to keep making sugar in a final symbol of colonial resistance.

*

Man is word, his silence cannot endure.

Then, came the rumors from the big white country, which fever-ish hands rushed to glean. Smuggled into houses, the rumors took on a life of their own. The masters, faces red with anger and fear, outdid one another in a rush to swear oaths and cross themselves.

Abolition. I was out on the veranda, waging war on chicken droppings when I heard about it. Something was happening. A new day was coming.

I was sure of it, the evening Monsieur and Madame had people over for supper. Judged too old and slow to perform table service, I'd been replaced by Cécile, a young Negro woman they just called Nulpar (*nulle part,* or nowhere) because nobody really knew where she was from. Arriving at the estate a few weeks earlier, she'd been noticed quickly. A green coconut makes you thirsty. Upon seeing her, the Black men went dry on the spot.

They could chase her all they wanted, but Nulpar was not a woman who would let herself be sown. Did what she wanted with men, including the master who, according to wagging tongues, had been seen creeping around outside the hut where she slept. Ears closed to the gossip, I opened my heart and watched over Cécile as I would my own daughter. For sure, she was no ordinary being, but carried within her what slaves and masters alike had been forced to abandon: our humanity.

One day, when Nulpar was beating the laundry, Madame erupted into the courtyard and planted herself in front of her. A frown on her face, hands set nervously on her hips, she announced that one of her dresses had disappeared, the white one with a wide ruffle at the neck. Someone had stolen it.

"Really?" said Cécile, to indicate that it wasn't her problem, but it could well become her problem if . . . The other woman would not let it go. Suddenly, Nulpar leaped to her feet. Stepped closer to Madame and shot her a look . . . a look that would blow up their steeples!

Terrified, Madame looked, she who never saw her dress again until the night when, awakened by the voice of the assoto drum outside, she ventured out of her room. Half-naked, stepped into the sea of sugarcane.

Had she dreamed those dancing Negroes? That woman with flour-white skin, dressed in a hat, jewels, and a ruffle?

*

In the house at the end of the path, the guests had arrived on time. Madame had rung. "Bring the soda water and liquors!"

Then things had happened quickly. Nulpar had sung, the ladies were chatting gaily. One of them, a tall, thin woman with red hair suddenly felt ill, had to go lie down. What a shame!

I was bathing the little one the next morning when I heard the news. Rushing into the room, Madame threw herself on the child. Hugged her tight to her chest like a doll. Paying me no mind, she sobbed, repeating over and over that the redhead was dead. The redhead. Found dead in her bed that morning.

Out in the sunny courtyard, Nulpar was again singing the song. Washing, beating the laundry. Gazing deep into the gathering dusk.

That was the last time we saw her on the estate. The next day, her hut was empty. Nulpar had disappeared.

It was the day of rest, but that didn't stop the White men. Armed with rifles, dogs, and Negroes, they strode across the fields until the eye could no longer distinguish between black and white lines. Two masters perished in the chase, another was seriously wounded from a bad fall. It seems his horse had suddenly bolted.

While the island, still turned upside down, wore itself out trying to get some sleep, waves could be heard lashing the rocks and with heavy breath, racing along the shore of this possessed land.

Never had night seemed so dark, never had dawn been so anxiously awaited. At sunup, people's faces were coated with a fine white film. Powder of salt, flour, or shadows of forgotten stars.

Months after Nulpar's disappearance, I caught myself humming her song. Gathered around the fire, we sometimes hummed in chorus, lowering voices when the grasses rustled, signaling the master's arrival.

What became of the woman, only the spirits know. Only the very old, who know the tangled way of trances, sing her fate. In 1779 (five years after our arrival on the island), some say they crossed her path. On a moonlit night, a few hours before the great massacre.

Parlor Negroes, garden Negroes, Negro children, old people, all had fled sleep, put one foot in front of the other, guided by the echo of drums. Upon reaching the clearing on the riverbank, they'd joined hands and wound their way around the drummers like creeping vines. Into their circle entered I-All-Alone. Sweaty skin bearing no scars or wrinkles, fluttered about like a clean sheet dangling on a line. A thunderous rumble brought forth a djinn from a drum. Perched on his head like a crown, Nulpar gazed down at the crowd, her mouth white with foam, eyes flaming. Some of the Negroes swooned. My eyes popped wide and I stumbled into the filthy wall of my hut.

A dream?

A sure sign that the time had come.

Today, Monday, will be a great day. A great Sunday for all Black people.

*

Heart light, I arose and left my hut.

The compound, usually full of activity, still slumbered, plunged in a strange torpor. Around the residence, which had been abandoned, nature had taken over. Dog and nanny goat droppings carpeted the porch, two mares ruminated near an uprooted tree fallen from the sky by some miracle. I approached the building, hesitated, then pushed open the heavy front door. A shiver ran through me; in place of the parlor was a shimmering pond edged in tall grasses.

Bounding down from a mountain, a laughing waterfall invited me to bathe. I plunged in and instantly, a delicious feeling of freedom. Never, oh never again would Madame ring her bell. Never again would mornings taste of soap. Black soap wash-White. White soap soil-Black. Like Madame, I would put on a petticoat, pin tight curls in my hair, wear dainty slippers for tiny feet. Walk tall, speak without tripping on my words.

Emboldened, I went upstairs where a couple of young bougainvillea were lounging. Intrigued by my presence, the bushes paused in their caresses, opening up their blossoms like ears. I just smiled and entered Madame's bedroom.

What a mess!

Banana tree roots spilled out from a layer of soil, taking advantage of the joyous disorder to defy nature and bear guavas, mangoes, and coconuts. The mattress, a disgorged animal, sprawled, its feathers giving off a rancid odor of urine. Only the armoire, crowned with its cornice, had preserved its dignity. Servile, awaiting the usual scrape of a key in its lock.

I was heading toward it, when my eyes met those of a woman.

Right in front of me, barely an arm's length away, stood an old Black woman, staring at me. I'd never seen her before. She must be new among us. The last of the Bossales, slaves born in Africa and come all this way to die. As my eyes took in her body, running over wrinkles, scabs and sores, I silently questioned this stranger. How, but how had she survived? What master could be so cruel as to spare her? Those looks were intolerable! As I stretched out my hand to touch her, I flinched and recoiled. The thing was stirring! I could swear I'd just seen her hand move!

A breath.

The thing was crying. Her whole face was streaming. Noth-

ing left but her mouth, her lips, almost-lips. A shapeless forehead. A pelt.

I stared at this person, and then it was my turn to sob. This woman had lived. Been through death a hundred times. I knew it, could feel it. A shout. I just realized. She, I, we were like each other. Were the same.

It's after that everything came back to me. The ship hold, the deck, the anger. How had I lived with all that horror inside me? The shame, the stench!

The memory works when it wants to.

By JUMPING, I'd thought I was putting an end to it. I'd let myself sink with no regrets. To those who hoped to swim back to land, I said nothing. I knew things, I was an old woman. I'd seen my man and my daughter depart.

So I thought I had died when I came to, little by little. A man was leaning over me, rubbing my chest hard, jabbering away in his strange language of dogs.

I wanted to tell him to be quiet, but the juices of the sea were smothering me.

I must have died for real because all daylight was gone when I opened my eyes.

No one left on deck, none of the other women who had jumped. Where had they gone? They never returned.

Back in the hold, I lay down and prayed.

May a great fire be lit to tell the heavens that death has passed through. Some of the sisters are broken! Let this be told to the uncreated, the great creator. We must wait for the *wawe* to open a path to the land of the ancestors. Up there, in *Blolo*, it is said that those women no longer have shadows. No *wawe* for dead branches who cut themselves off from the village when they left. No shadow for those who jumped.

They said that I'd lost my tongue, that I must have lost it when I jumped.

They said that I would never make it to the end, that my heart would give out right after TheSea. That's what they thought, but they were wrong. I endured. The sea held me.

*

They say she is still prowling. They say she is still roaming. When the great aster is snuffed out, she still goes on her way. Coming ashore to catch her breath. Using the moonlight to shake off men, blinded.

They say that she has no memory, remembers nothing. Unconcerned, she carries bottles into which the dead have slid their prayers. Their last wishes.

But I, I believe that she knows more, that she carries and records history. Holds onto us forever. Hypocrite, the old woman.

The sea.

I never saw it again. Made sure to avoid it. On an island, that's not easy. It took cunning but I managed.

I learned to walk head down. To flee the day, the trees, the sun.

I stuffed my ears with sand to stop hearing the drone of the waves.

They call me sequel. I'm the one who remains, the eye that has watched others depart. In 1804, only two of us still spoke of the country. The others celebrated. The island of the other: first Black republic, a big deal. What good does it do for me? They beat me, bruised me. Killed me.

Learned to swing a pitchfork. Pray to the Virgin. Speak the language right.

They put salt in my memory. Exposed it to the sun. They burned it. My mind smells scorched.

Haitian? Can someone tell me what that means? Someone to remember? Someone dead to talk to? Really.

Enough talking, my tongue is worn out. Tomorrow is another day. The first day.

Everything is ready. The dugout, the oats, the demijohn. It's all there, my old woman is just waiting for me.

Tomorrow. I'll shove off. No compass, map, or sail. Just the echo of Afiba's laughter.

And oh oh oh oh, there's the bawling sea
A gale up the fore, headwinds in our face
Steady Big Jehan, oh, steady your hand
Let's empty a bottle, tonight you'll go slack.

On the hard deck, you can catch a short nap
Sweet dreams, oh, Jehan, to you, Big Jehan
Your purse is now full, your life lies ahead
Fairy or fiancée, the lady back home?

Heave ho, Big Jehan! With all of your back
The life of the sailor will leave you behind
The sea is a lover, she'll take all your coin
And then hit you hard, and stiff is the blow.

the slave

Me, I come from the land of Nupe. It's there I was born beneath a sun grown black from seeking it. From my mother, gone up too soon, I inherited my smile, that celebration performed by the lips when the earth drinks the sky and the trees eat their fill.

Suddenly, the country is no longer the country. The men take flight, the day runs off. I'm dreaming. Wrapped in fiery breath. I rise into the sky to find *maman* again.

That time never came. I remained down here. In our land. In the hut with few doors, in the darkness inside to keep life from slipping away.

Our land is a land of earth, knows not the sea. Just the curve of the plains. The laughter of the water that flows between green banks, there where our animals graze, where our women wear down the stone until all is scrubbed clean, smells fresh, good. Under fingernails, in the folds of their loincloth, there is always a red-brown powder, the color, the scent we carry with us everywhere.

Our village is a small village. Ten hands are enough to count its people. Its chickens, too, and cows, and the hyenas that chuckle, prowl in the night outside the village walls.

Certain times, fear wells up to disturb sleep. Huts cower, bodies huddle, ears prick up at the sound of approaching savages. Death galloping into the village. Filling the night with a dirge of clashing iron.

One of those wars abducted my father and took me far from the village to a king. I, small daughter of Nupe, became a captive.

*

It is nighttime, a cool night early in the dry season. There's a forest, dense, so dark, I feel it closing in around me. Leaves rustle, the earth rumbles. I tremble. Surely, I will die, gobbled alive by some

savage beast. In among the trees, where I'm forced to march, I can hardly breathe, think I must be dreaming when the column halts and a city suddenly looms before us, enclosed by a wall protecting the palace, at its heart.

It is a hut of huts. A room big as a village. There's a path that leads into a courtyard, a courtyard that opens onto a path, a succession of spaces that keep coming back, as if we're going around in circles. The roundabout stops when a door gives way to reveal a dark, filthy room packed with a hundred captives. All are handsome and strong. I find a space to lie down among them, I understand that we have arrived.

The next day, only some ten of us remain, the night swallowed the others. I was sleeping when they left. The man who abducted me returns. We follow him again, wander from room to room, keep walking until we reach another hut. At first, I see only its floor because a slave never raises the eyes unless so ordered.

Forehead pressed to the ground, I prostrate myself before the All-Powerful, this king who, like the gods of my village, holds over us all rights. At his command, we will depart the earth for the heavens in an instant, our miserable lives cut short. We are his people, his things, his property. Under his orders and for his exclusive use. We are whatever he deigns to make of us. Beasts in the fields, slaves in the bedroom, bodies disgorged, quartered, buried alive, offered up in sacrifice.

On the straw pallet where we are made to sleep, I hear the song of the wind. Breach the walls, batter forests and savannahs, flee far from the palisades pointing at the sky like weapons.

Where are my sands, my flowers, my suns? My tiny country with its skies that laugh and cry? This house is too vast, it is not mine. Not the house, not me, this ripening body. Like the earth, my body gives like the earth.

I, small daughter of Nupe, I am becoming a woman.

I MUST HAVE been twelve years old when they moved me to the other side, the sleeping quarters of the queen's personal slaves. Five years I remained there. I am sure of it. Each time my blood flowed, I kept count. I lacked for nothing there. Always ate my fill, slept in a clean bed. The queen, our mistress, was not a spiteful woman.

It's only later that she changed. We were seven in her service. All young girls, foreign, abducted one fine day, and who would never return to the village.

To avoid falling, I, daughter of Nupe, worked even harder. With a lot of work, the sun doesn't last.

The earth opens its door.

The palace, reawakening at dawn with a clatter, is already bustling. My mistress's grooming completed, I cross the square courtyard to enter the room of bronzes. It's a dark room scarcely wider than a corridor where none ventures but the sure and hardened foot. There reigns a silence of muffled anguish, in which reason, casually dismissed, loses its way. After that, nothing remains but the mysteries. The masks surging from the walls, made up with ashes and dried blood. The faces in shadow that speak of the night.

Plunged in impenetrable dreams stand bronzes in each corner. Armed with slings and wearing skullcaps, the great men slumber. Awaken to the rumble of the prophetic drum. Attack! Fight to the end, until the enemy is no more. Indifferent to the fine red dust now filling the room, I polish my mistress's treasures. So she'll have no complaint.

The bell rings. I close the door behind me and hurry to the royal chamber.

I knock. Enter and kneel, when a man's hand grabs me, shoves me out of the room and beats me. To death. I must have committed some offense. The man curses me. I lose consciousness.

I am lost.

*

They gathered me up as the wind was whitening the trees. It happened at dawn. They arrived, astride their beasts. At a gallop, seething with war cries, champing on the dust that filled the air. Forty days that I hadn't seen the sun, shut up under double-lock, left to the mercy of darkness, fear, and evil. Thirty-nine nights chasing mosquitoes, finding ways to trick death. Gulping down watery soup of beans that give colic.

I've eaten nothing for three days, when the door opens and someone hauls me out. Now dismounted, the men look smaller, surround me and touch me. Close up, their skin is pale, wrinkled

leather. Pointed noses. Hair that curls under their scarf. They talk. Utter crude sounds that scrape the ear, grate on the throat. Then, it's all over for me. They bind my wrists and drag me into the arid kingdom of infinity.

The sun is white. Skies slide past and I'm thirsty. My new masters trot along a few arm's lengths ahead of me and, when they remember my presence, spare me a few drops of water. Which I absorb straightaway and immediately forget.

On the road of endless sand, I watch them live. Hunt, belch, bow down toward the East. What are they saying in their now-lilting tongue? What do their hearts hear that I cannot? Suddenly, one of them points a finger at the horizon. Look! Fires at an encampment, which we reach at nightfall.

Worn out from collecting so much wood, the Negroes finish setting up the tents. The masters savor a *mechoui* while a slave offers me a calabash of milk.

Then, only then, do I open my eyes.

There is no sun, nothing but sky. Limitless, crushing all human vanities. There are no longer men, only beasts that moo, bray, ruminate, tread toward death. Hunger always hovers, no matter, we have to keep walking, follow sheep, horses, camels at the risk of stumbling, not getting up again, receiving a final thrashing before the master departs. Because I'm frail and only recently attached, it is I who take the place of others. More than once they strike me, I, small daughter of Nupe, who is now worth no more than sand.

Another day and nothing has changed. The desert remains. A woman dead among us Negroes, accused of having stolen food from one of the white dromedaries. We don't bury her, instead release her on the desert's wings.

The dead woman brings us good luck, after the yellow comes green. Green palm, acacia, and finally an oasis where we hasten to set up the tents. Busy gathering kindling, I don't see the man come up behind me.

Violence fills our masters' eyes, curses fill their mouths as they burn our bellies. Afterward, they always laugh, liken us to the black monkeys that inhabit the mountains of Arabia. We're demons, they tell us, the very demons condemned by their law, if they don't turn their back, they'll face the fires of Gehenna. Hell is

a faraway country where it is too hot, too hot. Where the disobedient and the unbelievers, those who have not chosen the straight path, are tossed.

THE STORM has ended, the caravan starts off again, hesitates on rocky ground planted with thorns. Today, it's the new captives' turn to gather seeds. Preceded by two oxen bearing their loads, we head toward the East at a feverish pace, our eyes burning from the rays of the rising sun, bodies trembling in fear of running into a snake or one of those black beasts that sting. The danger grows. From the sand, declaring itself free to do as it pleases, swirling about our feet, lying in wait. From one dune to the next death prowls, tempting the fiercest among us.

Unharmed, we return to the encampment, rattled by angry turbulence since the sky is in a rage. To the clamor of the wind are added the bellows of animals, anguished, prostrate, or mad. Between *xaïmas,* where nothing is left, the goats bleat, the camels bellow, indifferent to what nature has given them.

First drops. Silence under the white canvas tents where men and women, their memory recovered, mutter prayers. What do they fear losing? What good is their ardor, their dogged determination to live? From what well do they draw their faith, which fades at day's first light and awaits the sun's peak to be practiced?

Rain, clouds, wind, hail in torrents. Canvases and tent stakes collapse. In vain, we prop the tents back up again, chase after the cattle. The sky is a furnace, the clouds are ablaze. The sand dissolves to mud, where hooves, heads, chests founder.

What a spectacle! Death, with full-throated howls, attacks at full tilt.

At the top of the hill where I've found shelter, where I watch the encampment sinking into the earth like a scorpion, there is a man praying, his forehead pressed to the earth. Before him who grants mercy, the Merciful One, this man of faith kneels. God of clemency, Merciful One.

Toward the East, I will walk. My only baggage, the book given by the sainted man before he disappeared. Like the clothing on my skin, he will walk with me. Offer me his arm, his tongue, his

signs, which dance, alive like tiny flames. Which my mouth patiently intones.

I, small daughter of Nupe, believe.

*

I straddled rivers, wandered under chattering skies, saw the moon go down and the rain come up. I slept in savannahs, unraveled sleep in the forests with trees taller than tree shadows. I suckled mangoes, nourished my body with pomegranates, bananas, walnuts that seemed to fall from the sky into my hands. I was a Peul among Peuls, a Mossi in Mossi lands, Mande, Bambara, Yoruba. Man, woman, child.

Queen here, dog there, when fearful villagers shut themselves up in their huts, gathered rocks and chunks of wood to stone me.

I, small daughter of Nupe.

The night is mild. The moon is full, breastfeeding the earth. I sit naked, both hands resting on the book. Heart at peace, body drained at the end of this long walk. It matters not where I am, West, East, near, far . . . I am here, alone for a few hours more, before setting out again on the trail of irons.

I was in the land of Borgu when they captured me. A few leagues from home, from the hill from which, in times past, I used to study our hut with its dark inside. I was sleeping, yes, when they came back.

*

Again, the trail. Travel to the ends of the country. Where there will be nothing more ahead, nothing after, but death.

The woods recede. The living being hesitates. In vain, I watch for hoofprints of the most recent warthogs. The only sound is the song of our chains. The ground rustles, strewn with white and ginger shells. Holding them to the ear teaches. A violent wind blows in there, like the one that is now whipping my skin. Under a sun whose bristling rays shatter the oppressive landscape. A flat country bordered by a lagoon, where manly limbs on thick, leafy trees shake with insolent heft. Teems with plants, as if escaped from hell, with thorns that intimidate. Clouds of insects swarm in buzzing columns of black smoke.

Stepping carefully here is essential. One captive learns at his own expense when, soaking his feet in the water of the swamps, he loses balance. Help! The man flails. To no end. Two monsters battle over him already, their tails thrashing him before their jaws close around what's left of the wretch. Horrified, we probe the depths, thinking, in every ripple among the mangrove leaves, we see the crocodile's shadow.

We arrive in the village. The northern section of the village where some ten big huts seem to await us. Each barracoon, for that's what my new masters call these sheds, houses forty captives. They sit clumped together, like a single man, gaping eyes locked on those who have come from so far.

The door opens, I'm shoved inside.

Bismi Hah Rahman Rahim.

One more night before the sun enters fully.

ON THE COAST, at the edge of the village, men and women never touch. Sometimes sense one another's presence through the iron grills which allow some light to filter into each barracoon, unveiling glimpses of other life, other skins. Our masters are neither good men nor devils. Exercise their task with attention. As ready to punish as they are to care for us. Their intentions escape me, the tongue they use is a mystery, as is their face, no emotion shows, ever.

I pay the rumors no heed, no one can know, we are all afraid. We all tremble when, in early mornings, a master inspects us with gestures, in his language, points at some of us with his forefinger.

"The tall one with red skin! The other one, in the back! That one over there!" Plus her plus her then me.

"Yes, you over there!"

"Me?"

I, daughter of Nupe, I have been sold. For coral, pipes, swords, and three copper bowls.

*

Not knowing. Still waiting. Sleeping here, in this hut where the sea seeps in. Walks in at night, with muffled step. The night that slips into our dreams. I awaken. The room is quivering. The ear strains. It's coming from nearby, from afar, from everywhere. Who can tell

with this sea, whose end no one has ever seen? The more you go forward, the farther you have to go. That's what they say. And they say the ocean swells. That a time comes when your legs are too short and can no longer hold you up.

The wind goes still and the heat is intolerable.

As the days go by, I learn the faces. The women talk, make friends based on languages and smiles. My new friend is my size. Same weight, same price, same heart. Never sleeps at night.

Everything I own is hers, and the little she has, she shares with me. Water, broth, her loincloth, which she unwraps, where we hide like two children joined by a formidable secret. Busied all day with different tasks, we rush to evening roll call, hearts pounding, moved to be together again. She and I.

I, small daughter of Nupe, I love.

It is not permitted by the Law, but He is merciful. He knows. He will understand.

That night, my beloved wakes me. Tells me, trembling, what she saw. She saw them, those flames that cut bodies to pieces, the fire that was chasing her and catches her in the end.

"You have to know," she murmurs. "It's because I can read what is after that I refuse sleep."

"Don't worry, I'm here. I won't let the dream take you. Never!"

They have moved her elsewhere, to a cell at the back of the land. It seems they take these measures when there are too many slaves and not enough space.

I've kept her loincloth, it helps me find sleep, bring tomorrow sooner, when I will catch sight of her, maybe.

MY EYES CLOSE. My beloved died tonight. The fire, in the end, she went to sleep. My mouth is dry. I, small daughter of Nupe, I cry.

In the night, I am cold. I no longer recite text.

In the night, I scream.

I detest Him, I hate Him.

<p style="text-align:center">*</p>

We never forget. The memory remains. We need only wait.

I waited. I, small daughter of Nupe, I waited for the past to return.

It happened on the eve of our departure, a rain of fire set the roofs of the barracoons trembling. All around, the waters began to swell, the leaves of the trees galloped about, pursued by a headless gale. Beneath the water-filled sky, we saw not a drop, barely able to make out the bottomless, endless, limitless sea through the mist that had swallowed it all.

My eyes stared at the harassed trees, envying the palm leaves leaping to freedom. Would we soon feel this same thrill?

The storm didn't last. Before nightfall, the sky burst into laughter, a tawny sun broke through, and all was forgotten. Taking advantage of this lull, we crept cautiously to the sacred tree. Here would take place the pact of the twelve.

Right after roll call, we heard a voice rise. A woman, someone new, declaring herself one of ours, with us, ready to fight. Busy filling the skull with blood, I paid her no mind. Not until we made a circle did I recognize her. Queen, my queen to whom I had devoted so much time in the past. Each morning pounded her loincloths. Braided, put in beads. And at night, there was more. At night, I am the shadow that watches over her sleep. Chases away flies. Tracks down drafts. Too hot, too cold. Would kill myself before seeing her harmed. I, daughter of Nupe. Daughter of nothing. Her thing. Does she even know who I am? She. Has she ever even seen my face?

While swearing to reveal nothing, I promise to avenge myself. What good is freedom, when the past is heavier than chains? Burns more than the iron of men?

That night, I can't sleep. Her again. Always.

UP BEFORE the dawn reaches us, I study the vast blue field on the other side of the grill. My tears recovered, I cry. Like never before. Like a woman watching her man die. Damaged by the storm, the big storehouse is close to collapse. Maybe I'll be able to see the hole if it caves in? See the shadow of my dead beloved, black as soot, crawl across the sand, greet me? *Take care of yourself, my beloved, bon voyage!*

Why did He call her to Him? For weeks I've been asking Him.

In tight rows, shackled together, we push forward along the shore. I'm cold. It's the heart remembering. Then, the wind rushes.

The sails swell. Then, I'm off, I, small daughter of Nupe, who knows not the sea.

<center>*</center>

It is a country where nights are black, where the air is fetid, the grass is burnt. No one sleeps there. Pain overwhelms slumber. Fear obliterates dreams. It is a cursed, rotten land, one where, absent light, the mind's eye butts up against madness and brutality. The people from here are not people. Whine, cry, brawl. Don't talk. Have long been deaf to the world's song. Forbidden to think, each dissects and speculates, shakes out yesterday to turn up errors. What did I do, we ask, desperately searching for a reason.

Day breaks, my eyes seek out the Queen. She's there, scarcely fifteen feet from me. I smile. She is my reason for living.

IT'S TIME. We jump. Together, shriek our war cry. Sea yawns. The sea is river. Like long ago, I slide in. It feels so good, cool. What pleasure! Land seems so near, over there!

Far behind, near the bow of the ship, Queen is doing battle with the waves. "Help!" she screams. "Help me!"

I'm on my way.

In an instant I am there. Just as in the past. Just a body.

Before my rage wanes, I strike her with all my strength. "Help!" she shrieks.

Don't worry, I'll take care of you.

<center>*</center>

When the sea spit us back up on the deck, I realized our error. We had been wrong to think our act would alter destiny. Before life which, despite us, continued, before these sailors, sometimes distracted, who seemed to have forgotten already, I measured our minuteness. What were our prayers in the face of His will?

And as hope died in the holds, I tamed my fears and resolved to serve only Him.

All is now clear and right. The clattering rain. The flowing sea. Our skins screaming in the night. No matter the ordeal, this is nothing, what happens to people is not truth. With uniforms, muskets, power, we'd be more formidable than our masters. The

same. Whites, Mixed, Negroes. Men of action, yearning for idols, forgetting God.

The earth turns and all comes back to me. The signs that dance the fire-dance. The old man's words of faith.

Praise God, Lord of the worlds: He who gives mercy, the Merciful.

In the room at the far end of the ship, there where they pack women and children, I recite verses, my forehead pressed to the floor.

Lead us on the straight path, the path of those whom you have filled with blessings . . .

As a soft shiver runs through me.

Up top, different prayers are intoned. On the deck, morning-night, the chaplain gathers us. "Glory be to God, the one and only, the only one to love," chants our master-in-faith with passion. Does he not know that the one true leader is Allah?

When I point that out this morning, the man flies into a dark fury. Curse the Negroes, idolaters, animists, Mahommedans and the rest, incapable of opening their heart to the Supreme Being. "God must be earned!" he splutters in conclusion, daunted by the weighty mission with which he has been charged: evangelizing the uncivilized beings of Africa.

Suspected of heresy, I provoke the priest's hatred who, from then on, never stops tormenting me. Ordered to recite psalms and verses, I set myself to the task, to make the Catholic happy.

His passion wanes in the coming days, when a strange illness attacks a dozen captives. Examined by the surgeon, those who are sick claim it's a witch devouring their heart. Because of her, they have lost their desire to eat or drink. Two days pass with no remedy for the patients. Eyes yellow and bodies gaunt, they are now deliri-ous, claim to be visited nightly by the demon. In consideration of our backwardness, our chaplain hastily summons me, naturally. "This Mahommedan must be responsible for this somehow!" he proclaims, when they have lashed me to a cannon. I'm preparing to be whipped until I bleed, when the surgeon, confused, interrupts the party. "The sick ones are recovering, they are up and around" he brays, and I, on my way back to the hold, hurl an *Allah Akbar* at the ecclesiastic's red face.

Calm returns, the ship stays its course, and I have no further contact with the chaplain.

*

On the island, the lady who teaches us catechism is called Martha. Sister Martha. Hard to tell her age. We know her to have no vice. She is a good woman, beautiful when she tells stories of the great acts of Christ. Blue when she is one with her gaze and I dive into it as into a river. For those eyes, it's tempting to believe her. Many do. I, no, I continue to serve Allah more than ever.

To hear Martha tell it, praying to Allah is a sin, and the Muslim is a barbarian to be educated. I endeavor to change her opinions, but these White sisters are hardheaded! No matter, it's for Him to unseal hearts.

IN TRUTH, there is no land more impious than this, and observing the residents confirms it. Everywhere, hypocrisy is law, the miscreant reigns, much less prompt to face the divine than to manage his estate and grow his fortune. If by chance, this one goes to church, you can believe he closes his ears to the commandments of God: he treats his animals with more deference than his own black brothers. Why would that be surprising on an island where none have a horizon, where none have a choice other than being rich or being Negro?

A similar fecklessness has taken root in the slaves. Coming, for the most part, from lands where the sky has several gods, many combine. Marry Christ to myriad spirits. That is a sin. Useless to insist; how to grow the idea of one powerful god, when all feel they need more gods for protection?

Even I am sometimes unsure.

So I pray.

Chance (though it doesn't exist) has it that I live near a Mandingo family. Allah is their master, and the Qur'an is the book where they draw their strength and faith.

By the tallow's flame, we wait until nightfall to leave our huts and creep to our den. Mohammed's woods, so have we baptized the place where, hidden from all eyes, we kneel to pray. Foreheads pressed to the ground, shadows to the east, we recite the Word . . .

Bismi Hah
Rahman
Rahim

. . . which rises and bursts through the roof. Cradles us, brings a sweet shiver.

It is You we adore, it is You we beg for help.

Lead us down the straight path: the path of those You have blessed with your generosity; not the path of those who have incurred Your wrath or those who have strayed.

Back in our huts, we are happy, so happy when we lie down on our mats. Later, dream of the promise. The garden of milk and honey where men find delight.

It is not their bells that wake us at dawn. Nor their dogs, nor their whips, no! Nor the fear that grips all at once, rather . . . what is the word? Joy! For joy, we cry in the name of God. I swear on my mother's head, I cry, at the call to prayer. At the memory of the first muezzin.

TODAY IS a bad day. They demolished our mosque. Dismantled it stone by stone until there was nothing left but a pebble when we arrived in the little wood. In the butchered earth, they planted their cross. A man there who was dying, sobbed. His scythe-shaped beard fluttered in the wind.

I don't know what made me slash his face. "Take that, that, that!" I howled before Aminata-Sultane tore the weapon from my hands. In a daze, I glared at her, then lowered my head, feeling ugly and ashamed.

"Something haunts me," I said later on. "In the Book, aren't we told to take up arms to defend Islam?" The Mandingo woman sat down, smiled, saying it was not against God that we must wage war, but against His enemies.

*

I was already an old woman when I left. My back worn out. Body as brittle as a branch. My memory limped but I knew the Book. To a degree . . . that no one can imagine! To the degree of recit-

ing it by heart, down to the last comma. The Mandingo woman had offered me hers. That's how I learned she'd been reading the Bible. Yes, the Bible! All her life, for all those years, she had been rewriting the Book, transforming psalms into suras. Rewriting the language of this place into the language of the sands! Over time, the two texts had formed one. The very one I asked Sister Martha to read on the day I departed, I, small daughter of Nupe. Heart calm. Like the day risen.

Long weeks out at sea before we unload
The world must be white where you live, Big Jehan
Into the fire your old woman throws chestnuts
Smells so good, the hot turkey and bread

We'll surely see clear with all this damn water
We'll do nothing more 'til the fever has passed
Will hunt down the barber to get back on my feet
Will hunt down some she-beard to get back on my ass

Sailor, oh Sailor? Are you still asleep?
The turkey is cooked, it is perfectly done
On the table the butter grows soft in its dish
Dance a chaconne to warm your damp bones

the amazon

The past, I want to remember it all. Forget nothing, tell all. Tell them again and again where I'm from, who I am, what kind of flame burns inside me.

Hear me, sisters of the chain, hear my story through to the end! So lived Sosi, daughter of panther, warrior of all wars. Heed not your fears! A man's skin is like a loincloth. It must be stripped back to see what lies behind.

When my tits made a pretense at growing, I took care to band them tight. My mother had taught me, "An amazon must go without teats." Against the blood that flowed from my belly, alas, I could do nothing. The woman's sickness kept coming back. Always. On time. Obstinate. It had just struck when I parted from the village the first time. I was in pain, but no matter, before long I would be at the palace, kneeling before Dada, father and master of all Dahomean people. Face painted with mud and dust, I made my way straight to the court of Abomey.

At the palace, which annual custom had put in a state of jubilation, an entire drunken crowd was celebrating, glancing up at the royal platform from time to time, where the monarch would soon emerge to shower his people with gifts.

Later would come the sacrifices. The ancestors would be fed. Bodies would be immolated, mostly criminals to be hanged, captives, all of them gagged, so that no curse, no lament be uttered in the beyond.

Away from the festivities, shielded from the gaping stares of the villagers, King Tegbesu had withdrawn to his two-story hut. He was supping in the company of his wives and most trusted ministers. The Migan, his high priest, sat to his right, as custom dictated. To his left sat Mehu, charged with the kingdom's economic affairs, and this evening, he looked worried. The country's finan-

cial situation was less than desirable, he stammered. Too much splendor and too many reckless expenditures threatened to exhaust the kingdom's tills. Furthermore, with the Yoruba menace growing, he would advise . . .

The arrival of liquors and smoked fish offered the Minister the chance to cut short his speech. Cheered by the millet beer, he eventually relaxed, even proposing for the next annual custom, that they erect a Yovo temple, a cathedral like those sprouting all over Europe.

In his headpiece and heavy robes of red damask, the Master of Beads presided, silent, regarding his people and wealth with equal indifference. Only recently in power, he was afflicted with boredom, the great illness of despots. Nothing, it seemed, could surprise him. What was left to feel, for him whose smallest caprices immediately became law? For him who, confronted with the people's credulous thirst, feigned immortality, when he knew his time had run its course? He was tempted to step off his throne, then, changing his mind, commanded a meager griot to give song. Accompanied by his gong, the fawning dwarf lavished praise on the king, glorified battle victories and the greatest ancestors. The illustrious Dogbari, who had founded the kingdom, and his grandson Aho, who had vanquished the great Dan. Other stories followed. They cycled through the kingdom's history, going back in time to the stormy night when, squatting over a bed of dead leaves, a princess had given birth to two sons by a wild animal. Since that day, the Fon, the first men-countries, had the leopard as their totem.

When the herald had finished speaking, I entered the room and threw myself at the feet of the master of the earth. Tall for my age and robust of constitution, I was immediately enlisted and guaranteed the monarch's protection.

I was young then, pitiless. Prepared to defend the kingdom at any cost. In good health, I was a true warrior, as ready to hack off heads as I was to keep watch throughout the night outside the royal chamber. At that time, I tell you, no war was won without me.

On my feet at dawn, I slipped into the courage hut, swearing before the go-ho fetish to conquer and crush the enemy.

Armed with guns, wad, and blunderbuss, dressed in skullcap, tunic, and belt, I set out on the road to death or life, my head held high. Never at the rear of the line, always out front, brandishing the gunners' flag. I did everything: hunter, archer, grim reaper. I was everything: slashing saber, slicing razor, horns that made us race like an antelope. Attack, decapitate. Burn, torture. In everything, I surpassed all the others, until the night I had this dream.

Day breaks. The palace gates swing shut behind us. We are a hundred marching to the north. Hearts full, swords drawn, we scoff at death and sing our glory. The blue sky and high clouds portend a beautiful day. Perhaps there will even be sunshine. As is customary, I am among those who lead the march, an honor many envy me, sometimes contest.

Reapers, archers, hunters, in tight rows we march forth.
Like buffalo who stand out among the sheep.
Our battle swords surround the kingdom, form a wall high, high, high. We march together, we march like men, let us march toward our mark!
No mustard in place of offerings to the divinities. We ask Ogun the destroyer to hack all to pieces, hack all to pieces!

The sun is perched high when the first enemy village emerges on the spine of a mountain. It is a land of a thousand souls, guarded by four old men with eyes sealed shut. These Cerberuses are known to be formidable; their ears, alert day and night, can detect human presence for leagues around. Blind from birth, a single gate is all they know of the world. Are the gate, shielding villagers from attacks by men or savage beasts. Forewarned, we foil their trap. Trot toward them in a single step, forming a single voice, a single shadow that the gullible old men let pass.

There is no time to react when the heavy gates give way, it is pointless to flee, we are inside already. Fear mounts on all sides, heads bow in a plea for mercy.

"No prisoners!" I shout, ripping up huts and running my sword through bodies. No prisoners. Nothing. Only bits of flesh scattered on the ground.

As long as anvils lie in the forges of the king, the blades of our
weapons will slash our enemies. All together you will die. Yes, yes,
yes, we will kill all your people and cut the head off your chief!

Their chief, where is he hiding? Is he trembling? Is he fleeing? Yes,
he is scuttling away on hands and knees, crawling like a coward
to the great gate. "Catch him!" I command. And my women sur-
round him, drag him to my feet. But what is behind this clamor
bursting forth on all sides like the laughter of children, and mount-
ing, like prayers, to the sky? Or this earth turning to mud under
our feet, giving weight to the body that might have been welcome,
had it not been foreboding, a preface to the irreparable?

The man rises to his feet. I sing. Sosi fears nothing. Sosi is cou-
rageous. He draws near. Sosi has no fear, she stands brave. Smiles
at me and I can't hold back my cry: "Sosu!" It really is she. My
mother before me, who seizing on my disarray, hurls herself at me,
and tears out my heart. I hurt, God, the pain. Stagger, then col-
lapse onto the red sand. Dawn is here, I must wake up!

<p style="text-align:center">*</p>

Troubled by my dream, I give up on training that morning. Dread
overwhelms me, a foreboding of great calamity.

The day unfolded smoothly until the Gaou summoned us to the
Bead Room and revealed our next mission. "Before Lissa is fully
risen, a handful of you will exit the courtyard and head north to
the steep hills that mark the end of the kingdom. There lives a tribe
without faith, law, or king, a small village which you will destroy.
The river is deep, but less deep than the sea," concluded the Chief
of Armies. In chorus, we repeated. We knew the Dada's mantra.

Back in my hut, I laid down on my mat and forced my mind to
think clearly. Out where the wind lay in ambush in the hills, near
the steep lands of Mahi country, lived my people. Men and women
with little, but who were stout of heart, who at that hour penned
up their animals at thousands of bamboo perches in the back of
the world, far from Yovo. Been years since I'd seen them, kissed
my mother's cheeks, held my grandmother, my old woman, eyes
dimmed, in my arms. At nightfall, I hurried to gather my weapons
and amulets, then downed a few swigs of a potion brewed from

plants and palm oil to make us invincible. Ready at last, I slipped out of the palace and plunged into the dark night.

I hadn't gone five leagues when I felt the earth tremble under my feet. Split open like a belly and spit out the leopard. It was she, yes, the panther that I rode all night until Lissa awoke, and my little village without faith, law, or king appeared before me. As in the past, the old woman was watching over our courtyard, chewing a cola nut solemnly, indifferent to the men whose woman she had been. She seemed not at all surprised to see me, acted without delay when I implored her to assemble the villagers to warn of imminent danger.

When all had been said, considered, decided, the villagers gathered provisions and livestock, burned down their huts, then withdrew to the mountain hollows where no one would come to turn them out. Once, already, my people had known exile, knew which path to take to evade the enemy.

I HEARD later that the amazons had spent days searching for them, interrogating the earth and studying the horizon. Finally, they left empty-handed, swords lowered, without a song. Dada showed them no mercy. It is said that he sliced off their heads. Displayed their bodies on the grand plaza, letting the poor and the vultures take care of them.

I never went back to Abomey. Followed my path, like a man.

Left to myself, I learned the infinite value of freedom.

Never again would I bend my knee to a prince. Never again would I wash his feet, gut his fish, scrub his spittoon, stand guard like a dog while he slept!

Times had changed. No king on earth would be allowed to misuse me.

A year passed, I lived in the bush.

*

Every man has his day. Every day comes in its time.

I had just caught a hare when, attracted by the sea's laugh, I released my prey and followed the path to the coast. Soon, I found myself at the end, on the beach where, a few years before, my mother had gone into the water and seen Yovo. There they were,

armed, just as they had been in the past. Flanked by a herd of Ne-
groes who were neither walking, nor moving forward, but under the
lash of the whip, were dragging themselves on the ground, crawling
along without shame or soul, robbed of the very breath of life.

What kind of people were these Blacks to accept such treat-
ment? Had they lost all pride, giving abject obedience to creatures
whom the gods hadn't even bothered to color?

"Wake up!" I bellowed to the captives, as I charged the enemy.
Imitating the wind, rain, lightning, landing blows by the hundreds.
"Wake up!" I roared.

Let our valor form a wall against their rifles. Let us strike together,
yes, yes, yes, let us spill blood! Yovo is weak and we are stronger
than buffaloes!

But there was no time. From ten, the Whites grew to twenty, more
and more came running, until their numbers gave them the advan-
tage. I was overpowered and knocked unconscious.

When I came to, I realized I was naked. Yovo had taken every-
thing from me. Nothing left but the mark on my arm, a reminder
of the night I'd sworn allegiance to Dada, to defend his kingdom
to the death.

Down under the sand, in the hole where they penned up rebels,
I also remember the blood in my belly.

"We are men, we are men!" I yelled desperately until Yovo raised
the trap door and rained down blows.

Once again, shame, I'm ashamed. Am the one who has brought
dishonor. Just put an end to this! I'd rather they finish me off, rip
off my head and my sex, and use them as trophies.

What worth has this war where the vanquished is condemned
to live on? Where the victor neither sings nor dances his triumph?

In the silence of the earth, I called on the god of the hunters.
"Light my path, oh Gow, you who inspired Naga!"

I WENT out of the hole this morning. Judged apt for work, but first
taken to the baths. I smelled strong, the blood had dried. After
feeding me a little broth, they put me to work. Then came night.
A door opened, and I laid down among women I'd never seen
before. Baule, Yoruba, Ibo, Ashanti, as if all of Africa had gath-

ered in this jail, organized into nations, sharing a single, common suffering that I tried to trick by telling stories. When I felt hearts beating again, I decided to speak straight. I had a plan, it was clear, so I got to my feet to explain it.

"By Naga, mother of my mother, queen of the amazons, and by Sosu, betrothed to the panther, I urge you all to hear me out. Yovo has defeated us but we have not been defeated. We will rise once again if we are men. Will soon burst these irons that assault our dignity. Give no credence to those who tell you that this is not the time to fight. The hour has come, our hour has rung. In just a few days, Yovo's ship will take to the sea and we will use that moment to jump.

"I see some of you trembling, dreading the great water and its mysteries. But let me tell you loud and strong, it is better to flee than to submit. Death before slavery!"

They hear me out, some even nod their heads, are tempted to speak but hold back, timid or still skeptical. One of them, however, gets to her feet and comes into the circle.

"Ask me not where I'm from or who I am. Ask nothing but let me tell you: I am the one who comes and goes. I know this one's heart, he has not lied to you, the great waters will open wide. I have seen this before. In my dream, there were also women who tried to find their way back to the shores. Then my eyes closed and I awoke."

The one who comes and goes sits down again, her lips reciting prayers to one of her divinities. There are so many gods in our lands! The moment she sits down, we see her fly away through the roof and across the lagoons.

Up all night, sleep does not come. No one expects it to. Count the days until the great departure. Now we are there, rounded up on the beach, eyes locked on the sea whose swells inspire no confidence. Here we are again. On the ocean already, watching the coast recede and the country die. As the last palm tree fades, the vessel's jaw yawns wide and devours us.

Black. Like the calm before a storm. Like the time I fell into a trap, a ditch several feet deep. Four moons I passed underground with nothing but worms for company. I was five years old. The age when we churn out stories. I remember telling myself that I was

dead. Really dead, but not for long. I would be reborn, for sure. Somewhere near the village, so that my mother, upon seeing me, would pick me up and slip me back inside her. At the time, I was scared to grow up, thinking that once grown, then old, then dead, I would no longer have the space to go back and live in my mother's belly.

I OPEN my eyes; a familiar odor just came into my mouth. Of blood that I taste and which speaks. That one over there is not yet twenty years old, swift as a torrent, sweet. Like life, the song will someday say. This one over here stinks. Is sticky. An old woman with shriveled breasts, who will probably not see the other side of the sea. That other one is crying, dreaming of those men my belly has never known.

Tomorrow, when the bells clang, when Yovo serves us our gruel, I will leave. I have decided. Time, distance, I have calculated every angle.

Let them chase me, unleash their men, pop their old guns, I will already be far away. Somewhere deep in the jungle where the hearts of White men rot like mangoes.

Tomorrow, at the appointed time, I will make off.

THE DAY is cut in two. It is noon. Past noon, when we all climb up to the deck together. We leap.

"Let's walk on water!" I have time to shout, pointing toward the nearby coast. Today is a day without victory, but we will return to avenge ourselves.

We women will return, hunters, reapers, archers. Holding our rifles high, we will kill them all. We will kill them.

Armed with a big-big razor, I slash their sails, slice their skins.

We women gunners, bayonet carriers, with our hoes and our sabers we will turn over their entrails. Yes, yes, we will defeat them and flood their veins with the deadly poison of our vengeful arrows!

A shout. I turn to look: three of my women have been taken. Two others are wounded.

An amazon does not abandon her peers! I reverse course and

swim back toward the ship. Aroused by all this red, the wild beasts of the sea circle, snapping ever deeper into the flesh of the bodies. Just let them try to touch me, I will smash their faces! The tiger cannot hurt the leopard. The Yovos are now five. Aim their weapon at me.

The young child is crying, everyone hears her bawl. They shoot.

THEY LET me live. Down below, here. Here, where eyes lose their sight. Don't know if dusk or night or when. My plan has failed but I will begin again. I will escape. I have my whole life for that. Body in irons (they've put me back in chains), I do not sleep. Don't want to. Like a warrior, I flex my muscles, dream of bloody battles and victory.

For long days, the ship marches onward, at one point, almost founders. Then the raucous sea suddenly goes calm, and one day, we arrive.

*

Yovo's island was not white. A deep green land, which we first glimpsed from the deck where we'd been herded to be sold. As soon as I hit land, I escaped into the bush, took the path to the mountain, beyond death's reach.

They tried hard to capture me but Yovo cannot match the antelope.

In the highlands reigned a silence broken only by the wind trumpeting among the rocks. A thick mist suspended from the lip of the clouds spread its shadow. The rains would come soon.

I was alone for some time, until the day I encountered a stranger. Called Makdal, he had been born down below. Knew the island by heart, could have roamed it with eyes closed. Like Sosu, my mother, and because I didn't understand his language, he made his hands talk, told me how, unknown to his masters, he abandoned his hut every night to climb up to the heights and build his kingdom here. "We will kill them all," he said simmering, and imitating the dagger, the whip, the rifle. Pinching the rim of his ear to mean Yovo. How did he come to know all this?

For long hours, we walked, as this man told me about his island. Teaching me each tree, stream, flower, surprised by my strength.

Only later would I tell him who I was. I learned much from him. Made myself tiny in his arms. It was the first time I'd seen a naked man.

As a cotton thread grows to a loincloth, Lissa chased Mahou, Mahou ate Lissa, and time passed, yes, until the morning when, bathing my twins, I thought of the village on the other side of the waters. It was straight across, I was sure of it. I needed only to take to the sea and let the currents carry me.

That very day, I gathered wood, palms, vines, and cloth, and built a boat just large enough to hold four. But my man wouldn't hear of it. Here is where he needed to do. A few weeks later, I left the shore behind. A cow, two women and one of my sons came along.

In the first days, we traveled without incident. The sea was the road and we walked upon it. Silently, we glided toward the countries whose secret only I held. Sustaining ourselves on fresh milk and fresh fish, we suffered no hunger. The child slept, the memory of his father fading. Had he just been a dream?

Then fortunes turned. The sea took us for traitors. Glacial winds, storms, sharks, we had to face many trials. Pirates too, people with no conscience, who came from the ends of the seas to attack anywhere at any time. One of the women died. We couldn't bring ourselves to push her body into the sea. Who knows where souls go in there?

Exhausted, wrung dry of hope, I saw my death hovering. I saw it, I, the warrior, who like Dada, had believed I was beyond death's grip.

WHEN I no longer am, I want my soul to return. May it be taken far away from here to a place where death never ventures. Where beings, made naked, rise into the sky, form clouds that will one day be split open by a storm because the time will have come to resuscitate them. Gently. May this be accomplished with care. The soul is fragile, cannot withstand missteps. When my soul has dried out, I want someone to find my mother, tell her the good news. "Your daughter has come back!"

Her daughter has come home, has been through slavery, this

strange war in which your body is not yours for fighting, your feet
for running, your eyes for scanning the horizon.

*

The boat has crossed the reef and scrapes bottom on the beach.
From here where I sit, I can see everything. Coasts, lagoons, bush,
mountains, the whole country lit by a dwarfed red sun. In this land
where all know one another, only old people remain, lips pinched,
gazes fixed on the blue and white line in the distance. Unfazed by
my presence (they have seen so many ghosts), they wave their hand
only to scatter the flies that wobble about as if drunk on the odor
of blood and shit dumped by the sea onto the sands, from time to
time.

The sun is at its peak when I enter the courtyard and make my
way to the hut. The old woman is dozing by the door. Only her
rusty mouth, reddened by the nuts, moves. Poverty has taken root
in the courtyard where a feeble flame sputters. The roof has lost its
skin, the straw is limp. A calabash gourd splits as if to announce
the end of the world.

The sun retreats a little farther.

The old woman yawns and three times lifts her head. Like an
old animal, has picked up my scent. Light returns to her eyes that
open to cry. "You're really here!" they repeat with difficulty, before
they're snuffed out. That night, when the great sea laughter rises
like a requiem, I enter the hut, my eyes searching for the chest. Just
as in the past, her loincloth lies within, the color of wind, newly
beaten clean, infused with Sosu's scents. Finely adorned, I braid
my hair into a crown and go out into the dark night.

I've pushed my way through, and the crazed branches of the
trees have forced me into a crouch. On all fours now, I race along,
leaping, sliding, and climbing, intoxicated by the nocturnal ser-
enades, unconcerned about being heard. At the foot of a sturdy
coralwood tree, I catch a glimpse my mother, or think I do. Imme-
diately, I lose her, then see her again, naked, at one with the river.
She's dancing, then nothing, her shadow fades. I wait, in vain. I'm
alone. No trace.

Just before dawn, the path to be taken appears before me, leads

me to this yellow clearing, bright as the eye of a flame. The earth gives off a strong scent. Heavy, ripe fruit, sticky milk underneath the bark.

I listen to the silence, just as I used to do at the peak of the island. It's the calm before the chaos on the day when, aroused from her sleep, nature will start to hiccup.

Then. Then the sky will explode into flames. The waters will steam, flick their tongues, spit their lava until the earth coughs and suffocates.

No more Yovo, or Blacks, or rifles, or chains, the world will return to dust.

THE LEOPARD recognizes me. Nuzzles my body, licks me clean of all men's sins. Joy! It is I, his daughter. I have returned home.

His lips draw back. The old man is proud of me, on his back carries me up the mountain, where the clouds die. Thin, round, low, heavy, each one different. Mine is black, shaped like a sword, its blade raised as though going into battle.

Rain falls. The water of life is entering me. So tender that it tears a little shout of pleasure from me. Through the fringe of my eyelashes, I gaze at the horizon. The earth, the other. Dark. Dying, almost.

A man who's never seen the bed of the sea
Has never gazed into the depths of Hell
He who's never gone past the end of the Loire
Has never crossed paths with the Devil himself

Haul up some more lime! More vinegar! Quick!
The shit storm on board could sink this old tub
Keep watch o'er your peepers, see you keep them tight shut
So you'll not see the sights that would lodge in your head

Raise your glass high, Lads, we'll drink to the Pope
Down the hatch 'til you're drunk and you belch loud and fart
Hoist the main jib, ho! Hoist high, and heave ho!
Keep your head down, work hard, earn your pay.

la blanche

La Blanche. That's what they call me. What they say when they think I can't hear them. La Blanche and a lot of other names, too. Words that soil, ruin my name, give them high airs when they have become nothing.

In the end, I couldn't care less what they think. For me, I believe there are days when you just don't have the choice. When a man who is living is a man who takes risks. And I, La Blanche, have decided not to die. That would be silly. Unfair. I'm not made for that. Never really suffered. Always took the best. They call that luck.

In the beginning, when I started hanging out with the sailor, I was afraid to touch. Afraid of being hurt. In my head, this White man was like a beast, a body without a body with something monstrous between his thighs. We don't choose a man for his beauty. That's what my mother had time to teach me, she who said nothing, did nothing when the eldest of her sons sold me.

She had no choice, either. You can't feed children on nothing but roots. The other night, while dreaming of her, I vomited. There was an old woman sitting next to me, do you think she helped me? Huh. She pretended not to see a thing. I could have died; no one would have lifted a finger. No one wants anything to do with me.

That's how it's been since the very first day. All because one of the White men, looking me over, murmured something that made them all laugh. And I, instead of screwing up my face, I smiled at the man, seeming to agree, to say I had the same thought as he did. Other words were said, then the guy pulled me to him and asked me my name. Because I kept smiling, he said he would call me Felicity.

We say White men, White men, but man is man. A woman is all he needs to soften his heart. I knew that. Every evening, I went to offer him my joy.

The first night was well before the ship set sail. I think it was sprinkling outside. It was still raining on the coast. Seemed to be doing it on purpose. Soaked to the bones, I ran to the White quarters. It's clean where they sleep, roomy, well-lit. Has to do with the flames they light and cover with glass hoods. I knock. Their hut is always closed up. "Jan?" I call. In the doorway, a Negro woman with a fat ass looks me up and down, and asks, "What ship? Bo-at?" repeating impatiently, imitating the water's dance. Just as she's shutting the door, a man's voice sounds from inside. I'm his Felicity, he says, so let her in. Each night. Every night until early morning. Until the day of the big departure.

"You don't need anything?" the fat woman's voice trails off as she disappears behind a curtain.

"You're not afraid, are you?" The colorless man eyes me from the other end of the hallway, observing me. I smile. Walk toward him and follow him into a dark, empty room. I don't know what to say, where to go or how to begin, I let him take the lead, my belly opens like a flower when it touches his fiery body. His thing burns inside me. I cry out. His thing burns me. Goes in and out down there. Fills me with dirty water. It hurts and then it's over. I may even learn to love.

Later, the man gets up, spits smoke. And words, a lot of them. I'm no longer used to hearing so many.

Now, there's sadness in his gaze. His eyes fill with water. My body closes up again, his own turns away. It's time for me to go back.

Night has almost ended when I slip into back into the hut. I say "house" but that's not the right word. The place where we are is unlike any I've ever seen. Nothing you can imagine. It's damp. It's dark. And I forgot: the mosquitoes! Vicious. Everywhere, all the time. Make sleep impossible. Seems they're attracted to water, all these lagoons that surround us, the last hurdle between us and the sea. Some here fear the ocean. Think the Devil created it. For me, it's just like land. I'm beginning to get used to it. It's been like that, only that, since I left the village. Tomorrow will mark three months.

Now that I've thought about it, maybe I always wanted to leave. As a child, I dreamed of it already. Take to the sea of sand. Live

without hut or door. Do like the Arabs, live the world. Everything
is so small where I come from. Scarcely room to grow dreams. And
people talk too much. Who's doing what, going where, all day
long. Sticking their nose in things that don't concern them. My
mother claims it's because they depend on one another. Whatever
the reason, they're not going to change.

In truth, I'm not unhappy to be here. For the first time in my
life, I feel light. A feather in the wind. Back home, it's different.
A woman stays on the ground, only a man flies when he dies. What
sense does that make?

As for the spirits and all that, I confess I've never really believed.
Always just pretended, including that day in Ouidah, when we had
to walk circles around the fetish tree.

They claimed it would make us lose our memory. So that when
we died, our soul wouldn't come back to the country to seek re-
venge. Right after being sold, we had to walk circles around it.
Walk around it for good, until we were dizzy. Walk around it for
fun: why would I want to return to the village?

After my mother was gone, something broke inside me. I had
grown up brutally, and in pushing, shattered the last links that con-
nected me to the country.

Must have showed on my face. It's probably why the White man
smiled.

Did that thing to me, then fed me in his room that same evening.
It was good, almost too much, but I still wanted more. Feel my
belly full until morning, never feel hunger again. By eating, I wiped
away my defilement. I was La Blanche. Not like the others. Half-
captive.

Back in the warehouse, I tried to avoid the bodies. Dropped my
eyes for fear of meeting a derisive grin. In the morning, I was the
one who had betrayed. Until the end, they said that of me.

*

She arrived the next day, while I was fighting over a lemon with two
girls who swore up and down they'd seen me steal it, *as if you're
not given enough to eat there!* I could have just let it go, but when
they started off, claiming a young woman like me had to learn to
keep her eyes down, I lost my temper. It all came out at once. I let

loose all the insults my mouth could spit. Band of bitches, it was not their affair! They'd do the same, if they weren't so ugly! Didn't come to blows, I had no time for that. Afterward, I just felt exhausted. It was foolish to lose my head over that.

The little one and I quickly became friends. Which was perfectly normal, after all, I didn't hold grudges. Ask the folks back home, they'll tell you.

I've never liked scenes, but they shouldn't have picked a fight with me. A real fury! Like my mother, every time some useless person came after her.

Our mother. What is she doing at this time of day? Is she already at the market or on her way to some other place, some corner to park her body, build a hut with all that cheap merchandise brought back from the slave market by her son?

How the old woman had laughed to see those pebbles. Beads from Venice! Oh là là! Wouldn't she be pretty! So chic, an Afro-European! Before you knew it, she'd be marrying an important man. Would have enough assets to get hitched.

Hair always grows back when it's cut.

Surely, with time, the mother would remember her daughter, think with shame of the one she had betrayed.

"What else could I have done?" she'd say, eyes red from sleepless nights wallowing in remorse. It was entirely possible that she'd end up forgetting the child. The day she'd come out, her smile, her name. Not remember. It's possible . . .

That morning, on the path leading to the great water, I thought I saw her. I turned toward her, full of anger and hate. Begged her to keep me. "Take me back, buy me back. Don't let them take me away!"

My cord is broken now. How will I knot it once more? Here is the broken cord of my life, the cord I used to draw water from the well is broken, how will I knot it once more? I can put tears into it, but tears are not enough. I can put money into it, nothing will work. My cord is broken now, how will I knot it once more?

She was about to open her mouth when, suddenly, her body was seized with trembling. My mother was laughing. I swear, I saw her laugh.

*

The little one has closed her eyes. Probably thinks that there will be nothing after. That all she left behind will come back one day. The little one still believes in miracles. I try to draw her a sun in the sand. A circle, with rays as long as locks of hair, a mouth saying hello, wide-open eyes, dimples in its cheeks. There, she's taking a look at the picture. She finds the strength to lift her head and look at me. She has lucky teeth, I tell her. Teeth that will attract love and good fortune. She says those are just stories told to reassure, children don't believe such things. Later, I make up an orange. Watch her trembling hands delicately peel the fruit. Her own. So real that she's amazed, presses it to her chest like a baby. Eat, I tell her. You have to eat. Live in the present, tomorrow is another day. Her eyes thank. For the orange and for the stories.

"They're not stories. That's what people think."

"Do grown-ups always think the wrong way?"

"It happens and sometimes it never happens."

"Why did it happen?"

Near the tubs where we're bathing, the little one, naked, hesitates. The buds of her breasts are hard. Her fingers knead the body of an imaginary doll. Behind her, a man eyes her. Thinks she won't protest if he does it. Too little.

In a flash, I'm there to challenge him. Let him approach if he dare. Just let him try to touch her!

"What did he want?" She's taken refuge in my arms, watches him walk away.

"What do you mean, what did he want?"

Is she feigning innocence, or does she really know nothing of men?

Suddenly, I want to be spiteful, stick my finger up into her belly and say, that's what he wanted! Yes, this is exactly what he wanted!

Terror in the little one's eyes. My own shame. I stink. The dirty water, the bitch, the woman. It's because of them, their thing that I'm unhinged. A woman is not born, she becomes, through contact with them. The way they look at us, touch us, fill us. So much the better if she knows nothing yet. She's right. We must never feel the way they want.

THE LITTLE one is sleeping, and the image of my own body comes back to me. At the age of ten, maybe twelve, when the juice of the belly was pure.

When I bled the first time, my mother started staring at me with suspicion. She was afraid, something to do with the old story I'd heard a hundred times.

In our family, one in four bellies is spoiled. That's what everyone has always said. That's how it's been for a long time, ever since the day some woman did something bad. I'm not exactly sure what the sin was. My mother refuses tell me. Says I don't need to know. It wouldn't change anything, the evil is already within me. It's she who confirms it: never will I give life.

When the blood came, at first I thought she had told a lie. There was so much of it in my belly that I thought sure something would end up growing in there. I hurt but at the same time was happy. I wanted to dance naked. Run from one hut to the next, announcing the good news to all. I had run out to the middle of the courtyard, was ready to open my mouth, when I heard someone scream my name. My mother. Behind. Stock still. Her hand gripping the ox nerve. No time to bolt, she was already upon me. Snap, she struck. Snap. All night it went on. Even though I was little, I shed no tears. I was hardheaded. Just like Obagadjou, they say. He's my father. Was.

I HAVE only a fleeting memory of him. His broad, square footprints and his laughter. A funny laugh. That rose into the sky until the clouds cried. Watch for the rain, warned my mother each time he laughed. A great dry spell is coming, she sometimes said, when, wrapped in deep silence, my father refused to leave his hut, stayed busy with his night betrothed, as he called her. For a long time, I thought he meant a woman. A real woman of breathless beauty. How I longed to catch sight of her, hear her scratching at the door, telling him that, like love, she was only passing. I found out she was just wind one night, when crouched down behind the hut, I spied on my father. Lying naked on his mat, he seemed to be wanting her. The hard belly murmured her name. Called to her. In the morning, there was still nothing. Alone, Oba slept, embracing the emptiness. Chained to the spirit.

I was six years old when I learned that a man could be weak. With my father dead, our hut started to smell like men. They were everywhere. All kinds. Old ones, widowers, crazy ones, sick ones. The head of the household ordered my mother to make up her mind, and a month later, he moved into the house.

Right away I hated him, him and his way of running his eyes over my body. Of burning my belly with his voice. Who did it, him or me? I don't remember for sure. It was dark. Humid. Rain had been falling for weeks. I was out gathering wood, when we crossed paths one evening. He blocked my path. He was laughing, it was like a game, and I acted like I was trying to escape. When his hand reached out and grabbed my loincloth, I knew this was for real. There would be tears, when he planted his body in mine, did what he did with my mother each night, while Oba's sex rotted away underground. I thought it would be good for my belly. I let him do it.

When I realized it was over, I felt water gliding down the length of my thighs. His juice. He had given me nothing.

The second time. We're lying on the sand. I'm naked. He's wearing a cloth around his waist. I don't know what he's got in mind. This time it's different. I scream, I hate this way. Cry afterward and run to hide in my hut.

She knows as soon as she sees me coming across the courtyard. She says nothing, but that evening, shuts the door, barricades it with heavy wooden planks. The little ones cry, afraid that the spirits from the depths, the ones caught in earthenware jars before plunging them into the water, are going to come and devour us all. The bastard scratches at the door. The tension mounts. This goes on for four full days.

My mother no longer goes with the men. She has grown old. I'm sure she resents me for extinguishing her last hope. Her smile returns the day she hears cannons, the ones announcing the start of the sale. This day is a lucky day, she thinks. I'm selling my daughter to the White men. She will probably be of more use to them. A woman with no belly is worth nothing to us.

THE TRUTH IS, we knew little about the White men in our village. Still, that didn't stop mouths from talking. Telling anyone who would listen a thousand and one versions of a story that amounted

to little more than a handful of threads to hold it together. One day, fiery men had come up the riverbank. Two crab fishermen had welcomed them and taken them into the court of the chief of the land. Soon after, our kingdom lost its name. From then on, it was called Porto-Novo.

Our people have not always been so few. In the olden days, we brought together a whole variety of people. All lived together peacefully on the banks of the Mono River. I've never seen this river, they say it's one of the longest in the world, and following it upstream will take you all the way to Arabia.

THERE WAS a celebration in the community the evening before I was sold. The rain had cleared out, smiles were back in place. Sitting around the fire, listened to the legend of the old Awanwa, the chief who had ended badly, who at death had turned into a pond.

The bastard was also there. His eyes glued to my mother's broken-down body. He would never be over her, as long as he had that thing between his thighs. As I've already said, man is man, all it takes is a woman to . . .

To distract his attentions, I played the idiot. Pretended to be afraid of the wicked old wolf. Just a little, not enough to refuse to follow him behind the big mango tree at the end of our concession. Mosquitoes were out that day. Stung and circled and made my head buzz. A commotion that wouldn't stop until dawn.

But we weren't there yet. Still in the dark of night. Couldn't see a thing, there was just enough light to do the thing. Atop the man, I couldn't stop staring at his mouth. The pleasure flowed from there. The spasm that marked the truce, the end of his embrace. As I rode him, a parade of images. My mother's large breasts. The blood in the earthenware jars. The room of the dead where my father lay in his stench.

Never has my heart pounded so. Not even on the day when we all jumped together, in one movement.

I waited for his mouth to open before cutting. The man groaned. My mother could sleep in peace.

Sometimes I think of him when I am with the White man. It's so powerful that it almost seems real. The sailor also has his fantasies. A woman whose picture he stole, and sometimes talks to

her in his sleep. The sailor dreams out loud. If I understood his tongue, I would know he was asking forgiveness. Pardon-me-Marie-I-love-you-more-than-the-sun. To calm his remorse, wipe away the wrong, he then tells her about little things. His mornings, his meals, the waiting. Thirty-three days more until we leave land behind and set sail for the colonies. Will he ever confess the inadmissible? His Negro woman is with child.

I have someone inside.

*

"How could you do that! The child of a White man is like a chain." Sosi stares at me hard. Almost slaps me, but controls herself. She won't hurt me, but it's important that I think. Having a baby here means feeding slavery. Sosi is a warrior. No fear, no hunger, no pain. That's why I'm telling her.

After making her swear to keep the secret, I looked out at the sea. What if I tried to escape? True, I would be unable to swim right, disappear like the sun behind the line. The child of shame in my belly.

Unless I can return to the village, to the old woman, the one who unstitches what the gods have sewn. The child of shame will escape with the blood. My dead belly will once again be flat. Like the beach that stretches out before our eyes.

Suddenly, something moves inside. A faint blow of a fist, a hand searching for mine. The child of shame does not want to die. Now that he's there, I'm the one who no longer is. A stranger to myself, standing at the door of my own body. I grow tired quickly, vomit often, cry every time the sailor falls asleep and leaves me alone with his fantasies.

On this night, the woman in Nantes will not leave us in peace. Haunts him until he shouts her name. Late in the night, the man screams, "Woman overboard, woman overboard!"

NOT LONG after, Sosi tells me her plan for escape. To hear her tell it, it's simple: jump, whatever it takes, as soon as the boat leaves the shores. Jump then make it back to shore, dead or alive. Free.

"How?" I find the courage to ask, her idea seems so mad. She cuts herself off, the door has just opened.

THE WARRIOR has not kept her word. The very next morning, she calls me over, claiming she can help me. She is not alone. Another woman is with her. "The one who knows the leaf," she whispers before slipping away. Without a word, the healer lays her hands on my belly. From a sack, pulls out barks and plants that she slowly washes in rainwater. That is why she has come. To rid my body of the child of shame. Make it so that the tenth crescent moon will not appear in the firmament. When she's preparing to recite her prayers, I run away from her. Would rather die.

"Be reasonable," insists Sosi. "He has no chance. Don't you see that the path out is arid? A child would never survive. And even if the two of you did manage to reach shore, who among ours will look at you? The child of a White man, do you have any idea what that means?"

Don't care what they say or think. A stone in the water fears not the cold. It is man who is afraid. He alone spoils luck.

THE SAILOR no longer has dreams. I spend my nights in his arms, listening to his stories. Today, for the first time, he speaks of the island that lies beyond the line. It's one of the most beautiful places on earth, he says—that's what any sailor will tell you—a tiny slice of earth where everything grows, and no one goes idle. There is plenty of labor there. Men, beasts toiling in the fields, born for that purpose. In the way-over-there-country stand splendid buildings. Large-size huts with all you can imagine in them, made-up women, well-lit salons with parquet floors, balls all year long. They give at least one a day. Lively brooks and streams gallop through the island, overflowing with joy. People bathe there, in the way of the country, naked, like in heaven. When I ask him where heaven is located, he lifts his eyes to the sky, then replies that I'll soon understand, a man of the Church will undertake to instruct us.

The next morning, I confide all that to the little one. The water, the flowers, the light, the balls, and also the finery. "If you saw that, you'd think you were in paradise!"

"Where is this country hidden?" asks the little one.

"Far away."

*

Things started to sour in my mind on the day of the fire.

One evening, a night thick enough to stupefy any beast. Sleepless night, when you search for sleep. I had just about found it when I heard voices. Women's voices coming from outside, from that hole, behind the storehouse, where they pen up the new ones before bringing them in here.

Then came a noise—hands digging, bodies crawling—and I knew they were coming closer. They were right underneath me, so close I could hear their voices. "Escape," they repeated, "We must flee far from this quicksand where we will all disappear, swallowed up."

I was tempted to follow. Was just about to, when the child who did not want to die moved inside me. Faced with the life that would soon come, I closed my eyes, deafened myself to the echo of the earth.

The odor of smoke awakened me. It was everywhere. We could see nothing until the door opened and they pushed us out. I didn't need to walk around the storehouse to figure it out. They had burned, been devoured by fire.

No one says a word this evening. In silence, the mind rehashes. Those dead are not dead, they haunt us. Sometimes I even see them at night. Then I sob a long time without knowing why. I feel guilty. Even tell the little one that it is I who should have died that night.

But the child is here.

If it's a boy, I will call him Oba. Like my father. Oba.

Like my dead, he will be proud and strong. Will know all that a man must not forget. The laughter of birds, the yellow of wheat, the dust of the earth after the war.

The child is here, and I need to see his father.

<center>*</center>

As usual, she was standing in the doorway. Her big ass, by some miracle, connected to the rest of the body. She was a force of nature, a woman-beast, was surprising that she understood, even spoke. I had no idea where she was from, she who made the White man's cabin her fiefdom, a place where she exercised her tyranny with impunity.

When I said the sailor's name, she burst into a kind of laughter I'd never heard. "He don' want you no more," she brayed, slam-

ming the door. I didn't expect to feel hurt. I knew men, had long known what to expect. I had loved no man but my father, but I'm his daughter and some things should just not be done. "He don' want you no more," as if I were rotten fruit, meat that stinks. He'd better not try to put his thing inside me, eat my mouth, ever again.

Back at the cells where they held the captives, I lay down and wanted to die. All around me, the women were laughing. They were jeering at me, La Blanche, alone and now ugly, pitiful. But Sosi shut them up. There is not one among them who doesn't respect her. She held me close in her arms as if to contain my pain.

"It's time. It's time to choose," she murmured. "My women and I are ready. All together we will jump. All of us. Know that and be ready."

"But my child might . . ."

"You can't think with your belly. Stand up for yourself, better to give death than to guard life jealously."

I HAD to think. I needed a night, just one, to be sure the fat woman had spoken the truth. I had to see him. The eyes don't lie. I had to. Touch him. All men like that. I'd find the courage to tell him and he'd smile, like before. Like he did when he left his juice inside me. Then maybe he'd take me far from here, to that country where men go naked with clear eyes, removed from sin.

The fat woman was supping, nose in her dish, backside flat on the bench. Silently, I crept up the staircase and found him stretched out. He looked surprised to see me, confused when I came toward him, daring to touch my thing. He stammered, and we took each other like animals.

When it was over, I guided his mouth to my belly. Whispered that from now on, we'd have to go gently. I wasn't alone anymore, there was someone inside.

The sailor rose from the bed. His lips were trembling. He rushed from the room.

"Jan, *Jan!*" I shouted as he ran out the door. He did not look back. Spit. Did he feel dirty?

Then the fat woman came in, yelling every insult she knew, and threw me out like a dirty rag.

In the morning, I was empty. Tears, juice, had drained away. That was the day I said yes to Sosi.

*

After we jump, the bell starts clanging, as we're all looking for the coast.
The sea takes on life. What a racket! Sulking. Shows its fangs and comes after us. First, comes after the little one who valiantly abandons herself to death, almost serving as an example. In the chaos, I can just make them out, daughters of suffering and courageous mother. Bodies skinned. Shredded but free. Sublime, they laugh. Swelling the ocean with their own fresh water.
But now a sailor hauls me out, plants his mouth on mine and resuscitates me.
In the distance, blood. The sea has eaten. I count. Seven of us lying here.
After that, I went mad.

*

That fly again!
I knew it would come back for my too-sweet blood. They like blood, flies do, but also filth, pus, excrement. I don't care if it comes back, it'll get what it deserves. I'll tear off its wings, stick them on my ears and fly away. Up there, I'll have peace for sure. Won't hear the sea whipping the hold, the whip whipping our asses. And so on.
Last night, I dreamed that I was traveling around the world. All was good until thunder started to rumble inside me. A hurricane in my head, snapping a forest in my stomach. It was so strong I had to get up to vomit. What a night. The next day, the sky was red. As if thousands of flies had killed themselves.
By the time I was grown, I had big breasts. One day, they almost smothered me. Between the thighs, I also remember that . . . There's nothing left between my thighs, and it's much better that way. Only I am allowed to enter there. Sometimes it seems like it's talking inside. The voice is faint, but closing my eyes helps to hear it. The last time, I could even make out words. I hid them, fast; people are so jealous.
All this water surrounding us! We have to do something with it.

Drink it or burn it, like the women devoured by flames the other
day. Horrible. Nothing was left of them after that. I wonder where
their souls have gone, the sea is so vast.

What if I just folded it up, *chiche?* Into little pieces? Then we
could tuck it into an earthenware jar, put the jar down a well, the
well in the courtyard, and we'd be done with it!

But that would require strong arms, and men lack courage.

By the way, I forgot to tell my mother where the blood was com-
ing from. The blood in the sky. If she asks, tell her. She likes to
make a fuss.

Every day I think of her because of the whip, as talkative as her
cane. Wounds and tears open scars. See these two scars under my
right breast? Yes, there! She's the one who made them. Claimed
I'd shown her disrespect. I, her own daughter.

Who's going to tell me that I really came out of her belly?

My real mother died the same day as my father. I remember
the loincloth, the fire, the prayers. That's how those who love each
other part. Together.

What's wrong with the sun, all of a sudden? It's going in circles,
doesn't know what to do. Because rain has started to fall. Already
one million, four hundred thousand drops have fallen. I counted.
Enough to drown the ocean.

We've been stepping over it for a long time. Two centuries al-
ready and always the same old story. The Negroes below, the sky
above, sails everywhere, they look like skirts worn by the pretty
ladies. I wonder how in the world they walk in them.

Sometimes, the whole boat celebrates. I like that. Dance bour-
rées, branles, the chaconne. The deck shakes, I love it. Alcohol
flows. In my head, I sing, chew the refrains to the very end, then
spit them overboard into the sea.

The sea is rising. Swollen with the saliva of Negroes.

THE EARTH has come back to us this morning. So vague, so thin,
I hardly recognize it. Doesn't matter, we have to disembark, pass
through the gauntlet of whips, settle ourselves as we can. Observ-
ing the bodies, I realize how much the sea changes a person. Like a
wall under the noontime sun, the sublime reflects and celebrates its

shadow. In the bright daylight, I can barely identify faces. Who's who? Now that the heroes are gone, only men under the uniforms. Back to normal life, away from the fury of the sea, they lower their guard, doze, look like little puppets. For us, too, flesh has replaced shadows. Outside the hold, we recover our sight, the spoken word.

"Yes, yes, yes, we carry our rifles high! We are men, more cunning than hares, strong as buffalo." Where have I heard that voice before?

Is it my mother, the one over there with big breasts who said nothing, did nothing when . . . When my traitor of a brother dragged me from my sleep? She was laughing. Noise everywhere. And beads.

Let them hang her, if it is my mother, let them deliver her corpse to the night. The bird of magic spells will take care of her. I lost my water. *My heartstring is broken.*

My mother who is not comes closer. Why is she staring at me? Has she seen a ghost? La Blanche, she calls me. La Blanche? But . . . How does she know who I was?

"Only six of us remain, the others didn't survive."

"It's because of the rats," I whisper, "They're everywhere. Krikrikrikrikrikrikrik, can you hear them?"

"I, amazon, daughter and granddaughter of . . . , I speak the truth, Yovo has seen nothing yet. We will fight to the end to take back our freedom. We, sword-women, cannon-arrow-razor-women, we will massacre them!"

I put my hand on her thing.

"We are men!" *Repeat. Repeat. Repeat.*

I touch. It's hard between her thighs. Could she be speaking the truth?

SINCE WE landed, there's meat in our dishes. No more fat. No more flavor. Don't care, I'd rather eat lighter. Better for the heart and the eyes. I can't stand fat bellies. I used to have one. Made me sick. Up all night, constant vomiting, swollen breasts. Lasted a while, then the illness left, I was lucky.

Chicken broth at noon. No, thank you. I might suffocate on the

feathers. Before leaving the little island, I pick a flower with white skin. Call it Felicity. I like this name.

<div style="text-align:center">*</div>

Up on the deck, it's cool. I feel beautiful, with a smile on my face, a real black sun.

Today, I have forgotten what we ate. I can still taste it. Tastes like men's entrails. Seeing sailors walk past, so ugly, pale, I'd swear it's theirs. Must have been taken from them while they slept. The rats' dirty trick. Here, the rats are princes, just like the flies.

The other day, I caught one. Taking advantage of my sleep, it was creep-creep-creeping. I didn't have time to squeeze my thighs together before the beast entered. Since then, I have pain in my belly.

Like before, in the time of the sickness that makes you swell.

Must get rid of it, whatever it takes. Shit it out or vomit it up.

SOMETIMES WORDS come back to me in my head. I say "back" because I don't remember what kind of life I led in the past, before the sea took us. They say I was proud and a man touched me. A big White man, a chief, who since then has turned his back, walks past without looking at me. I know the crazy, changing heart.

I'd love to ask him if what people say about me is true, I'd love to but can't find my tongue. My rat must have eaten it. It's also his fault if I bled recently. The flow was strong and thick. It burned.

This evening, I remember two words. Dress and stream. Not enough to form an idea. Too bad, I put them together anyway. I lift my dress and piss out a stream. I cut up the stream to make a dress. The dress flows like a creek.

At the end of all the nights, a day: land. It's the island. Spread open on the water like my lily pad.

<div style="text-align:center">*</div>

I felt a great lightness upon disembarking, probably because my rat had fled, sated, my thing in its jaw. I walked as though flying, without care for the irons, my gaze perched high, anchored in what was left of the sky. I smiled at the sun, such a beautiful star, as big as the one I had buried. That was long ago, behind my father's hut,

when my breasts were milk. Behind, there was also a serpent very much in love with me. One day, it slithered in. Like the rat. Like the chief. Like my finger that digs in my earth and almost stayed there the other time. Good thing Felicity was there. She helped me find it again. I need to plant it before it wilts. Plant it before it wilts. I have a secret under my tongue. So small that I sometimes swallow it. Doesn't matter, it always grows again soon. All I have to do is dive into the river with my mouth wide open.

Yesterday, there I was in the water, beating Madame's laundry to make it as bright as daylight. It wasn't easy because of the stains. Looked like the earth seen from far away. I tore up a sheet to make myself a dress. I had always wanted to wear one. I made two holes for my arms, a third for my head, and then I danced, all day long I danced. Felicity was laughing, splashed me with her petals. When my skin was all wrinkled, I stretched out in the sunlight, rubbed myself against it. It was soft. It stung a little later on, but only because of all the salt on my scars. They had whipped me and tied me to a tree. They can always try, but I am immortal.

That is my secret.

FELICITY HAS JUST turned one year old. Doesn't talk yet but understands everything I tell her. For her birthday, I promised to take her out to see the moon. She smiled then squeezed my hand full of gratitude. The evening of our celebration, I waited until the masters were dreaming before setting out on the path to the mountain. We walked straight through without resting, afraid we'd never arrive. At the end of the journey, I wakened Felicity. "Look!" I whispered, pointing at the sphere. She shivered. It was the last time I saw her alive. I buried her at the foot of the mango trees. The sky was spitting water, the toads pouring out their psalms. I put my forehead to the earth and prayed for her soul.

The cord of my flower is broken, its breath is escaping. Go off and chase, chase the wind! The bird of shadows and spells. The cord of my flower is broken. Already, the spirit is dancing wandering. Fall, rain! Wash.

In the morning, my body had returned to the house. It had not wandered. Had followed the path, the only one it knew. On this island of waters and hills, you don't leave. You come back.

Now that my joy has departed, I don't sleep, bleed again, scream in pain with each visit by the rat. He has found me again.

Inside my head, all kinds of noises come and go. Cut me in two, three, a thousand pieces, like a machete.

Moldy, me vomited, spoiled, thrown away. Me rancid. Dirty. Salty. Without. Alone.

My cord is broken, my water is draining away.

That night, it's my own scream that awakens me, drives me out of my solitude-hut. I set off toward the river at a run. Shadows at my heels. Hands brushing me, wanting to puncture my belly. I will not let them do that, ever.

Hush, my baby, don't be afraid, your mother is here, I won't let them touch you.

I scream, my mouth open wide. Ah! Ahhhhhhhhhhh! I'm immortal-tal-tal.

Try it if you have any! Hush, Oba, hush.

"What? Don't tell me you're scared of water!" They crept close to me, but I didn't let them off easy, I bit them as hard as I could. After, there was a wave. Sirens, water rats, who knows!

*

They found me at dawn. In the back of the workshop, in the big-room where they wring juice from the cane. They say it wasn't a pretty sight, all that blood on the workbench, the hand-to-hand battle with the blades of the watermill. In the room where they had so often seen me dance, I was galloping, I-blanche, the body ravaged. A dress without ruffle or thread. Vast. Finally free. From my smile, which the unrooted head had somehow held onto, they figured I must have been happy. I had fallen asleep, surrendered to the monster, my little hands feeding him even more. Until the rollers had pulled me in and crushed me.

In the vat of sugar juice floated my thing.

I still don't know what they did with it.

Pray, why are you bawling, my big girl Francette?
Your Jehan who loves you has gone back to sea
He's more rich and hardy than ever before
With white butter before him at every meal.

Back in his village at the end of the Loire,
They'll talk about him for long years to come
Big Jehan from Guinea, his name will be called
And remind us all of the good days gone

Calm your sweet heart, my beloved, my dear
She's a fine mother, the deep blue sea
If it be the will of the good Lord above
I'll soon be back home and out herding the cows

the twin sisters

"In the olden days, when the sun reigned over all the earth, the children of our village used to go into the river to fish. One day, while they were quarreling, fighting for the best catches, a loud thud echoed in the sky, a flash that slashed the waters in two. From the river emerged a knight on horseback, a veritable warrior outfitted in red and gold, wielding a saber at least this long. Several moments passed, then our hero approached the children and handed to each the share of the fish that was his due."

Thus spoke grandmother, when she told us the story of how the old empire was born. Hearts pounding, eyes glued to our ancestor and her gestures, we waited for her to get to the point, reach the end of the story, go over the great mysteries again. Ask about Ndiadiane Ndiaye that strange knight said to come from Arabia, who must have been half-a-god. Lacking the words, our grandmother drew us a map of the vast country. Drew straight and curved lines in the sand to outline the kingdoms of Kayoor, Sin Salum, Bawol, Dyolof, Dimar, Waalo. We recited them by heart, sometimes mixed them up, Sawol, Waalum, Dyomar . . . Started over, until the old woman laughed, made the fleeting map tremble and show, in the cool evening air, even stranger beyonds.

Of all the lines that meandered under our feet, the one representing the river intrigued us the most. The lifeline on which we lived, and which for years, disappeared far into the distance in the old country. Who could have foreseen where it would lead us? How could we have imagined the great raving waters? The land that turned its back on us for no reason?

In this dugout canoe that is tearing us from Waalo, we, daughters of the river, beseech Mami Wata. May she deliver us from evil, use the next rising waters to take us back to our country!

Because there is no longer anyone to show us the way, we will recollect our story.

Where to start?

If there is a beginning, it tells of an end. The agony of a land broken by wars. Brak against Brak, family against family. Waalo-Waalo against Moor. The Nars were the worst for our country. True barbarians who raided the villages. Mounted on stallions, using their feet like hands, they snared our people with ropes, dragging them for leagues into the most remote lands. The Moors were man-flames that we didn't see coming, the day of the millet, the night of the new moon, the time that would for us be the last.

<div align="center">*</div>

Anta and I were in the field when the ground began to shake. In the distance, a horse with light coat galloped toward us, a man planted on its back. In the evening sunlight, the horseman brandished his saber, slashing the air and men's highest hopes. In the petrified sky, birds suspended their flight, sought out the highest branches, where they could watch out for the stranger. Crouching near our empty calabashes, we smiled. It had to be him, half-a-god, surging forth from the waters, as from our grandmother's mouth. "Ndia-diane Ndiaye!" we shouted, but the miracle was already far in the distance, where the winds sweep aside human voices.

Before darkness falls, we take the path back to the huts. Hearts pounding in the silence. Thrilling at the memory, under Chétane's mocking eye.

In a cool May sky, the stars' little eyes twinkle. Soon the great yellow mouth will open, infuse the river valley with its color.

Later, we pester our grandmother. Did she, too, see him, the warrior? Will he help our hungry people?

MY SISTER, leading the march, I can only see the back of her neck. Sometimes her profile, when she hounds me to pick up the pace. Conceived in the same belly and born at the same time, we barely resemble each other, truth be told. A world separates us. A memory haunts me. The day she almost drowned in the river, and I, sitting on the bank, let the water do its work, take hold of my body's twin and drag it away.

She would be dead, Anta, if a fisherman, alerted by her screams and braving the currents, hadn't pulled her out. We wouldn't be here today, she in front and I behind. As usual. As if I counted for nothing.

Never have we talked about what went through my head that morning by the river. Perhaps she knew?

As we keep walking, the sky tinges with pink, then veers to red, when we rub the bark of the old silk-cotton tree that is supposed to protect the village. Village? But where are *kër* and *sakets?* What's that fire, cracking open huts, enveloping livestock and people?

Panic mounting, we take off. The sand churns, the paths shudder. We see *flairons,* bodies surprised by death and whose final gestures—unrolling a mat, eating broth, filling a gourd—speak of an ordinary existence. Yes, ordinary.

We turn our heads at the pulse of hooves. Abruptly, toward the East. Horses approaching, my sister whispers to stay back. Hide our bodies in a dry place, away from the winding path. Beneath flaming skies, we flatten ourselves, mouths clamped shut, foreheads pressed into the dirt. Fear. We are petrified. Somewhere ahead of us, on the other side of the flames and the blades, our mypapa-mymama are watching. *Gorgorou,* they shout, Be brave! Hide! Don't cry!

Suddenly, one word fills our throats. A premonition. Grandmother! I dart into our compound, into her hut. Stumble into emptiness, the great void that follows a fire. Horror. There, where the old woman used to be, is no longer. Wide black streaks stain the ground. There, where she spoke, has lost its tongue. Nothing left but a few bits of straw, the base of a pitcher, a crazed dog guarding the remains of the door.

Walaï.

The heat intensifies. There are shouts. Everywhere, tens of villagers stumbling about, climbing back to their feet, hobbling up the river. Anta-Feyor is crying, Feyor-Anta is still bawling, her eyes fixed on the carnival sky, where the clouds have monstrous faces. More than pain, it is rage that takes root within us. We have seen so much collapse this night, we, people of the river, born of mists and dusk. Here ends our people. This evening, our rites are being

buried. Tomorrow, what will we be? Freshwater women and girls dragged away by the feet like dogs?

Before they capture us, we wade into the river. The water feels so good that night, full of the warm bodies that lately bathed there. Under our feet we hear the earth rumble, speak of worlds old as the world, which will someday also come to an end.

The next day, wooden posts have grown all over our body.

*

After the Nars left came others. *Laptots,* White man's Blacks, who must have been fishermen, knew the water's secrets by heart. It took a few moons to go down the river. A long time. And the country is black, cries for its burned villages, ruined fields, cows with no pasture to graze.

Our canoe trembles, fears the too-many fevers, the too-hot, the pillaging, those shadows hunting down Negroes and gold.

"You know, I've never understood why a part of Africa allowed that to happen."

Life on the water was either all one or the other. It depended on them, on the way they decided to treat you. Us, we didn't have many complaints. Who would dare to harm twins? The other captives came from the East and the high country. They had been taken by surprise, hadn't heard the drum. The one who rolls and beats the tam-tam announces the arrival of the great hunters. In all, there were maybe twenty of us. Per head, worth less than one hundred guineas.

In truth, I should have cost more than Anta. "One piece of cloth more," added the tallest hunter, after examining us. But a broker protested, claiming to see no difference between us. I disagreed. I've always been sturdier than my sister.

Before the great water, there was Guet N'Dar.

"Be careful!"

An island that speaks all: English, Arabic, Wolof, and walks fast. We stay there a week, in a cellar they call the *slavery* and where we hear all the utterances of the world. I can remember the woman from above, the *signare,* who laughs and makes noise. She must be happy. Laughs and acts as if there's no one but her on

earth. Whose jewelry acts just like her, skirts and buckles, too. I
talk, but I don't know her well.

"The truth!"

In the morning, after the ball, God calls the men. Only He could
shout so hard for so long.

*"Dedit, no, you lied about the signare. She's the one you're
trying to please. Like a dog, you hunt down her caresses. Like a
shadow, you follow her, laugh when she laughs, sob when she cries,
repeat her words and copy her gestures. And in the evening, moh!
What would you not give to have her keep you by her side? Offer
you her breast? Idiot!"*

She promised me she would protect us. How could I have sus-
pected, or you, either? How could I have known that a servant was
worth less than a nail, in her eyes?

"I have never been able to count on you."

> *(Anta-Feyor goes quiet. In the dark night before the great depar-
> ture, hear her sad, sad song.)*

Damel lel na dac oub Yene

Yobbouv ale na quia sama quioro guiame

Baba le bel teye guilne ma naccar

Bell bouggatou ma nane sangue

Bouggatou ma lecque requiere

Sama quioro dana douggue randy gou

Co dy yobbouguy guia sil ya

Ma guy dilagnie nec guiame bel ma nec ac mome

Nan mou nec ac mome guiame

*Mo ma ganal nec que guiambourre fou mome nec oul.**

Not another word, no, not a word until the hunters' big boat draws
close to Saint-Louis. Never has night been so black. At dawn, only
a handful of slaves to load. Quick, it turns out slave trade is illegal.

"Have you told about the initials marked with the iron?"

*The Damel pillaged the village of Yene; he took my mistress captive; since
that day, I've felt such sorrow that I have no thirst for palm wine or hunger for
couscous. My wife will be sent to the islands. I'll ask to be taken captive to be
with her; I would rather be captive with her than live without her.—*Author*

A detail.

"So you think history can be skinned?"

Don't care about historical truth.

"We must tell all."

What difference does it make, the shoulder, the ass, the back, the breasts! What does it matter if they took care to slide a rag between heat and the skin? So it won't burn, so it won't burn!

IN THE HOLD, the bodies' maneuvering ceases. One, a few, several mouths open and cry out. Impossible to sleep.

"Better that way. Must not sleep. Always stay on our guard, ready to get up and run, as soon as the earth returns. Then we'll go back to the village, heads held high, hell behind us."

*

The boat had to stop sometime; all that water must lead somewhere. Upon orders of the hunters, we vacated the hold and piled into dugout canoes. Once ashore, a rope around our neck, we realized our misfortune. How many Negroes, deaths, countries would we have to cross to return to our village? Feyor tried to ask the way, but the Blacks here didn't speak the same Black language.

After nightfall, bearing torches, men with dog faces started to patrol. Formed a column of fire between earth and sea.

All over the country, Negroes walked. Coming down from the near North, coming from the far East, they advanced in single file. Through high grasses, across forests, swamps, for days, stopping to catch their breath, submitting to the authority of the vicious dogs. For the hunters had planned for everything. Places to keep them penned up. Techniques for keeping them under control. Marketplaces where sales would take place.

One night, we freshwater daughters saw them wash up on shore. Tempting fate, defeated. Wretched before the ocean, the signature of misfortune, the symbol of the end of a world. Among them, in the background, I also remembered that girl with light skin. You would have thought she was a White woman. I remembered her because of the old woman she was clutching with all her strength. The harder the girl held on, the more the old woman tried to pry herself loose. The more the woman resisted, the more the

White woman insisted. It was like a game for amusement. After the old woman left the beach, I no longer saw the girl. Too dark out, probably.

And then the sea started again.

Different men. The same ones, really. A different route. The route. Until this strange town whose name no one could ever say. For weeks we wandered from site to site from seas to lands, from days to nights! We no longer felt fear, even when crossing the lagoon on foot or heading deep into the coconut forest.

"*Egun ô!*" howled the new captives each time their body brushed a palm tree. Were they already seeing the ghosts?

<center>*</center>

"I never thought I'd see the light-skinned girl again. In my mind, she was dead. And I never would have noticed her, had she not started going out. Coming back in. Going out. Going out. Coming back in. Had to wonder what was going on with her, when none of us had permission to leave the cell. She wasn't nasty, but I never liked her. She reminded me of the woman from Saint-Louis."

And yet, it's thanks to her that we learned a rebellion was being prepared.

"It was a setup, we never should have gone along with it."

You're still mad at me, aren't you?

"What good does it do to dwell on it? From now on, nothing binds us but chains."

I never wished you dead, that morning in the valley.

"Leave me in peace on that subject. It's ancient history."

Let me tell you now, we have nothing left to lose.

I was behind when we were born. The one who comes after. You, but after. I didn't want to come out. You're the one who pushed. I always loved sleeping. That's why I love the river. To avoid displeasing you, I did like you. Learned to walk like you. Talk like you. Smile. Eat. Cry. Pick my nose like you. Not one gesture of yours escaped me. I adopted them all. All you, so I'd no longer exist. And then, one day, doubt crept in. I started to hate you as much as I loved you. Flee your company as often as I needed it. It was either you or me, and I had to choose.

That morning in the valley is still the most beautiful day of

my life. In the mist, it seemed like the river and sky were embracing. Like the fish had learned to fly. You went into the river and I blushed a deep red. God, you were beautiful! A real *linguère*, a royal princess. Dazzled by your reflection, you didn't see the danger, you smiled, not suspecting a thing. I could have shaken you—I was stronger than you—I could have dived in, but . . . No more breath in my body, love in my belly, strength in my legs. You were dying and, by leaving this world, giving me the chance to finally live free.

※

> *(This time, the boat has left for good. In the moaning hold, Anta-Feyor has closed her eyes. She utters no cry, what good would it do? The hunters said it all: abandon all hope. But they didn't mention the sand clenched in hands. Probably don't know that a whole country can be held in a single fist.*
> *It's the White woman's voice that wakens the twins. The woman with light skin is trembling, still hesitates to jump. Over there, in their corner, the other rebels have gone quiet. Listen faithfully to their leader's final instructions. Of the two sisters, Anta is the first to stand up. Go out through the hatch, cross the deck. Climb up there to the poop deck. Without a single look back at the sister behind her, who's begging her not to throw herself into the water.*
> *"All together we will do it, all together . . ." She knows the song by heart, does Anta, now walking straight ahead. Jump. Jumps, a smile on her lips.*
> *It's the first time in her life she's thought and decided for two.)*

※

My sister is dead. I saw the fish eat her body, her blood spread out on the sea like a loincloth laid out to dry. I did not go back down to the hold. They carried me somewhere else, to a little room, a room smelling of ether and camphor. Lying on a straw mattress, I stare at the ceiling. I avoid thinking. I need to get through today.

My body hurts all over. Feels like I have nothing left, neither skin nor feet nor thighs.

Am I dreaming? My dead sister has just entered the room and is

watching me. She is going to part but I hold her back. Don't leave me alone.

"What more do you want of me?"

I just want to know.

"You'll know soon enough."

I beg of you, tell me. How is she?

"Will you never leave me in peace?"

Your place is better than mine.

"Why compete? We are equal."

I'm so afraid.

"Those are just words in your mouth."

I'm in pain, and it's so cold. Do you think I am going to die, too?

"Who can say the day?"

Do you think I'll die tonight?

"Perhaps."

When I'm dead . . .

"He commanded us, 'Do not say, They are dead.'"

When I am no longer, I would like to go to heaven. They say you eat well there, laugh all the time because there lives everyone you've known and loved.

"The way it used to be."

We've already lived so many revolutions. I don't want the world to change. I've always thought you could make your fate like you tell a story. When they captured us and our beloved siren ignored our prayers, I started to doubt.

"Grandmother had not told us everything. Man does not have a choice."

Then, all I ask is not to suffer. Light on the path, flowers in the trees, a sky without blood! And good weather, yes, hot and sunny, the night I leave. Will you be there when I arrive?

"Who knows what He's planned for you."

I'm so afraid!

"Néné, néné. Take it slowly. Fear nothing, soon you'll be far from the hunters. Don't you know that His most favored creature is man?"

Oh, listen good mothers, oh, listen brave folk
The true tale I'm telling of Jehan of Nantes
Had not twenty years when he put up his sails
Had all of his teeth and a heart lifted high

For sure the Atlantic wore down on his nerves
The sky grew excited and got out of hand
And for sure he swore, good Jehan, good John
To return to his country, his chapel to pray.

A man must have nerve to face off with the sea
A man must have flair to ride over the waves
When the good God decides that you'll have no say,
When the good God gets started, yourself, you will know.

the employee

It wasn't a first. I'd already done it several times. It was my job, and I'm a professional. Generally, people like me look for excuses to justify their acts, calling it bad luck, poverty, or misfortune. Invent pretexts out of fear of being judged and called bastards. In those cases, there is always someone who claims to understand, some upstanding person who listens to you, absolves you: "It could have happened to anyone."

If I had to find a reason, I would begin by telling you about my father. The boatman. A man who works his ass off. For rich people. A man who knows the sea and its sandbars better than anyone. It's all an art, what he does, my papa. Nobody can imagine what it's like, when the ocean howls and unleashes its fury because it refuses to convey the men. As someone who's always seen it up close, I can tell you, the sea is not nothing, you feel tiny before it. And it was something living on the coast, too. We used to say that the country had changed since the foreigners arrived. More wars. Less kindness. Dirty money everywhere. Things were better before, people said. And after? I can't abide nostalgia. I always want to throw up when old people talk. Guardians of memory . . . really? What memory, I ask? What memories? To each his own memories, is what I say. To each his own regrets and his own crap.

I was so young when I went into the trade. I learned fast. It wasn't that complicated, all they wanted was someone agile and brave, someone who kept a level head when the ocean turned playful. The trickiest part came later. After the sandbars, currents, sharks, when the White men bartered for our prisoners. Excuse my silence. I don't want to go into details. I only followed orders. I've never been one to make trouble.

Then, I moved up the ladder. I started hanging out with high society. One important Monsieur introduced me to another above

him, and so on, until someone recommended me as a miller for a
ship heading out to sea.

Feeding the prisoners, that was my job. A simple task, one that
never really inspired me. I'd always dreamed of being a helms-
man. I could have been second mate, at least, if they'd given me
a chance. If only, oh, if only I'd been able to grab hold of it, that
night of rebellion when the vessel, almost out of control, raging
with fire and blood, stripped of captain and masts, almost crashed
on the rocks! If I had taken my chance that night, I might have
managed to change course, to explore the beautiful corners of the
world where high-up people go. But as I've already said, I'm no
revolutionary. Believing that one person can change the world just
makes no sense.

For a time, I wasn't alone in my thinking. The day after the re-
volt, those who'd led the coup weren't boasting. Ridiculous, they
looked, dangling at the end of a rope, skins without skin, serving
as an example. I didn't work that day. On orders of the second
mate, the cauldron remained unlit. No one ate.

For years, I carried out my duties: grind the flour, the beans, the
corn. Oversee preparation of the gruel, adding a little fat, no more
than necessary. Chores, morning, noon, and night. I did with-
out complaint; and I wasn't too badly off in this boat where men
dropped like flies. At least that's what people said afterward.

I must confess, I'd never seen such a spectacle. I heard their cries,
of course, the creak of their chains, their heads banging against
the hull. I could tell something was not right in the hold, but what
could I do? They don't pay me for that. Besides, I barely had time to
get used to one lot of prisoners before another appeared. One time,
they loaded eight hundred on board. Eight hundred in a 260-ton
boat, what chaos! I wondered how they managed to live, all those
people piled on top of one another in the hold, until the dead gave
their place to the living. I never had reason to see the corpses up
close. Usually, sailors took care of them, four of them would drag
the dead out of the hold and sling them overboard. They performed
this chore at night, so it wouldn't bother the others. Anyway, it's
pretty simple: all dirty tasks were done in the night, when, feeling
hassled after a hard day of labor, the boys sat at the table and drank
like fish. Holed up in my corner, I could hear their singing, brawl-

ing laughter, shouts. I listened until the voices grew faint and I saw
their shadows going down below to unload their balls. They never
touched me. I looked like a guy at the time.

*

Time passed and I changed jobs. After being miller, I was charged
with creating atmosphere. Seems simple at first, work anyone
could do. Yet, making mood is not insignificant. It's a key position,
a sort of psychological companion for the prisoners. From the mo-
ment they arrive on board, the prisoners, drawn to suicide, subject
to all kinds of madness, need to change their thinking. Dance to
live. Sing to forget. Laugh not to cry, to smother the scream that
systematically rises from the hold when the ship sets out to sea.
Though I never shirked my duties, I admit freely that I singularly
lacked motivation. Bringing zombies back to life with a drum and
accordion was not my thing. Me, all I wanted was to keep dream-
ing. Take to sea like a real captain.

That's why I gave it up and boarded a ship to make my way
back to the coast. I'd been there for nearly a year when *Le Soleil*
docked. An ordinary three-mast ship, neither large nor small, its
hold was full of barrels and cheap goods. Arriving from France,
it had made the journey in a matter of weeks. Only later would it
fall behind. They say it's not until after Africa that the sea shows
its anger. Sometimes it won't let you move forward. So, there's no
point in forcing the issue. You have to wait, sparing water and sup-
plies. But nature knows what it's doing. There are always islands
en route, where you can take a break, resupply and care for prison-
ers in poor health.

*

He was called Moisonnier, the captain of *Le Soleil*. Everyone knew
his name. He'd been sailing since my father was a boatman. He
was no brute. Just one man working in the service of another, com-
ing here to do his work and in a hurry to go back home. Trained in
his country, he was a well-spoken man of few words. Didn't haggle
over merchandise. Took it or left it without malice or bad faith.

I should tell you what the coast was like when I returned there
to live. It was a lawless zone, where each man made his own rules,

where money bought money, and evil brought evil. All the rabble
of Africa and Europe flocked there to buy and sell at any price.
Never seen such a circus.

This is where she came on the scene. One morning, shortly
before *Le Soleil* left Africa and set sail for Saint-Domingue.
Usually, I'm indifferent to beauty. The word's very meaning escapes
me, as does the effect beauty has on most of my contemporaries.
Yet, that's the word that came to me when I saw the one who would
be known to all as the amazon, and for good reason. In chains,
the back of her neck held tightly in place with a forked stick, she
seemed impervious to suffering. Strode forth at a strong pace—
period!—like someone used to forced marches, unfazed by shack-
led feet. All muscle, with small, high breasts, she was both man
and woman. Depending on the day and people's desires as they ex-
amined her. No time was wasted bargaining over her. The French-
man paid. He was happy. Good captives were increasingly rare.
They tried to sell anything. I'd seen a lot of people come and go,
and for sure, this girl's presence on board *Le Soleil* would mean
headaches for the crew. Thanks to her, I might have a job.

Because I spoke pretty good French, Moisonnier hired me as a
guard on his ship. Before departure, I could help out below deck in
the bunks. We were supposed to set sail on March 11, but a tropical
storm kept us grounded for several days more. The amazon took
advantage of the delay to rally her troops.

*

At the risk of being too technical, let me describe in more detail the
prison where the women were held. It's an enclosed space where
almost no light penetrates. In fact, I'd say no light has ever entered
there. The planks that form the walls, though nailed together, look
ready to collapse at the first gust of wind. But appearances can be
deceiving. Never have I seen a barrack fall down. They say they're
as sturdy as the palm oil trees that border the beach, drawing a
curtain of greenery between inland and coast. The other problem
is space. The women have almost no room to lie down, which gets
complicated when somebody falls ill and shits or vomits on her
neighbors—and that happens almost every day. I spend hours try-

ing to control the odor. But usually, I can be found in the kitchen. I fix the meals with the help of a few prisoners. They mostly do the tasks I refuse to waste my time on. I've dealt with my share of misfortune and am not about to start over again at the bottom.

Away from the guards and probably thinking I don't understand their languages, the captives often use these moments to tell one another their life story: the village they were forced to leave, the man they love, the children they'll never see again, stories meant to distract me, no doubt. But they're wasting their time, I'm no dupe. I know something is brewing. My instincts rarely betray me.

On the eve of our departure, it was clear that something was about to happen. The amazon appeared as a small group of women were filling barrels with grain, barrels that would be stowed in the hold of *Le Soleil*. From all appearances, they were already all in agreement, for the warrior just spoke briefly, only reminding them of their promise. A shiver of fear ran through me when I realized what they were planning to do. It was pure insanity to imagine they could organize a mutiny. Even if they reached the room where weapons were stored, how would they shoot, when none among them had ever touched a rifle? And really, what did they plan to do, all by themselves out there in the open sea? Did they think a captain could be replaced with a snap of the fingers? The ocean is no game. You have to know it. The sea is filled with storms and powerful currents. I said nothing to Moisonnier. I needed more proof. I don't like to upset the boss for nothing.

*

Night was falling when *Le Soleil* weighed anchor. Up on the deck, you could count the stars. Tomorrow, we'd have good weather. The sailors would open the hatch and we'd dance to their chanteys.

According to my contract, my responsibilities as guard would begin on that day. So, I waited for all the prisoners to embark, then went to the women's quarters. I dreaded it. Eleven years at this work, and I'd never been down in the hold. Well, maybe I'd passed through once, but so quickly, I've always wondered if it was a dream.

I don't know how I got through that night. All those bodies, good god, all those bodies! And I haven't even mentioned the stench, it

was worse than the barracks! The secret to life is to not be scared. That I knew from experience. Most of these women would die in their own droppings.

I found a spot and squatted to avoid letting down my guard. All around me, captive women were dying, shrieking each time a wave lashed the hull. A little girl reached her hand out to me, and I wasn't sure what to do. This wasn't my job, I don't like to mix things. I had to move away because she started crying. For her, like many others, this was the first time at sea.

When the ocean had stopped making a racket, they lifted the hatch, and I could see a little more clearly. There was the rebel. She appeared to be snoring, eyelids closed, long legs folded up to her chest, but I would have sworn she wasn't sleeping, waiting for the right moment to wake her troops and take action. What was her plan? I was being paid to find out.

*

Looking back, I'll say I was mesmerized by that girl. I envied her sense of freedom, I, who had always been the employee, who had only ever acted on the orders of my superiors. My work was all I knew. No more and no less. With her, my whole way of thinking collapsed. In this world, there really were people who fought to defend their ideas. Whatever happened, whatever the cost.

I had nothing special to ask her, when I kneeled by her side. Let's say I just needed to hear her voice, to be closer, to ponder the flame glowing in her eyes. I was taking a risk, acting like this. A guard must impose respect. That rule I knew by heart.

She didn't look surprised to see me. More like she'd sized me up long before and was just waiting for me. I must have looked awkward; I'm not used to talking in strings of sentences. I really must have come across as awkward because I'd barely started talking when, without a word, she turned her back on me, as if I didn't exist. To move her and because I can't stand defeat, I placed a gentle hand on her shoulder. Her skin was hard. The girl grabbed my arm and twisted it like a madwoman until I howled and begged for mercy. "We don't kill dogs," she hissed, and spit in my face.

A woman next to her clapped her hands and they laughed as I

backed away, my eyes filled with tears. I could have squealed, made
her pay for what she'd just done. But why get all worked up? I was
on a mission. I wasn't there to settle scores.
Late that night, I heard them whispering. In the same spot
as earlier, the rebel leader was calling roll. About ten prisoners
(I counted) whose faces I still had to identify. I have an excellent
memory for voices, so putting faces to voices was child's play.
Before long, I'd drawn up my list. I'd done good work, could be
proud of myself.
My arm still hurt when I was admitted to the captain's quarters.
Seated at his secretary, Moisonnier was writing a letter. The paper
was pink, so he must be writing to a woman. I waited for his order
to deliver a first report on my investigation. As always, I was brief.
Went right to the point.

<p style="text-align:center">*</p>

Not everything is simple in life. There are things we don't under-
stand. Violent obstacles block our path—accidents, you might call
them. Back up on deck after reporting to the captain, I had the
shock of my life. By some miracle, the thirteen rebels had escaped
from the hold, had reached the poop deck, and were getting ready
to jump. They were about to hurl themselves into the water. Right
there! Before the night could take them, before the coast disap-
peared. They had climbed up there together, united by their pact.
They acted as one, one faith, one people.
Normally, I would have sounded the alarm. The boys would
have come running. And later, we would have seen thirteen corpses
flapping at the end of a rope. That's my job, that's what I do. I'm
a professional. But when I saw these women, willing to do any-
thing to remain free, something broke inside me. I wanted to be
like them. They were so beautiful. With no hesitation, I jumped.

<p style="text-align:center">*</p>

They say that when facing death, our whole life passes before our
eyes. That's a myth. I saw nothing at all when I jumped. Nothing
like that happened. Probably because until now, I've never lived
anything interesting. Anyway, that morning we were lucky. The sea

wasn't rough. I didn't even have to swim. I just drifted, let the current carry me to shore.

I have no idea what happened to the rebels. Me, I went back to work. No time to lose, a Portuguese ship was lifting anchor with five hundred captives on board.

Pump hard, boys, pump hard, to dry out the hulk!
Take a quart, sailor, to give you some heart
This cursed old girl will not let us go
Pump hard, boys, pump hard, to push out the sea.

Some days out at sea, I think of my cows
I go 'round and 'round, patapon patapon
We're much better off when we're back there at home
Where people have heart, patapon patapon

If the Lord is so good tralala tralalair
You'll suffer no ill, no hell to traverse
Soon, bonjour to the coast, bonjour to the loot,
A glass of warm spirits and joy, tralala!

the little one

It's wide up ahead. A river without banks. A river so vast that
the end is out of sight. It's slow. The water, the hours, the sun,
then suddenly, everything bursts open and moves faster. A storm
empties the sky, waves fly up into the air, the merry-go-round of
wicked men on the sand. Stretched out on the ground, I dream of
throwing stones at them. A hit! They crumple. I run away from the
beach to join my brothers.

Because I'm the only girl and my legs are short, I follow in line,
my eyes riveted to the prints made with their feet. It's so beauti-
ful here, where my brothers are leading me. Full of swamps and
wild animals. Raptors hover overhead, their talons ready to rip out
hearts. Night has come back again. On my mat, far from the sharp
stones, I feel my mother's hand on my skin, her fingers tracing
a path from top to bottom, removing the filth, the evil, the day.
Mama, the cradler, is a human smuggler, the one who guides me
to the land of happiness, where the trees sing. Where I want to stay
forever.

She had always been there in time, my mother. Each time my
hand searched her out, terrified by the thought that it might come
back empty, dangling. She was there. Always. I never had to re-
member her.

The sky has gone quiet. Dark all around. Night all around,
with strong odors I don't recognize. Heavy breasts, rancid puss-
ies, strange women in haunted sleep. Wedged in at the back of the
jail, in the corner farthest from the door, I listen to them weave
dreams. Hastily, badly, as if they were going to die tomorrow. But
they must hold a secret for living. At dawn, they are already up.
Outside, doing as if.

*

From now on, I'm not scared. I have someone. A girl who listens to me talk about my walks and my games. She laughs, amused by my stories. Only once have I seen her cry. Later on, just before the sea took us and the wicked men shut us up in the big box. They called her La Blanche. I've never understood why. They said it behind her back, but to me, she was the Grown-up. I couldn't tell how old she was, she looked like a woman, that's all I know.

She's happy to be my sister, the Grown-up. Or father, or mother. Whatever I wish. She likes to play with me mornings and afternoons, but not evenings. "My nights belong to the sailor," she explains.

Standing on tiptoe, I make a game of staring out at the horizon. The blue thread seems like the end of the world. A wall hiding a ditch, the big pit where we'll all rot someday. Will I have a chance to grow up before then?

My hips have grown a little rounder, my breasts a little bigger. Farther down, between my thighs, I'm still waiting for the blood that won't come. The Grown-up says you must be patient, she thinks I'm lucky. Childhood preserves us, childhood is priceless. You should stay a child for as long as possible. I ask her to tell me how. How does it feel when the blood comes? Like a wound, she says. A scar that keeps opening. When I beg her to show me, she refuses. For weeks she's had nothing. Her blood has stopped flowing.

In the perfect oval of her face, her mouth opens slightly and hesitates. She thinks I know nothing of women. "Don't listen to what they tell you about their men. About the sweetness, when they do the thing. About the importance of the very first time. None of these women will admit to their pain. The day they thought they were dying, when a man stole what it had taken them centuries to preserve. Who would dare say what she's thinking, a girl just become a woman? Is the mat on which she awakens a marriage bed or a deathbed? Where she sees the daylight enter, blind, indifferent to her pain? With innocuous clarity." The Grown-up talks too much. Her words are too big for me. She's raving, and I tell her to hush. Just tell me something beautiful. I don't want to die sad.

As she strokes my head, I listen to her talk about the land of after.

"The sailor says it's a fairy land where the sun is good, gives twenty-four hours a day. A land where people go without irons, people who, fastened to the sea, know neither hunger nor thirst. He also tells me that all over the island, overlooking immense fields of sugarcane, stand splendid white houses. Far more modern than our huts, so neat and stylish with blinds and those pretty chairs that let you rock back and forth all day long."

Lulled by the Grown-up's tongue, I see. In my head, I see the sugarcane. A field of gold-green, where men dance and sing. Hunh, hunh, they chant. Arms raised. Until late in the evening, making you dizzy. A bell rings and the cutters lower their arms. Follow the path home in silence. With a little imagination, I should soon see them. There they are! Feet flat, hats perched on their head. The leaden arms expressing all the worker's candor when, away from his daily task, he travels through the world without seeing it. Outside the building, they seem to pause.

"There! That's enough for today." The Grown-up plants a kiss on my forehead before heading out. "I have to go see the sailor." She has a secret to tell him.

When I'm alone, I squeeze my eyes shut, trying to re-create the island and my characters. Bareheaded—they've taken off their hats—they haven't moved an inch. Impassive before the estate, before the White man, before the order of things, they seem to be waiting for something. For me to name them, maybe?

Alright! The girl with light-brown eyes and a funny white scarf looks like an Awa. She has a fiancé. We're going to marry them soon. The one on the left could carry his grandfather's name; he's the spitting image of him. As for the woman over there, the one who just opened the blinds and looks angry, she seems to have no name. She'll just be called the-boss's-wife. That's how it's been for generations. "Fanchon! Fanchon!" The woman with no name calls me, looks me straight in the eye, as if we've always known each other, as if she were real. How foolish! She must not realize that she exists only in my head. A man comes over and taps me on the shoulder. "Madame is calling you Fanchon, don't you hear?" Fanchon? What kind of silly name is that? Why does my dream have to turn sour, why does my mouth open just enough to squeeze out an I-don't-know-what-reply: *Pa'don maît'ess eskizé mwen mè'si?*

When the relentless night sucks in my characters, I wake up sobbing, a foul taste in my mouth.

Could it be that the Grown-up is not telling the truth? That what will happen to us after, no one dares say? How to imagine an island where Negroes sweat like beasts? Where the Negroes are us? The ones far away, who, viewed through the shades, entertain the Master's eye? From time to time.

I didn't have the heart to tell my Grown-up my dream. She was so fragile. Let her talk. So white in that dress that he must have given her. Over there, she said, we would wear dresses just as beautiful, made of silk, with lace and ruffles. When I asked if she really believed we'd ever escape this situation, she burst into laughter then gently guided my head to her belly, to the very place where it was moving. Where life was timidly taking shape. "I can't die," she kept saying, "not now, not like this, I have so many things to do, the earth is so vast!"

As she talked, she looked outside, thought she was seeing, through the wooden slats, a world being redrawn, a different world in which she would talk to me only to tell me about beautiful things.

The sun is perched high this morning, a bird has sung, we will have white tuna at noon.

<p style="text-align:center">*</p>

Not long after that came the idea. That they worked on every evening to plot out. In the beginning, I didn't take part. I didn't dare, some of those women could have been my mother. Especially the warrior, the one who didn't think of herself as shit. No need to understand all she said to figure out what she was made of. Just by watching, you knew who you were dealing with. Watching her act out her exploits, I couldn't help wonder who I would be tomorrow. Would I have the courage to be like her, or would I be just a girl like any other? A woman for making babies? A mother with big breasts? An old woman who'd seen nothing of the world but her hut and the field?

One night when I couldn't sleep, I crept to the circle to listen. Her story began like this: "I, granddaughter of an amazon, daugh-

ter of Sosu the warrior and of a panther, I swear that the irons will not take me!"

I don't much remember the rest of the story, but there were so many words, blood that flowed, wars ended well! Like the day on the battlefield, when all by herself, Sosi vanquished an entire army of men, ripping off at least three dozen heads, and two hundred fifty arms, tearing out one hundred twenty-seven tongues, and so on, until all was still. In this prison where they forced us to obey rules and make ourselves small, hearing that did me good.

As the days passed, their voices grew in strength. For the rebellion to mean something, they would need at least ten women. Fear gnawing my stomach, I, too, spoke. I was one of the last to join. But the grown-ups did not approve. I was too little. There was a chance that I would just get in the way. "This war has already stolen too many of our children," they protested. I would have dropped it willingly, but the warrior intervened. "Naga, my grandmother, wasn't yet nine years of age when she killed her first man. This child can manage as well as any adult. It will be as she has decided." No one dared refute her. Afterward, I felt proud.

It was like in my mother's stories, when, after enduring so many trials, the hero marked his first victory.

"THEN IT'S true? You really believe all their stories?"

The next day, the Grown-up was furious. I had betrayed her, I, her dear sister. Poor stupid girl who believed their tall tales.

"You imagine that escape will be so easy! What do you hope to do by jumping? Don't you know that life is worth far more than death?"

I would have liked to tell her that there is no life without death. That to live is to accept dying.

I wanted to tell her, but she'd already left.

*

I'm going to kill her! That's the truth. Tear out her eyes! And tear off her dress, even whiter than she is, the one she hasn't taken off since her belly started to show. I hate her. I hate the Grown-up. Want to kill her for telling me that nonsense in the courtyard just

a while ago, all for revenge. I have almost finished my chores when she comes over, plants herself in front of me, and asks me if I'm happy. Without even waiting for my reply, she declares that you can't trust anyone. That there are times in life when our closest family betrays us. And that's not all. Then she asks me if I'm sure I can trust my own.

"I mean, do you trust them completely?"

When I just stand there, speechless, she adds that, in my place, she wouldn't act so proud. I really have no grounds for boasting, considering what happened.

"Maybe deep down, you don't care about the truth. You prefer not to know?"

"Know what?"

I don't have to tell you that I had no idea what she was talking about. The Grown-up leans in close, tells me, do you know what she dared tell? That it had been mother, my own mother, who had sold me! Mama, a traitor, a . . . How dare she?

*

The circle has widened. We've been nine since yesterday evening. No longer am I little. I've made people respect me, I'm one of them now that my blood has started to flow. Every evening, the warrior opens her mouth to spread the word. My neighbor takes it and then leads us to her country far from here. It seems a body needs several days to get there on foot. It's a land in the land that the sea has never visited. There, the sun burns, the sand smokes, the women's skin is dark as the tree's shadow. There, they eat as we do in my country. Millet, banana, oil that gives strength and flavor. One night in the village, one night when the huts are sleeping, men come. Nobody knows who they are.

Is she the same one who later walks along a river, wades into the sea and watches her son perish? When she bursts into sobs, an old woman breaks the silence to tell the mesmerizing story of Queen Pokou.

The warrior shrugs. That queen never existed! And even if she had, what is a princess next to an amazon?

*

Ten, now, with La Blanche.

"I'm ready," she declared, even if it's clear that she never will be. Rumors swirl around her. Apparently, her sailor has rejected her, her despondency over this lover makes her join us. Whatever, her life is not important to me. We all have our own reasons for jumping.

Say what you will, it's not easy to risk your life. I'm scared. All night, I was scared stiff. I even peed myself. Until now, being alive meant waiting. For the door to open. For night to fall. For the bell to ring. Tomorrow, none of that will be. We will have to act. Irons or freedom, we will have to choose.

This morning, women have started singing. It's nice, like a lullaby. It's beautiful. Even the wicked ones say nothing. They let it go, they know it is our last day before the big exit.

For the occasion, the sea seems to have dressed herself up. Shining and dancing as if at a ball. Impossible to appreciate the spectacle, the dugout canoe is bobbing forward and I feel sick to my stomach. Bite my lips to keep from vomiting.

*

So that's what the hold was: a black box where stacked-up bodies survived. Did everything that is impossible in normal times. Once inside, the game was up. Trapped like rats. With no air or light, we could see nothing.

It would take more than that to discourage the warrior. Barely arrived, she gathered her troops and filled us in on the situation. Whatever she said, we would do. Together, in one movement, we would jump.

We didn't have long to wait. The next day or maybe the day after that—how can you tell, when time won't pass?—we had the chance to climb up to the deck and jump.

*

Of course I did it. Of course I, too, swam like the others. But the women were right: I was too little to make it out alive.

They say the girls all have brown sugar skin
So sweet and so smooth that honey should flow
Down inside their thighs it's all warm and wet
There I'd willingly plant my sailor's straight mast

Life out on the sea is not like life at home
No place for a man to be just a lad
So come out and join me, if you be a man
We'll offer no quarter to bastards among us

You have no idea, young lass, young lass
A sailor's honor is good as his word
It costs not a nail, hangs by a thread
All ready to flee like a pack of dogs

the queen

The rain has stopped, I'm still sleeping in the cool air, on a mat that I share with no one. On my face with its high cheekbones, nothing can be read. Only by going deep inside, roaming through the pit of my stomach, can the waiting and boredom be felt. Sleep leaves me. A mosquito buzzes about before sinking into the flat yellowish water in a copper bowl.

Night has departed altogether now, I recover my body, slip it on like an old tunic before going into the other room. They are there already, always have been there, born to serve me, making sure that each day that rises, I also rise, that I lack nothing, that everything is in its place: fresh water in the jug, my jewels, my loincloths, the kola nuts, the platter of candied oranges.

Forehead to the ground, in the dust, they greet me, start on my back, my chest, my thighs, which they rub with oil. Then on to my hair, which their fingers deftly untangle, gather, and sculpt into a mound on my head, weaving into it beads. My toilette concluded, my women retire. I don my heavy necklace of jasper, then make my way to the western section of the palace, there where the Oba has ordered me to join him.

Two months since he summoned me, forbade his people to receive me, any of his wives to speak to me under threat of punishment. Two months because my belly is not giving, because I am tainting the royal family's name.

At last the door opens, I am led to the white pavilion, this room, its walls lined with cowrie shells, where visitors and strangers sit waiting. Seated on a mat, I look around me, count and recount the little white shells, split like women's lips. I am waiting and have almost forgotten for what, when armed sentinels burst into the room and without salutation, order me to follow them. We stride through courtyards, rooms, galleries. Brush past walls pierced with

doorways and openings. Wherever I look, space stretches out, hints at paths that lead yet farther. Finally, after passing the buildings reserved for the ministries, we reach a well-guarded door. A servant pushes it open, then leaps to the feet of the king to fan him.

Three times I bow, then wait for the Oba to wave me forward.

Slumped on his bench of red velvet, the king strokes the ostrich plumes on his hat. His silk brocade cape falls like a river of gold, revealing beneath its folds the collar: the breastplate with insignia, symbol of his omnipotence. On a richly embroidered cushion rests his foot, ornamented with bronze. The king, the Oba sighs, pauses before announcing that tomorrow he will take a wife.

"Tomorrow," he repeats, "at the hour when the sun retires, the entire kingdom will enter my palace to feast."

Tomorrow, I the most beautiful, the adored one, will be worth no more than the others, those princesses he married but who are caressed only by the fingers of the sun.

*

Today is tomorrow. I haven't closed my eyes all night. Alone in my apartments, I hurry, disappear from the palace at dawn. This is the hour when the old healer woman receives, opens her lair to visitors. No use talking, she possesses the science. Knows which plants dry out a belly, which elixirs torment the soul, obliterate reason. She knows who I am, despite my disguise, the opaque veil masking my face, protecting the barren queen that I am. With warmth, I thank the old woman, kiss her hand, promise to honor my debt. And the sacrifice I will have to make, but whose nature I know not yet.

Day is dawning as I retrace my steps. Above, the sky is splitting open already, spilling its waters out on the leafy canopy of the trees. The forest is exulting. The earth is sweating. In this forest of vertical green, a grave event seems to be simmering, the end of a time, the beginning of an era, a revolution only nature can sense. No, not a storm. Nor drought, nor trade wind, nor monsoon. "It won't come from the sky," whispers a vine, as it climbs a tree and takes hold.

My women don't seem to have noticed my absence this morning. As attentive as worker bees, they plant long gold pins in my

hair. With braids arranged in a crown, my head is dressed for a festival celebration, just like two years ago, when he married me.

It was hot out that day, one of those suns that make precious the smallest gesture, and heavy the lightest step. We danced. We took pleasure in palm wine. We laughed. Such a night! Laughed. Such a fête! Never had a day been so beautiful, a marriage so richly celebrated! I was queen, I am still, able to describe every last treasure in my palace. Tell the story of the fifty-eight brass masks hanging on the walls of the great salon, polished day and night by four of my most faithful servants. And this long horn made of an ivory tusk, a pack of galloping dogs carved into its side, the massive bronze bas-reliefs illustrating the rich hours of our history. The arrival of the Portuguese two centuries ago. The visit from the great chiefs of the North. Our battles, our hunters, our kings.

I was queen, at the head of a powerful kingdom. I had at my feet a people, held in my hands the blood of thousands of subjects. How many lives had I sacrificed? How many men had perished on my orders because I had decided that an individual's life belonged to his sovereign?

I AM the queen. The future bride is nothing. I will bear a child before she has a chance, I must!

THIS IS NOT the first time I've seen her, we knew each other when we suckled at the same breast. A few months younger than I, she is my milk sister.

This evening is the celebration. Like the night not long ago, blond wine flows, acrobats fly through the air. We dance, we sacrifice. So ugly, that dwarf with skin white as an egg! Let's cut off his head! Plant it on a pike and roast it!

Peals of joyful laughter. More dancing. Life flows.

My blood is boiling, I must swallow my rage, smile again, offer blessings, shower my co-spouse with loincloths, rings, earrings. May she be welcome in the palace, may she lack nothing. In the great salon where the union is being celebrated, I can't tear my eyes from her belly. My eyes desperately stalk the life wanting to be, ballooning flesh, under her loincloth stiffened with starch. Soon she

will be round, I know it, I feel it. Soon she will be unable to walk straight, will be forced to her bed, eat this, that, avoid harmful dreams, the spirits who use the cover of night to steal bodies of the almost-born. Soon, I will be old. Dried out, no better than a seed.

SHE IS with child. I heard it from a slave. I have not slept since. Think back to the old healer woman's counsel. Eat the root that renders invisible, pass through the walls of the palace. Slash that belly with a blade. No one will know a thing. Like every day, I will arise. My women will wash me, rub my body with balms and oils. Until my skin grows soft and my belly finally grows round.

<div align="center">*</div>

A noise in my ears punctures the silence. I struggle against it, the noise persists, infernal from the depths of my sleep, which it disturbs and interrupts. There is someone in my room, people, many people. Shadows scraping the floor. That crazy woman beating her head against the sea. She wants to die, she howls. It's she who is making/is the noise.

The trapdoor rises. They make us climb out. Move it, move it, move it!

Do they know who I am, these men with flaming skin that comes loose in the sun? Do they know where I come from? What blood flows in my veins? I am a queen. My kingdom is vast as the sky. A sun-queen, jewel-queen, queen of loincloths. Do you not see the *caladaris,* that delicious cotton cloth from Bengali?

And this marvelous dagger, come straight from Spain? Rubbed to a shine. To plant, deep in the night, in the rival's belly.

<div align="center">*</div>

The day he married me was the most beautiful of my life. When the last torches had been extinguished, we made our way to his apartments in silence. There he laid me on a mat. A cock crowed.

A sweet shiver inside me. I was trembling, loving, everything to this man, my king, my prince, whose desire like a fire had taken hold in my body. I was the queen now, he slept, his head thrown back as if imagining the stars and believing in his own eternity.

While he slept, I arose.

Noon was behind us. The sun's rays beat down, dismantling one by one the shadows carefully placed by the night. Bathed in light, the entire space offered the eye an unheard-of spectacle of a world no human spirit could have imagined. So much had been said, so much had been dreamed. So many legends woven around the palace. Some swore they had seen lions there, tigers, panthers, elephants, and dromedaries whose single white hump held all the mysteries of the East. Rumors told of powerful lords dining there every day, offering the monarch a thousand treasures: empires, seas, stars, the moon. All these stories, yet none able to capture the reality.

For I tell you, in truth, this palace was a marvel among marvels.

From the walls, high as ramparts holding up the sky, skulls jutted out, of such august nobility that they could only be those of kings vanquished in combat. Aligned in a tight row, as if atop battle pikes, these leaders never faltered, gauging the enemy, braving eyes upon them, ready to take up arms again. Thus could be seen in the alabaster masks, empty eye holes, silenced mouths, life as it appears when it defies death. Life in its final leap.

Across from these heads, which the raw light of day made glow like torches, stood animal heads with gaping jaws, with still-seething blood, as if they had just been ripped from the bodies. Farther on, hanging from a beam, were furs drying. An old woman brushed them slowly, her gaze fixed, forgetting that she had once had eyes to see. As our custom dictates, no slave must see the king when he awakes.

In an alcove sat bronze chairs in conversation. Two women, stuffed, sat there, faces and hands showing the first signs of decay. At their feet lay a rug of rainbow-colored beads that clicked in the gentlest breeze. Suspended from the ceiling by some kind of thread, gigantic golden butterflies shimmered, perfect, with silk feathers. They looked ready to fly off at any moment! I would have loved to have wings as well, deploy them in the fullness of day, while the whole palace slept.

The laughter of a fountain pulled me from my thoughts, and I ran out into the courtyard of the waters, where other splendors awaited me. When I passed through the gate, I blinked.

Luxurious beauty stretched in all directions, ordered by divine laws.

From a bronze statue representing a young warrior flowed the purest water in existence. Gushing from the soldier's mouth, it rippled along the wide garden paths where only the Oba's feet had the right to tread. Arranged in concentric circles around the masterpiece, the dwarf kola trees drank in the precious liquid, bearing at all times and in all seasons bouquets of crystals instead of plain nuts.

Paved with skulls and trimmed in gold, a little bridge spanned a stream. It led to the monarch's own salon, guarded day and night by two sentinels. Held up by wooden pillars ornamented with bas-reliefs in bronze, the edifice housed undreamed-of treasures: pipes, handkerchiefs, mirrors, beads, perfumes, eaux-de vie, weapons. And what weapons! Formidable sticks that were said to spit fire and could finish off any village. Barrels, stacked pell-mell around the room, overflowed with all sorts of fabrics. Cloth called flannel, Indian, bajutapaux, velvet, selempoury. Here was beauty in every sense of the word.

The king was still sleeping when I returned to the bedroom. I admired him. Stroked the heavy rings that encircled his ankles before falling to sleep again. At his feet.

<p align="center">*</p>

They were there when I opened my eyes.

"Take your hands off me!" I ordered. "Sons of nothing, men of nowhere! Take your hands off me and beware! In my veins flows royal blood. Within me rumbles the wrath of a queen! Gang of nothings, dogs, incompetents! Just wait, you will soon be back in your place: in a pile of droppings!"

This queen's fury boils within me, this queen's fury boils within me!

"Who do you take me for, anyway? What is the meaning of those gestures, those hands patting me, examining me? This iron for branding animals?"

I'll make them pay! I swear, I'll make them pay!

Let me take up the thread again, there where they broke it off.

*

For as long as I could, I struck, not stopping until I was sure that my rival's belly was empty, would give nothing more. Before dawn had fled, I was gone.

Our well-appointed king has lost his heart. His days are dark. His nights are light. Our king the beloved has lost his heart. Toll the bells, beat the drum!

They didn't realize what had happened. Upon finding the body, they all believed it to be a stillbirth and sent to her death the slave woman charged with watching over the bride's health. I have no regrets. A slave is not a man. His blood has no worth. So says our law. So goes the world.

The old woman healer had done good work. A few days later, I was with child, was once again the adored one, the joy, the pride of my king. Because too much happiness spoils the memory, I never went back to the forest. Forgotten were the path, the hut, the promise made to the mother. Forgotten until the old woman came to me one moonless night, a few days before my delivery.

"The hour of sacrifice has rung," she declares. "I have come to collect my due."

Of the two lives that will be born, she requires one.

"I came to take that which is not yours."

"No!" I shriek, "No!" I ring for my people. "Take this sorceress away! Outside the palace walls and into the forest! Burn her!"

My waters break as my men obey. Again, I ring. Servants rush forth and convey me to the room where the princes are born.

Night has fallen over the kingdom. Surrounded by my women and the queen mother, I push, push as hard as I can. Pain tears animal cries from my throat. The sweat on my skin flows like a river, sweeps an atrocious wave of icy cold over me. Two women fan me, encourage the labor. "The twins who come will be the masters of the world," they sing. "They will reign over the seas, our lands and the lands where men go without skin and their weapons go pop."

I push. Between my thighs, hope; let those who are coming, come!

What is happening inside my belly? War. Inside, two enemy
forces confront each other. My twins are in battle. 1–0. 2–1. 2–2.
2–3. 2–4. 2–5. The second one crumples. Out cold. And while bit-
ter blood floods the mat, my body contracts and expels a body.
"One of the two has survived," murmur expert lips. They bring
forth the victor: a boy, an albino, who is glaring at me already. In
the morning, the child sneers and gloats. Why don't I have the
strength to strangle him?

Such jubilation throughout the kingdom, where everyone greets
the birth of the prince! Such clamor on the pathways, normally
calm and deserted. Gathered in the great courtyard, my women
sing, mime the sacred hours of the delivery.

*The queen, oh, our queen is blessed on this night, a prince she holds
lovingly to her breast, the gods will protect her, the gods have ful-
filled her, our queen, oh, our queen, will be mother this eve.*

While the room rings with their song, my weary body offers itself
diffidently to a rubdown. Wash, oil, perfume, I let them go at it,
display this ornament worn only by queens whose bellies have spo-
ken. At my forehead, on my arms, at my neck shines my glory, at
my hips hang feathers soft as skin that trail on the ground. A hun-
dred women escort me into the Gallery of Arts. Acrobats follow,
then dancers, storytellers, the guardians and mouth of our history.

The gods will protect her, the gods have fulfilled her.

Near the Oba where I am seated, I play the role of mother and
spouse without flaw. As in the past, I preside. Let the celebration be-
gin! Joy calls for joy. Late that night, to bring us good luck, twenty
virgins will be burned.

*

The monster is growing. The one who brought death is growing.
I hate him, am that mother who keeps an eye on him day and night,
spoils his food, pinches him, hits him, prays for the breath in his
body to cease. But the albino endures. No prayer, no deed can
touch him.

He has just turned seven when I order one of my most faithful
slaves to go into his room, where, lightheaded, he is resting with a

headache. In the brew that I send into him, I have mixed the great poison. One pinch of that powder would fell a lion.

"The prince drank it all," reports the servant. I sigh and hold back my dance. Soon, this evening, the death child will be no more. I will be free. No more his smile, no more the sorceress who taunts me each night, reminding me that this child belongs to her, that he killed mine. Will have my hide.

*

Some called it bad luck, others suspected a political crime. Who could have known? A mother doesn't kill her own flesh and blood.

To deflect suspicion, I ordered an investigation, ordered that all personal slaves of the prince be disgorged. To be on the safe side, I had one of my little slaves put in irons. She cried, the daughter of Nupe, when the merchants of the sands took her away. She was crying . . . as if that could change anything!

Our child dead and buried, the court takes time to reflect, the Oba consults the ancestors' spirits.

"Let him speak, he who holds in his mouth words of truth, holds in his heart stories not known by men!"

A voice rises, intoning my name. May the gods forgive me. I killed the crown prince.

A curse upon me.

I am finished.

Our hearts bleed, our flesh is wounded. Who can heal us, will we ever be healed? Our land has been spoiled, the queen is cursed. What punishment for her? Who dares succor her?

They let me live. In exchange for a few rifles, I was sold. Stripped of loincloth, beads, and oil, I followed the stranger out of the palace. Outside, the sun shone. Just as before, the rays beat down in a single white wave that wiped out the horizon.

*

This must be a dream. At any moment, I will awaken, see my women come into view. Bring me the loincloth for special days, my jewels, my kola nuts. Quick, faster! The queen is hungry. Long live the queen!

Are they sleeping? How dare they? Just wait until I get my hands on them. From this moment on, I want, I demand that they no longer appear before me, not even before the sun. To prison with them, on a diet of millet and water! Those who lack respect for the queen deserve not to live.

It is a dream. Slowly I awaken.

A room. Slum, cellar, cesspool.

With walls like grids, a muddy floor. I am suffocating. My hands are sticky, my whole body is sticky, and the wind can do nothing about it. A shadow. Daylight filters in, and I catch sight of them with fear and disgust. Pus women, lice woman. Filth. Born to suffer the irons; a man cannot be changed to that degree. One of them draws close. Does she imagine I will address her? Her hand in my hair is torture. Her breath stinks. What a horror! I pull away. We are not of the same blood.

The thing smiles. She recognizes this pride, a hundred times she has encountered it, and each time, seen it snuffed out. So go the new ones, no matter where they are from or what they are.

The wench knows nothing. Must I remind her? I am a queen.

*

How can I keep believing?

Hang on to what was, perhaps. To what every princess must know. Hold oneself tall. Speak well. Act rich. Eat well.

How can they swallow the same sustenance every day? Are they dogs, asking for more, scraping the bottom of their dish, wearing down their fingertips? How?

"Remove me from here!" I keep demanding. "Open the door! My blood is pure, my life has high value. I was queen and still am, no matter what. Let me speak to the leader, I will inform him of my situation. There's been some error, he must be informed. A queen cannot be a slave!"

My request is granted. One morning I am led into the house of the Whites to speak to this man who passes for their leader. A few feet tall, plump, with pale complexion, nothing regal about him. Seated straddling a small bench, he stinks of tobacco and sweat. Into the room lacking all charm, with its wide view of the shoreline, a Black man has just entered. "You need only speak," he

explains. "I will serve as interpreter." Since my host occupies my rank, I extend a brief greeting to him and, head held high, present my request.

"There are two kinds of men: those born to be governed and those who by nature govern. You have erred in believing I was a woman of chains. An unfortunate incident brought me to you, but this is not my place, this cannot be my fate. I am a queen, please pay that heed."

The White man speaks. The Black man repeats.

"He says that all Negroes are Negroes and it is really of no importance to him to know who did what, who was who. Here all slaves are the same. No distinctions. No privileges."

I insist: "I urge you to weigh your words and consider the issue more seriously. Do you know what all this means? My kingdom is one of the most powerful in the region. We can negotiate as equals. If you consent to liberating me, I will guarantee you gold and arms in exchange. Otherwise, I fear you will expose yourself to great peril. Our king does not allow others to infringe upon his wives. My husband, my beloved, would not suffer anyone touching a hair on my head."

The Black man: "He is sorry, but says he has nothing more to add. He will not run the risk of returning to the backcountry. He knows you will command a good price."

"His price will be mine."

"He can do nothing more for you. Your blood and your gold will do you no good."

"I will have him arrested by my people. Soon he will be nothing more than straw on a fire. Like the sorcerer! Like the sorcerer, I will make him burn!"

The door opens, two men rush at me to hold me down. I scratch, bite, spit. Fall.

"Lock this hysterical woman in the hole!" orders the redolent chief, before returning to the window to probe the horizon.

*

There is no *there* more terrifying than here.

For two days, maybe four, I have been underground. Like a worm, crawling each time the trapdoor rises and falls at the hour

for eating and drinking. Never would I have believed this pos-
sible. I, wretched, nothing but sores and chains. Hoping for death,
dreading escape from it. How to survive with this disgust of self?
There is no *when* more absurd than tomorrow. No question more
foolish than *"What will become of me?"*

Assuming I still exist.

Confronted with all these silences, I am surprised to find myself
listening to them, the women with no social status, who talk for no
reason. The people don't think.

It shames me to brush against their bodies. To share their hopes,
their cries, their piss. To lose my blood, ruin its rank. Face this
reality: we are in the same boat.

Freed from their chains, my wrists and ankles still feel their
weight. Recalling past-me, the queen. The I-mistress organizing
the sale of slaves, our war captives crossing the waters. And what
of it? A king has all the rights. That is the way of the world. We
will not be the ones who change it.

<center>*</center>

The days of slave sales were days of jubilation at the palace. Awak-
ened by the big bell, I quickly gave orders to my women. That they
dress me in my most beautiful finery, bring forth my jewels, my
ivory, my pearls and my mirrors to be ready at the designated hour,
attend the parade of slaves. From my apartments, I watched them
pass. Tossed at them flowers, stones, laughter, searching among
them for the most beautiful piece, the one who would move me.

<center>*</center>

The voices go quiet. The trade winds rise, nervous gusts sweep into
the hole. In this night where all creation seems on the verge of war,
sleep does not come.

I dream of my death.

A misty day all over the kingdom. Low, dark sky, where black
kites trace circles. In the distance, moving forward, a people—little
people come from all over—dragging along livestock and children.
Stopped, as though forbidden, at the gates of the palace, the crowd
peers through the gates. Inside, the court expresses its pain.

Our queen is gone. We no longer deserve to live. Our queen is no more. What purpose our song?

Assembled in my courtyard, my women lament. Some rip out their hair, others brandish sabers, vow to die tomorrow.

May our life be taken, we will taste it no more.

Stretched out on his bed, the king my Oba has donned his mourning robe. His head bare, his heart heavy with sorrow.

Day will dawn no more. My star has departed.

On this day of celebration, I am the most beautiful woman on earth. Wear a loincloth of silk and precious stones. My toilette completed, the doors opened wide, I'm conveyed to the water garden. As in the past, the bronze soldier presides. No longer proud or courageous, now weary.

Our queen is gone, what purpose my struggle?

After crossing the little bridge paved with bones and gold, the procession pauses, and all bow their head. Ahead loom the columns marking the entrance to the chamber no one enters without orders from the king.

Oba commands. We enter. Inside, it is sunny and cool.

Laid out on a bed of feathers, I depart in peace. I fly off, guided by the breath of the spirits. They sing. The song of death that prepares a long journey.

Our beloved queen has departed. May the gods protect her, may our prayers carry her forth. The queen, our queen has left us, may death come to us soon. What joy to join our beloved once again.

From the sky, where the trade winds whistle, I take one last look at the palace. I am crying yet I am happy. Never has there been a more grandiose funeral.

*

Tomorrow is another day

Back in the big jail, I feel a scream rising within me. Enough! This comedy has lasted long enough. With no gold or crown, I am

out of luck. Of little worth. Sham queen. Bauble princess. Like a warrior overcome with fatigue, I lay down my arms and strip off my frippery.

I have not always been queen. They called me Huita. I was born twenty years ago. Slowly, words lead to phrases, build images, in the time when life was life. It was in my tenth year that I learned I would be the king's.

The lice-pus-filth women are amazed, fall at my feet, surround me like at court. I am once again satisfied. The people think not, but obey and fulfill me.

I'm hot! Two women come running. I'm hungry! They bring me the best, the most tender beans, the ripest fruit. The water that does good.

Trying not to displease me, each offers to entertain. Sing for me, dance for me, would damn themselves for me.

Our queen the beloved, has returned. Let us offer our lives, our hearts in sacrifice, our hearts in sacrifice!

Just as before. The sleeping room, the garden of golden water, the mask room . . . Just as before, until the day dawns brutally.

<center>*</center>

Time passes, the season dries. At the top of the trees, skinny birds build nests, back from a long journey. The sky is now bleached. The wind sweeps through, carrying misfortune and news. In this way, I know the time will soon come. Before long, the Whites will shove off from land, the ocean will yawn and consume us. Through my women, I hear that a rebellion is planned. In another cell, some ten slaves argue incessantly, under the hard, blue sky, dreaming of escape.

I lose no time meeting with their leader. A tall Negro woman who speaks to me directly, looks me straight in the eye. Using my language, the woman comes right to the point, summons me to clarify my position. I must admit, she knows what she is doing, has a flair for the art of negotiation. "If we achieve our liberation," she promises, "I will help you conquer your kingdom again." Thousands of warriors devoted to her will not hesitate to fight. Do I have a choice? I swear, Queen's word, to ally myself with the rebels.

The very day, at the hour when night changes bodies to shadows, we all gather, the leader's women and I, under the largest tree. A skull filled with warm, murky water passes from hand to hand among the women who have said yes. The mouths swallow, I taste, almost spit out the blood cut with alcohol when it fills my throat. Intoxicated, I then offer my left arm to the cold slice of the blade. And while the skins flow with blood for the pact, I feel the weight of a stare. What does that woman want? Why do I feel that our paths have crossed in the past?

<p style="text-align:center">*</p>

They say there are beings who keep men's destinies cloaked in secret. Know the underside and end of the path. Was it she who, the night of the pact, was watching me, who is now swimming toward me, slicing through the water with her strong, supple arms? Here she is, before me, hardly a meter away, smiling at me without smiling. I search my memory, but recall no name, nor place, nor encounter.

Suddenly, a heavy hand strikes me in the face. Is it she? My vision blurs, my body flounders, struggling to escape this fury. Feeling myself weaken, I beg her to spare me. "Mercy!" I yell, before she strikes me with a masterful blow.

She has hit her mark, my queen's blood is flowing. Across the waves, I watch her disappear as the monsters, interrupting their nap, cut a path through the scarlet blue.

Let's raise a glass! Now the boat is all clean
To the captain's health and the King of France!
The sparkling ocean, three steps to the left,
Raise a glass and a song, Dance the sailor's round!

Men and women of Nantes, oh, soon we'll be back
Aboard Le Soleil, to where Jehan embarked
The sails are full high, the holds full of sugar
Oh, City of Nantes, you'll be able to dance

And then we'll see coming the girls rosy white
Plenty enough to fill you right up
Our balls are at full and so are our holds
Ah, the work of a sailor! Boss, bring out the cups!

the-one-who-flies

I waited for the moon to be born before breaking my chains and coating my eyelids with the bitter milk of plants collected in the past. Sweaty, moist, the ship hold slept on. Senseless, futile sleep, which persisted, nevertheless, each day. Guided by a ray of light, I stepped over dreamless bodies. Vermin swarmed all about—fleas, rats, worms—each taking care of its dark needs. Wretched labor that emerged from the shadows, rustling here and there with no modesty or compassion. Among the shadows with no savior, sometimes faces. Gaunt, pallid. A limp hand, an exhausted heart. Nothing that hinted of rest. Of movement forward after a pause.

Voices were already tumbling from the bridge. Night was approaching. Relentless cold. Far from the officers' cabins, wrapped in thin blankets of wool, sailors whiled away time. Shuffling cards, whistling, focused on what lay directly ahead, not daring to defy the ire of a sky whose threat never let up.

Courted by lightning, the opaque mass above suddenly started to moan. Arched its back, hips swaying above the fevered sea. The moon veered to red. The waters awakened, hurled foam against the ship's hull. All held their breath, then nothing. Nothing more. The ocean had sunk into slumber, reminding sailors of their austere servitude, and man of the foolishness of his existence.

Taking advantage of the lull, I slipped into the big room where the master of the seas was finishing his meal.

The man, who couldn't see me, was plunged deep in thought, mopping his plate with bread instinctively, much like walking, and peering sadly through the porthole from time to time. Abruptly, he rose from the table and walked toward what must be his bedroom. There, sitting down at the secretary made of wood and mother-of-pearl, the only luxury he allowed himself, he took up his plume.

How was the weather in Nantes?

*

A thick fog had dulled the city. Men sighed, dreading the hour when, subject to the tick-tock of time they would leave the bedroom, walk through the foyer, swallow icy morning winds whole. Out on the uneven, bricked pavement, some braved the cold before disappearing into the gray cloak of fog. In the misshapen city, the clock had started to chime. Seven o'clock. The stone city of Nantes yawned and stretched. Trembled under the weight of the first carriages drawn at a well-mannered trot by horses who'd forgotten the time when they galloped with the wind.

Across from the River Erdre and not far from a church with still-snoring bells stood the house of Captain Louis Mosnier. Severe in form, an edifice of *tuffeau* stone with, emerging from its walls, heads of laughing Negroes.

On the second floor, behind the transom windows could be seen the captain's wife. Marie-Madeleine. Porcelain pale in her purple velvet dress whose wimple was all that could be seen from outside. Marie in winter, attentive to the spectacle that would soon unfurl before her eyes. Early morning, the banks of the Erdre River come alive, shouting *For sale! Stop, thief! For rent!* It was true that everything came at a price here, and a captain's salary barely covered household expenses. "Unless. Unless we decide to rent out the ground floor. What good is it to possess empty apartments? Would be a good idea to study the Quennecs' proposal, that couple who arrived from Montoir two nights ago and whose visit . . . What luck! There's the husband going past! Nose in the air, wearing a bourgeois hat. What nerve! The kind who would go to any length to settle in Saint-Germain! He can always try! The old Chapeau-Rouge residents would never permit it. What did a common surgeon from the provinces imagine he would do with the Francs-Maçons? The world belongs to those who think it does! Haven't we already seen little people take an interest in the big things of this century? When my Louis returns, I'll have to talk to him."

I APPROACHED the windows, Marie-Madeleine stepped back, bringing a handkerchief to her lips and ringing the little handbell nervously. The door opened, the maid entered. Her step heavy,

cheeks rosy, she carried a small heater, which she placed at the feet of her mistress before withdrawing from the room.

Reclined on her sofa, Marie had returned to her thoughts of Louis, this man thirty-seven years her senior, whom she'd wed in a marriage of reason, and whose return she would await whatever happened, with no thoughts other than those of a married woman. Nearly six months had passed since they'd bid their farewells in Paimboeuf, down the river, there where the slave ships passed through. When the vessel had set sail, she remembered standing on the dock for hours, long after the last waves had swallowed the still-flaming white sails.

Even as great cold descended on the city, she hadn't moved, still searching the horizon with a ferocious eye, this unknown zone from where people came back rich, a hero, or dead. And then the forgetting had settled in or, more accurately, growing accustomed to the absence, The captain still hadn't appeared, leaving behind a portrait and this round belly, which in the doctor's words, augured a delicate delivery. She slid a hand under her skirt that sailed over her skin, then shook her head slightly as if to quiet the tiny voice that had recently threaded its way into her dreams, following her into the wee hours. Judging by the dark circles on her haunted face, the voice had sung all night. Marie shivered.

She had known no other man before Louis. Had remained a mama's daughter, darning sheets, polishing silver, knowing nothing of the world but its skies, and nothing of love but the laughter that sometimes escaped the neighboring houses. Thus, Louis viewed her as a timid child with delicate health, one he would need to protect. Sea captain for a good forty years, he had decided that this voyage to Saint-Domingue would be his last. In the spring, God willing, he would fix up the ground floor for the offices of a new Masonic Lodge. "Universal thinking," "Mankind on the move," or some such thing. God willing, and why wouldn't he be, he would have a son. A decent man, a freethinker who would dream of traveling the world, would travel it, and then give talks on the subject at the impressive Great Exhibitions.

As Marie-Madeleine slips into a languid slumber, a violent gale sweeps through the bedroom. Furnishings and walls hiccup, as though taken by fever, and are near collapse when the sooth-

sayer appears. I throw myself at her feet, kiss her hands heavy with amulets.

"By the grace of the spirit on high, you who know the leaf and the head, tell me how to save our people from this misfortune!"

"Only command, great father priest, and I will obey." Just as in his temple, in the country, the master reflects, amid the rumbling of drums, invokes Vodun. May he possess him. Vodun descends, the priest stamps his feet and utters hoarse cries. It's the spirit speaking and moving within him.

"The child of the White man must die," he chants. "On the night he comes out, he will go. I have begun the task but some remains still. You alone can help me." Upon orders of the master, I draw near the woman, lift her skirt and petticoat to spoil her belly. My prayer completed, I hear the voice of the great initiated speak. Tell of a country far away, well beyond the blue line. There where the White man's vessel sets sail, where our people are being tested. In that footless and rootless country, there are men who have inherited the science. One of them will liberate us. The wind flies off, the priest disappears, and I am alone once again, in this city capped with slate tiles, gripped in the vise of the wind and the scent of the sea.

Into the sleepy Loire I wade. Swim until the river awakens abruptly, accelerates in its rush to join the great water. The Sea!

I am a fish. I frolic in a cool gulf before retracing my path to chase after the sea.

I'm lifted high by the azure blue. Guided by the wind. I'm flying, leaving France. Heading south! Southwest. I am an eagle. Tracking the bonito and white tuna. Before the stars sink into the sea, I will soar over the Azores. Cross into the tropics, see emerge the island of the man who knows and sees. But now the gods decide otherwise. Mowed down by a cloud, I falter and lose my way in a sky of soot. What is this? This wind closing around me and dragging me from my path? I plummet down, where the waters yawn open, a gaping abyss, where the ancient city, forever cut off from the sun, casts its spell. Nostalgia of men. Capricious. Magnetic.

At the heart of the buildings guarded by atlases, sleeps an entire shadowy people. Djinns watch over, with their fairy song, keep the tigers of the sea at bay. Luring, with magnetic breath, travelers

driven by misfortune into these remote and cursed regions. Their memories erased by strong potions, they live at the mercy of jailers who are worshipped as masters and gods. Their bodies go without heart. Their life without thought. I shiver. Think of the ship hold. Time is short. I must find the man.

THE SUN has reached its peak when I break through the top crust of the waves. The winds have subsided, whitecaps are rocking. A glide of flying fish splashes and escorts me. Several leagues from the Tropic of Cancer, a dark mass breaks the horizon's flat line. Is it the island? The island where the White man docks his boats? It can't be, the terrain is too flat. How, in this land, this place, could we reach shore and pray to our gods? There's another isle to the right, high, as if cut from a single block of stone. The island is steep. I climb. The island is mute, dreading the lava spew. From its crest, where I look down over the great whole, I call on man-God. You who know the leaf and the head, where are you?

Moments before dusk, a languorous song breaks the silence. Animal tears, like the croaking of toads, calling out to me. I'm here! I am almost here. Finally here: Saint-Domingue. Ayiti of the mountains. The great island of croaking rain.

*

The north end of the island. The toads keep watch, as I slip under the door of the great-hut. The wooden floor is cold. The light faint. Around the table of manchineel wood, five shadows are supping.

"Mostly in the evening," concludes a woman without conviction, "in the evening, mostly." Her hand brushes her pale forehead reminiscent of Amandine's doll. Amandine, the master's daughter.

"Courage, Isabelle [the Mistress], only a few more months to hold on. When exactly will you be going home?"

A Negro woman walks through the room, all go quiet. A precaution. Then: "Who can say? Look what happened at Beaunay last month. They burned everything, everything! The workshop, the gardens, the mill, the house. There's nothing left now, nothing! And the worst part is that no one saw anything. Seems the fire started all of a sudden. I don't know any fire that catches without help."

The voice trembles. Anger.

"They will pay dearly for this, mark my words. I will not be intimidated by this vermin. The longer the flea stays under the skin, the more likely it will nest there. Our Negroes have grown too comfortable. They need to be put back in their place, in the lower courtyard with the chickens."

They titter nervously, then cross into the other room, the salon where French doors open onto the garden.

"My heavens, what a night! It's so dark out there."

"Because of the rain, Madame."

"Of course, I'd forgotten." The voice trails off, disappearing into the clinking of teaspoons. "The last time was on the fifth. It's my habit to note the rainy days in my book. Robert [the master] thinks I'm becoming obsessive, those are his words. But for me, it's a distraction from boredom. This country is so hard, and it is so hot here, don't you think?"

The silence weighs heavy. The bodies move. A little farther away, the women are trading memories. One of them leaps to her feet, screaming. Thinks she feels some kind of beast under her foot. A toad, a mouse, a snake.

"Good God, Gérard, do something, you know I have an absolute horror of reptiles!"

A man's hand grabs the kerosene lamp, searches.

"I had to kill half a dozen of them yesterday. Grass snakes. Must be the season."

"People say it's *they* who attract them."

A woman sighs.

"At night, with their drums!"

She takes a sip of alcohol. Her hands are trembling.

"Those bamboulas, we should put a stop to them."

"A happy slave is a slave who works. I leave it to you, in your wisdom, to think through the consequences. Madame, perhaps you imagine that these Blacks rub shoulders with cunning? Nonsense, they are no more wicked than you!"

The odor of Negro in the passageway. First, his shadow, then the body crosses the threshold and comes into the room.

Master to Bienvenue: "Melody has worms, we have to purge her, and don't you dare let me catch you riding her, or you will have

me to answer to. For the docks, be ready at seven o'clock. We'll take the main road."

The frizzy head bows, the body backs out until it reaches the rail.

Mistress to Master: "Remember, tomorrow evening we have an engagement." To the dinner guests: "The West is coming to us. The Le Torts, do you remember?"

A little later, that same night.

Far from the Negro huts with their crumbling walls, where the cousin is growling, the same solemn song is rising, the lament of the shoeless. Sudan. Congo. Guinea. By the glow of the tallow candles, the masklike faces, ebony flesh, all ponder the man's face made up like a warrior.

As I slip in near them, the earth starts to shake. The sky thunders, Black people scatter. A gale rears up, rushes through, and here I am again, beyond the island, beyond the night.

*

France. The bedroom in Nantes.

Three lines crease the forehead of Doctor Roche. At his patient's bedside, he sits quiet, just listens to the mad gallop of her pulse. From the maid who requested his services this morning, he has learned nothing. "What do I know?" she grumbled, when they crossed paths in the hallway.

In the bedroom with curtains pulled, Marie-Madeleine sits up straight. Sweeps the room with terrified eyes, saying: "I'm out walking. I don't know where, but the air is heavy and damp, as if the rain refuses to come. I'm hot, cold, shivers course over my body, the fevers, perhaps. I long to sit down, but the path is obstructed, shadows by the hundreds, laid out head-to-foot. Finally, the street empties, I lie down on my side like an animal. That's when I hear the voice, the song of the mourners kneeling before their Christ or whatever. The moon goes dark. The sky uncoils its beads. It rains hard. The pool of water grows, and I shrink. Steps. Coming toward me. Someone wants to eat my belly. Please, not my child! I want to implore him but my mouth can't move like a mouth, can't utter a sound. The water is rising . . ."

Out of breath, Marie-Madeleine asks: "It's just a dream, isn't it, only a dream?"

She clutches the sleeve of the learned man's frock coat, her head bobbing up and down until her body falls back, slack. Still at her bedside, Doctor Roche observes. Dry. Hypothesis (probably nerves). Counts and recounts, ten months of pregnancy and still nothing.

Suddenly in a hurry to be out of this house, the good doctor buttons his coat. Stumbles down the stairs, running into the maid on his way down. Excuses himself. It's dark in this house. I'll be back tomorrow, he pronounces, crossing the threshold out to the street under the mocking eye of the sculpted *mascarons* over the door. From behind half-open curtains, I watch him stride quickly toward the church. The bells ring, a coach passes on the street. A horse breaks loose and, as it races away, slams into the man.

<div align="center">*</div>

When she had finished bathing Amandine, Isabelle de Bougainville headed for the kitchens. Seven times already she had gone there this morning, and after each of these inspections, hurried back to her bedroom to open her large rose-colored notebook.

Begun on the day of her arrival in the colonies, this journal now held nearly one thousand eight hundred written pages. A document she intended to publish, far more mannered, she argued, than all those dreary works produced by random travelers with little concern for authenticity or style.

Catholic on principle and convinced that all humans beings were descended from a single, original couple, Madame de Bougainville had not been able to reconcile the notion, widespread among the Residents, that Negroes were not people. Thus, she accorded especial place in her writings to a study of their customs and ways, a study it pleased her to call Negro psychology.

Upon return from her eighth trip to the kitchen, however, she had no heart for the work. She'd just been assailed by a dark premonition. Without knowing why, she sensed that this night would never see dawn, would no longer sing, as it had in the past, the glory of some and misfortune of others. The end of a world? This prospect, more than death itself, frightened her (Isabelle de

Bougainville was not a woman to insult God). Could it be that their efforts had all been for naught? That the world they had so carefully built here would disappear without a trace, with no one to tell the story? After crying, and as if wanting to hold onto what would soon no longer be, she parted the blinds and drank in the scene that lay before her. She smiled: the dovecote really was . . . fantastic.

Fidèle pulled the pigs out of the oven when the first guests came through the gate and walked up the path, bordered with orange trees, to the big-house of the Bougainvilles. Rain threatened, so the little group retreated to the salon, each with a glass of Bordeaux, since there was no ice for orangeade.

"That's all people ever talk about anymore: colored people, colored people! Now they're demanding rights! God forbid they end up gaining equality under the law!

"Still, they're better than the Negroes."

"It's all the same race. What's part of that species cannot be dissolved."

"But they do have white blood in them."

"The wines of Provence don't agree with me."

"Instead of putting up a fierce resistance, perhaps we should think more about making them feel a bond with us."

"I must admit, I find it difficult to share your passion."

"If you had a better grasp of the art of politics, you'd understand the interest of such a method."

"By authorizing commerce with Negroes and, dare I say, Negresses, we have gotten ourselves into a real fix, and we have only ourselves to blame!"

"They will probably arrive in the next ship. I suppose the prices will be just as extravagant."

"Have we been backed so far into a corner that we will just let it happen? Really, Monsieur, if we fail to intervene, those mixed-bloods will soon bring us to heel! Look at Théofraste, for example, he now owns as many slaves as any among us."

Isabelle de Bougainville rose. "The meat must be ready."

It is ready. The two wild pigs bathe in their sauce. At the table, the conversation continues, dwindles, goes in circles until a woman with red hair complains of violent stomach pains.

"They claimed the meat was not fresh. Brown pig is always tricky. I know very well that something else was going on. They poisoned Marguerite, just as they will kill us all. I would confide all this to Robert, but he wouldn't believe me. Robert never believes me." (A Poitou woman in the colonies, *Isabelle de Bougainville, p. 1812*)

In the same book is written a little further on:

"The cart driver Bienvenue has escaped. Our bursar almost brought him down, but the slave managed to escape. Before taking off, he poisoned our hens, dear Mélodie, and the rest of the livestock. Two of our best curassow pheasants were found dead, massacred, in the dovecote. We will never find any others like them and I must confess that this discovery has deeply affected me.

"In the fugitive's shack were seized a number of gris-gris. These amulets are used by certain Negroes to bring good luck and to traffic with the devil. By what furtive means were these sordid trinkets able to come across the waters? I don't know but presume that these Blacks have more than one trick in their sack. Also found under the straw mattress was a wooden 'doll.' With several needles stuck in its body. Leaves for hair. On its back had been carved the letter M, for Marguerite.

"As punishment and as a warning to others, five Negro women were put in the nabot, three are now in jail. We also hanged six of the brute's accomplices. Soon we will lack the hands needed to run the sugar factory."

<div align="center">*</div>

Night has taken over, and the island its mysteries. Lying on a rush mat, Bienvenue presses wild guava leaves to his fresh wounds. The bleeding soon slows. After rubbing his body with soot, he places a string of amulets around his neck and takes the path up into the mountains. Up there, his tribe is waiting, twenty men at the most, keen to see their chief, the great Makandal.

Curled up in the branches of an old mapou tree, I watch them greet his return with joy. Form a circle around him. Hail to you, oh Makandal, son of the loas and the gods of Guinea.

On a seat carved into the trunk of a sampa tree, the hero takes his place, soon joined by his most faithful snakes. One of them

rears up, has sensed my presence, splits the ground, slithers over to me, coils himself around my body, and victorious, deposits it at the feet of his master. A clamor among those in attendance, then the man motions for silence. Asks.

"What estate?"

"I come neither from fields of cane, nor places where tobacco is grown. I come from farther away, well beyond the line. Guinea is the name, Guinea the source, the mama-country, to which our spirits will return. Those who are here are from there, but most have forgotten. The sea washes away memory. The sea drinks the earth.

"Who sent you?"

"Hogbonu, the great papa priest. He saw you in his dreams, he knows you have the gift. I am here to transmit his science to you. Will teach you how to deceive the human heart, move like water, run faster than wind."

"What do you want in return?"

"The same as you. Our freedom."

DAWN IS coming. We have to act fast, erase all traces of our presence here. Already, their rifles echo. Dogs bark in the distance. Take the route to the south, go back up the river, cut across the plains. Plunge into the ravine, sleep.

The next day, climb. Up to the peak named Mount Noir by those who are from here. It is steep, full of gorges and canyons. The chasms form a border, cut the island in two. On the other side, in Spanish lands, we will hide.

*

The room has drifted away from the corridor. I'm floating in a space unbound by geometry. Near the bed where my belly rises immodestly, a woman in white. Your fever is rising, she says in a low voice, more to herself than to the old woman, slightly deaf and worn out by the journey. She traveled to Nantes to visit her daughter. The shape in the bed moves, the mother rouses, stammers, "It's because it's her first. Of course, she's not used to it."

Then she gets to her feet, the mother, admires the grand armoire, the play of light on the mirror, the exquisite inlay. Thinks city folks'

life is quite fine. That the countryside makes people poor, ugly, dumb. So stylish, this brush handle. Looks like mother-of-pearl or ivory. Ivory . . . The old woman sighs, dozes off again. I'll have to ask the captain to bring me back one of those.

By the way, any news from him?

<div align="center">*</div>

"Rough sea."

<div align="center">*</div>

"Push, Marie, push!"

Both hands gripping the bars on the bed, Marie, now naked, obeys.

Daylight has fled, the room lies in twilight. Damp, as before a tropical storm. In the grip of sharp contractions, her belly implodes, releases the first waters.

"There, now it's coming." says the nurse, "Deep breaths."

Her mouth falls agape, ventures a sound. Pants. "Deep breaths, I said." Marie nods, prays she'll never hear this voice again.

"One more time, you're almost there." Marie no longer hears. "Focus, my child!" Her belly trembles. Swells. "Good lord!" The nurse stumbles back in horror.

From the gaping pregnant woman, water surges. A sea of blue night. Black. Full of Negroes.

<div align="center">*</div>

High winds. Great swells on the seas. Weather so misty, it's hard to make out objects a quarter-league off. On board, dread is gaining the upper hand. Shadows stand watch, peering at the horizon, not yet daring to interpret the signs. Alone, in the map room, the captain is holding his breath. Suddenly, bursts out of the cabin, strides along the bridge, slaps the first fat drops of rain that hit his neck. "Close the scuppers, tie the anchors fast. The barrels, too . . . Snap to it!" he orders, as, dizzy from the swells, the ship pitches, sweeps back before the first waves. The ocean is steaming. A gale. Waters in chaos and sails in bedlam.

"Masson!"

The topman rushes to execute the order. Grabs hold of the helm. Navigates a passage between the breakers.

"Brail up the sails!"

Then comes a monstrous wave crashing over the bow and kicking the rear of the ship. Cables that brace the mizzenmast snap. That mast dances. The brigantine swoops away. Thrust forward by its topsails, the ship swerves, bows as if greeting the master of the seas.

Rain starts pouring down. Pelts down from on high, and in its mad rush, in a mayhem impossible to contain, beats down on the men indifferently and rocks the vessel, which hiccups each time it is hit by a breaker. After each thrashing by waves, it belches, dips. The back bridge is submerged. "Oh, god! We're done for! We're going down!" a sailor bellows, clinging to the guardrail, his body frozen. Floats ghostlike for a time, before sinking. Steps ring out. Shadows cross themselves. Call the chaplain!

Into the wretched foam: a rope. A pitiful gesture, a challenge hurled at the furious elements. While the winds slice the flames in the lanterns, the tempest howls. Howls the storm. Rings out a righteous reminder.

Revenge!

Hunched down behind the forecastle, most of the sailors have lost their calm. Moan, curse. Promise plaques of thanksgiving for the church. Listen, sapped of strength, to the *Te Deum*.

> *The tides of Death circled round me,*
> *The torrents of Belial terrified;*
> *The nets of the Hell wrapped around me,*
> *The traps of Death awaited;*
> *In my terror, I called on Yaweh.*

The wooden ship shrieks. The sea is breaking the hull. Cracks scatter in all directions, haul from their torpor the last sailors still on deck.

"Portside!" A voice in the night. "Portside!" A shadow gesticulates, waves an arm mechanically toward . . . Where? Straight ahead! A dark, monstrous mass, suddenly appears in a flash of lightning.

"My God, never, in the name of God, have I seen such a thing!"

By Vodun, by the grace of the spirit from on high, I implore our gods.

Gods of the iron, the seas, the thunder!

Crouched down, all alone at the helm, the captain scratches his head. "Where the hell did that reef come from?" And all those tangled scraps of wood, standing like . . . "Crosses, by god, they look like crosses!"

In the bottomless dark of the hold, hope is reborn. Revenge, insists the mouths, sure that after the deluge, they will once again see the coasts. Africa.

Iron gods, thunder, and the seas have laid siege to the cargo hold, disemboweled the barrels and burst open the sacks. Water spurts, beans fly through the air, thousands of grains of rice float on the water, giving the vessel the sorry look of a wedding night in Nantes, after the feast.

Bacchanalia! The gods are exultant, grow drunk on wine and rum before disappearing.

Gods of the iron, the seas, the thunder,
Gods of the iron, the seas, the thunder!

They're back! In front of the poop deck, just behind the main mast. There they are, yes, blowing on the infamous rail, shaking the wall topped with steel blades, where Negro flesh is impaled.

The crew is trembling. The chaplain brandishes his cross, prattles on about threats, shouts like the godless before plunging back into his Bible.

To my God, I uttered my cry.

But the captain has no time to give orders at the helm. Surging up from the sea, in the rushing winds, a wave high as twenty shreds the sails, sets the solid mast trembling under the weight of the heavy foam. In the besieged hold, sailors pump. Pump, pump! Let's pump, sings a one-eyed sailor scarcely twelve years old, whose blue eye, wide-open in the night, flits from one body to the next at work.

Gods of the iron, the seas, the thunder,
Gods of the iron, the seas, the thunder!

Clew lines and foremast defeated, the ship reels. Pants.

<div style="text-align:center">

Gods of the iron, the seas, the thunder,
Gods of the iron, the seas, the thunder!

</div>

Pants like a bull being skinned alive and who, drawing on its last ounce of strength, prepares to die.

It bucks, almost goes down, when suddenly,

> *He extends a hand from on high and takes mine,*
> *He pulls me from the great waters,*
> *He delivers me from a powerful enemy,*
> *From enemies stronger than I.*

What is happening?

The winds are stilled, the storm has come to an end.

Pray, though I pray, Vodun will not hear. The science has left me. Naked, abandoned by the gods, I return to my place in the hold. It is still warm, ready.

It was waiting for me.

<div style="text-align:center">*</div>

She bustled along, Isabelle de Bougainville, in a long cotton dress that revealed a hint of her ankle boots and lace petticoat. Gripping her parasol, she pushed herself to catch up with her husband, losing sight of him at each bend in the road. Having learned a few days earlier of the slave ship's arrival and the opening of a special sale that Monday at Saint-Marc, the couple had risen for early-morning prayers. All week, had gone over the accounts, pulled together the coin and supplies needed to purchase slaves. In the wagon that was now transporting them to the west side of the island, they delighted like children in their upcoming acquisitions. Their sugarcane plant needed new blood, the blood of Bossales, fresh from Africa, said to be less nervous and more docile than Negroes here.

A turn in the road, Robert's shadow on a wall, then the port of Saint-Marc came into view, teeming with merchants in broad-brimmed hats, out where the crowd waited impatiently, eyes locked on the slave ship *Le Soleil*.

After two weeks at sea, *Le Soleil,* somewhere between a brig and a schooner, seemed more dead than alive, a phantom vessel emerg-

ing from hell, deep in a slumber that the waves, strangely silent, dared not disturb.

On the docks, from where rowboats were launched to carry the buyers (the sale would take place on board the ship), conversation was lively. What terrifying ordeal had this old tub been through? Had it been the prey of dreadful pirates? Or had the sea toyed with it, hurling squalls, cyclones, sharks, and, why not, whales, at its hull? God only knew what the ocean contained!

Or, since there were Negroes on board, it wasn't unlikely that they'd fomented some kind of rebellion. There were those who remembered the case, some thirty years earlier, of *L'Afriquain,* the slave ship that had dropped anchor in the natural harbor of the Cape. Wretched boat whose captain and some of his men had died, victims of a bloody slave revolt.

When it came her turn to climb into the rowboat, Madame de Bougainville hastily hitched up her skirt and ensconced herself on one of the benches at the back. It seemed to her the beginning of a great adventure. Life, in sum.

She squeezed her husband's hand tight when the rowboat had completed its trip, and with a leap she imagined to be graceful, bounded aboard *Le Soleil.*

The odor made her retch. In accordance with the rules of hygiene requiring that all slave ships docking at the island be disinfected immediately, the entire vessel had been scrubbed down with vinegar, which made everyone on the boat press a handkerchief to their nose. Fanning herself to no end, Isabelle clutched Robert's arm and, probably thinking of his noble work, did her best to take in the spectacle.

One hundred, two hundred slaves had been herded onto the quarterdeck, paralyzed with fear, forced to show teeth, eyes, armpits, anus.

On a platform in plain view of the assemblage, a few dozen Negroes had been corralled. Specimens from India, surely the best, whom disease and madness seemed to have spared. At one thousand eight hundred pounds per head, that had better be the case. "Inspect them carefully three times," Isabelle murmured. A small problem overlooked could leave a slave costing a hundred times its worth. Monsieur de Bougainville summoned the surgeon and or-

dered him to examine the merchandise with the greatest care. He had just picked out two strapping fellows and a Negress.

"And where does the female come from?" asked Isabelle, who considered Mandingos the most refined and the gentlest Negroes of all. She seemed annoyed to learn that I was from Ouidah but took no offense. Time was short. The sky was growing dark, better not to be out at sea.

THE SQUALL was full-blown by the time the dinghy tied up at the dock. Hugging her parasol close to her body, Madame scurried away from the port. Gasping for breath, as if escaping great peril, waving frantically to the carriage waiting in the distance. Caught in a deep slumber, the carriage sprang to life. The horses whinnied, made all kinds of racket until the whip lashed their flanks.

"We'll make a stop at Widow Le Tort's house," shouted the master to the Negro driver when we were all on board. I raised my head. Makandal was smiling. Setting his horses in motion. Flying like the wind, rushing faster than the river.

*

They died that night. The master, the wife, the son, the daughter. Died like Negroes, the ones who hang at the end of a rope. Pounded like grains of millet. We beat them. One hundred, three hundred, five hundred blows. Dumped their bodies in the ravine, there where the snake gods bite.

The White man died this evening, but I was still there. I, the initiated, the mambo, the-one-who-flies, la volante, la soukougnante.

I, Cécile. I continued walking.

First mate back on land, you'll have a good sleep
Topman off the deck, you will eat your fill
Stay there in a place where you'll never know thirst
Bed down in the place where it's nice and warm

Once the old tub has been stripped of her load
I swear I'll remain a good man to my brood
I'll work hard for my pay like an honest man
Adieu to the sea and the rollers within

Men of the land who study the sea
My counsel to you is to study the girls
You're better off married, regrets won't be yours
And to hell with the sea, let the devil take it

the mother

I died on the seventh day, as we were penetrating deep into the forest of gold. That's what we called it in the village, for the trees that were topped with bright yellow tufts that shook in the wind like little bells.

My child on my back, I'd been walking a long time, sparing no effort, taking careful note so that later on, each step could be retaken in the other direction. We would go back, I was sure of it and with that faith, studied the sky, where flocks of black-eared kites had hovered since our departure. We were thirty, maybe fifty. Torn from the night, exposed to the hottest part of the day, the sun searing our wounds. We moved forward as one under close watch, a strange convoy taking us far from our home.

You want to know the name of the village. Don't you see that I am from everywhere? I come from the coast, the great lakes, the forest, from the fearsome isles where the gods are mosquitoes. I was born in Dyolof, in Angola, in Louango. I'm from everywhere. Wander everywhere. Ségou, Khasso, Ouidah, Bambarena, there where the Negroes are sold, where merchants bargain.

<p style="text-align:center">*</p>

It's a long journey, one lasting days. Idiotic savannas. Pebbles that come after the sands. I'm hungry. I cry a lot. I spit every day. I have lodged in my throat a lump that wants to/won't come out. And I'm scared, god, I'm so scared to go down this river.

Under a white sky more blinding than night, our dugout canoe glides. Transporting its cargo to the point where the waters widen suddenly—the sea!—finally free to flow aimlessly. A vessel has just split the mist, with insolent hull, and fat, proud sails. Flown high,

the ensign is impassive as a mask, as the ship bears down on us. A few meters off, it halts. Now unmoving. The canoe draws closer. On this great boat, little red sailors bustle about. They look like the long-haired djinns who haunt women's flesh at night. The Red men drop the ladder. We have to climb up. It's my turn to grab the rope. I'm gripping it hard when a violent wave knocks me off balance. I plunge into the water, and scream as my loincloth unwinds and my son disappears beneath the waves. My child, called to the all-powerful Baé! Brutally returned to the country of ancestors.

Hush baby, sleep. You were sleeping. I swear you felt nothing, you never awoke as your body drifted down. No suffering to your soul, it's gone up to *Blolo,* where live the shadows. That's where they go, go, go, the well-guarded souls.

You want to know how. How the holds, the darkness, the at-sea. How, how, how? Mama promises to try her best, but I'm not good with words. I no longer trust them, since they have been unable to say anything.

The ship is immense, with as many men aboard as in our village. Each morning our paths cross when, torn from the holds and driven in groups to the deck, we are ordered to dance, to submit our stiff bodies to exercise. They want us in good shape. A sick Negro is without worth. So I jump, yes, I. Twirl, scamper, run around until out of breath. Then comes the daily wash, squatting at water-filled tubs. Each morning, stand, mouth agape. Watch out for the stinking vinegar that disinfects! When fingernails are too long, they're cut. When skin bleeds too much, it's rubbed with salt. Every morning: deck, wash, vinegar. Every morning.

Why do you note all, consign each detail to your book of accounts? The doings of the sky, the treatments applied to us? Camphor for smallpox. Bleedings for yellow fever. Fresh fruits for scurvy. White alcohol for black melancholy. Are you with me, or shall I start again?

Confronted with the incomprehensible, we summon the imaginary. To madness, we respond with folly. To counter history, we invent rumors like the one about the Red Negro-eaters. Their big cauldrons set up on the deck consuming our corpses. These bodies, ours, that they fattened up before chopping them to pieces and leaving them to simmer. Penned up at the back, we sniff our food

dishes. Even refuse, one day, to touch our ration. The Red men bellow at us. Let them yell! I clench my teeth shut. I will not eat my brothers. Gruel is distributed and I'm forced to obey. They've stuck a strange tool in my throat.

*

On the twenty-first day. I see.

The coast, everywhere the coast, yawning monotony lined with trees. Nothing else. From time to time, startle: the threat of a shark gliding past, the flight, far off, of an antelope, minute disturbances immediately forgotten. In this world of seas, sand, and silence, anguish grabs you by the throat. A human being counts for little, rolling inexorably toward the darkness in the distance, before the world which, like the ocean, never founders, remains, wherever the feet wander, wherever the voyage leads.

From among the trees emerge huts, this morning. But hint at no life. Crude huts showing no sign of life. No shadow of a mother on her way to the well, no old woman at her pestle, not a rooster announcing the morning star. The worrying awakening of worlds, always beginning again.

No rest on board. Sailors come and go, all in a sweat, all fixed on the sea. Firewood to collect, grain to cook, Mass, baths, chain on the anchor like a snake uncoils, crashes through the hawsepipe. Muffled sounds in the hold. The anchor has just hit bottom.

Casting off and braving the sandbar, two rowboats head in our direction, jostled by swells that keep shoving them off course. Still there, though it doesn't seem possible. Heaved on board with their merchandise (three women, two Black children, and an old Negro man), the oarsmen bargain with the big chief of the Red men. Leave empty-handed, despite all efforts; their lot of slaves is worthless, spoiled by scurvy and yaws.

The catch is better a few leagues on: three men. Then two, six, ten more. All sizes, all languages, all colors. All Black. To brand. Pen up. Trade, sometimes along the coast. That's what happens to me. My Red men sell me again. To other Red men. In a few months, I'll sail with them. Once more in the hold, but no matter. Before long, I will be with my son. I have made him that promise.

*

On the seventh day following my arrival on the coast, I had to consult Thospital, a so-called doctor.

It was because of my breasts, so full of you that a crust had formed on my nipples. An infection that drew flies and left me screaming every night in agony. Truthfully, not that bad. I even felt a certain pride to my have body speak that way. In spite of my chains, in spite of your absence, I was a mother.

Would remain so, as long as the milk flowed.

In the hut where he practiced, Thospital applied warm compresses to my breasts, insisting this would do me good. With time, the swollen flesh would go down. My body would be as before, healthy, clean. To prove his goodwill, he suddenly turned tender with me. Waited until we were alone to do his thing. But couldn't go all the way. Too much liquid under the crust. Pus. What kind of man would be crazy enough to like that?

You speak but what can you say, you who've never been in my place? You say, "If I'd known, if I'd known . . ." But what do you know? Who could know? It's in the head of no one. No one can imagine it.

The skin grew hard. The milk dried up but I couldn't sleep. My body caused me horror. My empty breasts caused me disgust. The one thing I'd been able to give you had left me.

*

Now, abandoned to misfortune I am here, alone. Useless. Cut off from the greater whole. In the storehouse where they keep us penned up, I latch onto whatever I can see, a slice of the sea, its blue so joyous that I am angry. In a wave of madness, I claw at the wood until my hand pisses blood. Blue + red = purple.

Today, I took up words with another woman. We talk the same, know the same ways. The djinns that inhabit the earth, the roots that clean, the things that we break, the *canaris* that we empty to bring good luck. In the night, facing the sea, I press close to her. Her old woman arms wrapped around me form a wall against the hate. The disgust of self.

In the village of truth, my people are talking about me. Rejecting me. Saying I'm the one who sinned. In the village of earth, spilling blood is a sin. If you make blood flow, all the earth will cry. In the village, all the people are threads of a single loincloth. "Put clay in your belly," the old woman whispers, "if you want to live in peace again." I look at her. I look at her, as tears of shame spring to my eyes. Why couldn't I protect you? In the night, in my mind, the worst is the barking dogs. Driving me to madness. Bark! Bark! Bark! According to the young woman who knows the leaf, I need only wash my body with sea water to hear them no more. Wash twice. Scrub hard to get it all off. Salt kills. Life will not grow in salt.

That's why I jumped. For that reason and because I wanted to stop the tears. And no more fear. No more darkness. No more hearing your screams, that day, every day, when you fall into the water.

The hours pass. The sea approaches. Tomorrow will come death. DEATH. Red man's word, unknown in the village, but here, it's the only one I've found. The only one that seems to fit this place.

In the solitary night, only the stars still speak, carrying on their back all we had to leave behind. When I gaze up at the sky, I see my hut again. The yams cooking on the fire. My man trudging home from the fields, full of millet beer and earth. The *canari* bubbling. You laugh. My hand tickles your belly. You gurgle until that last day dawns.

Outside, on the beach, the canoes are ready. The sea is calm. The ship awaits. Climbing aboard is child's play.

*

It is March 23, 1774.

I have kept my promise. Early this morning, I did as was written. I threw myself from the deck. Despite all possible diligence, with the sea extremely choppy and the wind blowing a gale, sharks had already eaten me before any could be hauled back on board.

You want details? You haven't heard enough? As you wish.

Let's say the weather was nice. Weather typical for the dry season, when the sea, made fruitful by the sky, spreads out on the horizon an icy blue paste. Or, no. It's raining. Look! Rain

is falling. Dripping into the hold. The deck is slick. The black
sky bursting with kites.

Now, the women. I know not a single one. Perhaps they're
sisters. Sometimes entire families take their lives together.

Why are you trembling? The show isn't over. Open your
eyes and forgive me. Forgive your mother who, even dead,
continues to feed the slave ships.

A woman sings. That's the signal. Without shouting a warning,
we plunge into the sea.

It happened so fast. Don't count on me for description.
All I remember clearly is the color of the water.

Blue + red = purple. Blue + red = purple.

*

Now that it's over, all that remains is to join you again, up there
in *Blolo,* the land that comes after life. But I must have gone to the
wrong place, it's too dark here. It stinks, the ground damp.

What's going on? Can someone explain?

In this night where I feel my way forward, my breath is an echo.

How strange to hear my mouth speak after being shut up for
so long. Hunger torments me, walking exhausts me. Yet, I must
stretch my legs. *Run, jump! Kick your knees, higher!* The doctor's
voice rings out. No salt to shut him up. In the distance, something
is moving. Bodies move. Jaws open. *Help!* Men in the throes of
death. I approach, and terror strikes as I realize where I am. In the
belly of a shark, where so many bodies are rotting.

Are those your future idols, these Negroes cut to shreds?
For how many more centuries will we have to bow before
them?

You say: They've built museums. Written plays for read-
ing, thinking, praying. Monuments that Red people flock to,
come to grow the list of those who weren't there. Seriously.
You talk. Tell stories of laws, damage and interest, of for-
giveness, the great forgiveness, reconciliation. What is the
suffering worth? Who can say? What is the hell afterwards
worth?

A man's hand brushes my calf. His body is still warm. His voice weak.

"I'm in pain," he says, showing me the wound that has ripped open his belly. "The sharks are everywhere, they're circling us!"

His breath slows. The man is going to die, I ride his body with fury.

WHEN I'D finished, I took my dead man onto my back and walked.
Lying next to his corpse, I have all the time I need to bring you back into the world. You will be born, you can be sure of it. In the belly of the beast, I, mother, will sing.

Red + blue =, red + blue =

Perched high o'er the fo'c'sle that dances out front
I turn my eyes aft to gaze out at the sea
To the place where others will wear out their skin
My god! What a miserable life!

O'er the quarter deck, I stand at my perch
My squinting eyes fixed where sea meets the sky
The spring has arrived, so we unfurl the sails
Long live the ladies of Basse-Goulaine!
Long live the ladies of Basse-Goulaine!

Months away are eleven, it's quite a long time
A year on the water leaves marks on a man,
There's no greater wish than your wife in your arms
When you see land draw near after such a long year.

the heiress

The sea spread out below. With no beginning or end, let itself be taken, be split by carefree bodies that seemed to have forgotten how greedy it had been in days gone by. On the beach, men dozed and children played, building sandcastles, towers, drawbridges. Illusory defenses, yet less yielding than those the Black African kings had believed they possessed.

In the torrid midday sun, only the trees remembered. Branches dipping like lips recounting the great odyssey of the Black people. Everywhere, the same movement, the same impulse, the ocean. Ocean to swallow, to take on against one's will, to cross naked, dead, or mad. As if warding off more misfortune, the coconut trees bow their heads. Two centuries have passed already.

On the other side of the ocean, in red ink on the back of a postcard, Carlos was telling about his vacation. His trip had gone smoothly. Of course, the weather was hot, but the hotel was well located, right on the ocean, and though the water was dirty, he hadn't fallen ill, knock on wood. He missed Caroline. A lot. He hoped she would join him soon, despite doctor's orders and their argument a few days earlier . . .

The flight attendant's metallic voice interrupted my reading. I slipped the postcard into my book and followed her instructions. The next day, I made my way along the shore and walked into the lobby of the Hotel Sublime.

THE ROOM they gave me was scarcely wider than a hallway, wallpapered with a certain care, but manifestly without taste. "It's the largest room available," said the hotel clerk with apology, promising to take care of things, move me to another room as soon as the Germans checked out. I thanked him, locked the door, and tested

the mattress. I like a soft bed. So well worn, it could draw its last breath in my arms.

The cool water in the basin refreshed my body, pulled me out of the torpor brought on by the long, sedentary hours of the journey.

Seated on the toilet, I realized I should shave. I've always had a strong odor under my arms.

In the dining room with an ocean view, the Germans had already arrived. With the aplomb of explorers, they studied a map, calculated distances, established a schedule, visibly confident of what to expect tomorrow. Their discussion was interrupted when the restaurant chef made his entrance in the dining room to announce the evening with solemnity. "Today, Sunday, the culinary team of the Hotel Sublime has the honor of proposing shark with devil sauce. Our coast is full of small white sharks," he added, running a hand through his hair with its frizzy quiff that seemed to be paying tribute to Elvis.

"In the past, this coast overflowed with slaves!" I suddenly wanted to shout. I controlled myself. Elvis was dancing the twist. The Germans were snickering. Couldn't care less about history.

Alone with my bowl of shark fin soup, I kept my head down and focused on eating. I hardly even glanced at the platform where *for the first time ever at the Hotel Sublime!* the blond twin of Nina Simone was performing.

"*My baby just cares for, My baby just cares for, My baby just . . .*" droned the starlet. I pushed myself back from the table and stalked out to the beach.

Just like in the picture on the postcard from Carlos, the sea was calm, casually lying in wait for its moment, when some person would be crazy enough to dive in. Tired of teasing the crabs, the waves contemplated the stars. Dreamed bitterly of the unattainable crystals above.

Surprised by the moonlight, I looked down and studied the fading footprints in the sand. Where did they lead? Back to the days of hunters and Black-captive-eating sharks, two centuries ago? I was tempted to follow them but suddenly anguish washed over me. Had I done the right thing, coming here? Would this beach tell me any more than the blank page?

I DIDN'T SLEEP that night. Too many dreams in my head. Got up well before dawn and listened to the rain drip steadily on my bed. Cockroaches skittered across the floor. I killed one, a female, and made sure to crush her eggs. I could almost imagine the scene on the beach, all water and shadows. Slight women bidding silent farewells to the land, mourning, dry-eyed, their dead selves. Before the breakers swallowed them, one of the women, maybe two, must have looked back toward the hotel in a silent cry for help. Prayed for someone in their room to hear, someone who would crash down the stairs, sprint across the terrace, and issue orders to the sea. Make it give back all those people it had just taken!

Because no one was intervening, I opened the window and bellowed out to them with all my strength.

"*What is happen, what is happen?*" The Hotel Sublime security guard burst into my room in a panic, probably fearing a terrorist situation. "*What is happen?*" he sputtered, pointing a revolver at me.

His face softened when I told him where I was from. He knew Kassav, had been to their concert at Lagos in 1994. We were both singing by the time he left. A few hours later, I woke up in the rain.

That's when I asked to see the hotel manager and unceremoniously demanded a room change right away. To hell with the Helmuts. They had no special rights here, Nigeria had never been a German colony. In the name of the Rights of Man, the manager implored me to lower my voice and wait quietly in the sitting room, someone would come for me.

An hour had passed when a redheaded woman bustled into the room and called out to the customer staying in room 17.

"*Mister Carlos? A call for you!*"

I turned to look at the man who was walking briskly toward the reception desk. So he was the one who had sent the postcard. Neither handsome nor ugly. Some charm. Big feet and a lover's blue eyes. As Carlos picked up the phone, Caroline's smile came back to me. She and I lived in the same building on Rue Saint-Maur in Paris, she lived in the apartment above mine. I had been up there only once. One afternoon when I couldn't settle down to write, she'd invited me up for tea. Vanilla-chocolate, she said

she loved that, and "Dead Can Dance," the album with the green cover. When she leaned over to put on a record, I noticed her large, white breasts with blonde peach fuzz. Because I really had nothing to say to her, I just let her talk. The classic story of a girl and an impossible love, a guy who was tender, but one she no longer loved. His first name ended in *-os*. That's all I remembered.

A few days after that, I found an envelope slid under my door. Probably a mistake by the postman. A postcard with the ocean pictured on the front, and on the back, a signature in red ink: *Carlos*. At the bottom, the caption in italics identified the photo as a view of Badagry Bay.

So, Carlos had had to fall in love with my upstairs neighbor, and the postman had had to mix up which floor she lived on, for Badagry to come back to haunt me. For the story to pick up again where it had left off.

THREE DAYS before leaving Paris for Cotonou (from there, I would make my way out to the coast, then head east toward the Nigerian city), I called Dan to set up a get-together in a pub on the Left Bank. Two years since we'd seen each other: Daniel was a busy man. The kind doing three things at once, both there and not there.

This time, he was there. His broad shoulders ensconced in leather, his paws—hands for making love—resting open on a book that looked like it had traveled the world. What was it? Something strong. To be downed in one draught. Something radical, like Barbancourt rum from the Duvalier years. The seat crackled when I sat down, making me laugh. Reminded me of my childhood. My teacher. She made us sit on a bench, an iron base covered with leather. The same leather.

Not knowing what to say, I just rambled. Small talk, a waste of breath. Sentences with no meaning. Words with no value. All the little things the memory collects over time, then releases to avoid silences. His eyes didn't move, kept staring at the pages. In his book was a woman. The kind who has no need to speak to make herself heard.

"Let's suppose that the problem is solved." That's how Dany started in, adding that a writer must know how to avoid history-

with-a-capital-H. Just keep the bare bones, scuttle the content, forget the historical. That was the trick, the only way to escape Negro literature. I said *ah*, then *yeah*, then *no*. No for the duty to remember, for memories of the slave trade, for fourteen random women fished out of history, whose voices I was hell-bent on restoring. When I'd finished, I felt a weight on my heart. A corpse beginning to stink, one I'd have to shove aside to avoid spoiling the evening. I don't remember how it ended. Late that night, the leather seat was empty. Only the book remained. By Derek Walcott. A story of boats, girls, and a saint.

"LET'S SUPPOSE that the problem is solved." I couldn't follow his advice. Lacked the strength. Too many relics floating around in my head. My grandmother used to say that. She wore two white braids in the last years of her life.

<p style="text-align:center">*</p>

Night is fading when I leave the city and take the road to Ouidah. Wedged between a rickety door and a reckless driver, I drink in the trees, the sky, a rooster, my head bobbing to the rhythms of this coupé-décalé, whose meaning will remain a mystery. Onto this stretch of land that seems to cradle the ocean, I toss my dreams like a Hop-o'-My-Thumb. Looking for Blanche, 1.65 meters tall, red skin, high breasts, no apparent infectious diseases. It seems she would have lived around here back then. Would have been seen in the company of others. There, on the auction block, also here in the *zomaï*, where light never ventures.

The old woman, who is listening, smiles. Sings a song, the story of a young girl who went to the well and never came back.

"When the White men arrived, they brought with them things they traded with people. For four things, they would take two men, for six things, they'd take three. A little here, a little there. They traded people like at the market, when you give fish and take *gari*, when you give corn to take pimentos. My own grandmother was bought this way. She was from Nigeria. She walked several days before reaching Ouidah. You go out of the village to draw water

at the well, and they grab you. They strip you of your joy, your strength. Sometimes they beat you, and if you are lucky, maybe you don't die. You can't say yes, you can't say no. Sometimes, if you've come with your child in tow, they take you both. You have no power. That's the way it used to be, but people don't understand today. Go see the slave trail, maybe there . . ."

Dawn breaks over the trail. Seven. Seven circles I walk around the Tree of Forgetfulness. To no avail. No one. Just the sky. Pale and threatening to split open at any moment. Seven times. Nothing. Except the belly laugh of the *zémidjans,* the motorcycle taxis. The city's breath.

Where are you? The question hangs in the air. What must I do to set the memory in motion? One evening, they were gone. The memory sleeps at night. One night, they trampled this ground, trembled upon meeting trees that towered over them, erect as soldiers. Not a star in the sky, just the full moon, surprised to see them.

A fisherman appears, hurries toward land. His eyes, faded by the salty seawater stare unblinking at the dawn. Laugh.

Maybe I should do the same, turn my back on misfortune?

Shed this story as you'd slip off a dress, because it no longer swirls, because it stopped fluttering long, long ago? Maybe Daniel is . . . Forget it, I'll walk.

The trail is not that long, actually. Not even bad, not even hot, not even warm. Not even bad, not even hot, not even warm. Not, bad, hot, warm. Especially not bad, at first. Then the sun rises, is risen, full. At noon, it will be white. All this is connected. There's no such thing as chance, right?

Where is the sea, anyway? What's it doing? I can hardly hear it. Yet it's there, I learned that from my schoolbooks. If they were telling the truth, the sea should be down there, at the end. At the end with a big ship that will probably take us far away. I don't want to go (I'm crying)! Don't want to go (sobbing)! Even if my feet keep stepping forth and my body says yes.

A whip would snap. It snaps. Just like in the books, since we are amnesiac. In the sunlight pissing blood, I start running. Cross paths with a barefoot woman—*bonjour maman*—going to a place she knows, somewhere familiar. All this greenery around me,

marshes with lily pads unfolding. The day will be long, the day will be beautiful. So much to accomplish and it's not yet eight o'clock. *What was that song again?*

*

All the Dahomean people will tell you: Nigeria is different. Will keep telling you, as you make your way to the border, those people are crazy, will do anything for a few *naira*. According to Sam, my so-so guide, you could go straight there without fear or a visa. Just walk-tired to the border village. And after that? After that, it was all up to God. If he loved you deeply, you'd be sure to cross. If not . . . Sam didn't have time to finish his thought. Straddling a sputtering two-wheeled *zem*, two Yoruba cowboys ride toward us and block our path. "Police!" is all I can make out, then, "passport," "France," "money." A wad of *naira* for beer. The jackals satisfied, we continue our trek, until Natan, our human smuggler, shows up. Because only four-wheeled vehicles are checked at the border, I'm stuffed onto a motorcycle behind a large woman with a gap in her front teeth.

One, two, five, eleven . . . on the road to Badagry, I count border posts. They say there are twenty, most of them illegal.

Ahead of us on the winding road, I see sparks in the darkness. Taillights of idling vehicles glow in the dark like embers. The motorcycle snorts. The city. Built of brick, tiny shops, bits of boarding houses. "Dieu *te le* aime beaucoup," Sam whispers to me, "God loves *you* a lot," and hands back my papers with a hug. I yawn, still one hour to go before we cross the lagoon and reach the shore.

The room. The shark. Nina Simone. The cockroaches . . .

You know the rest.

*

When Carlos hung up the phone, his eyes were no longer the same blue. I never knew what happened. Led by the girl with red hair, I crossed the lobby and moved into a room that a German couple, annoyed by the bad weather, had just vacated. I decided to take my meals in my room and didn't step outside until the next day.

*

A week goes by. I'm lying on my stomach, feet pointing to the north end of the room, pressing into the crumpled pillowcase. Only in the daytime do I sleep this way, head-to-foot, unlike most people for whom sleeping still has meaning and reflects a certain tradition. I'm not sleepy. The woman in the room right under mine talks too loudly, unless it's the impartial heat getting to me, and promising to grow hotter. Since yesterday, the weather has changed. We have entered the rainy season. The sky is sweating. The earth is swollen. And this fan doesn't work!

I still haven't begun my search, am content just to look out at the sea. Especially at night, when the children have left the beach, when nothing but a tower remains of their castle. I have never liked museums or archives, or written records, so I listen to the wind, try to persuade myself that the dead are not dead. Ten days I've been here and not a single line to show. Just images. La Blanche's dress, full of salt. The filthy-hut where the old woman lives out her days. The mute woman's finger exploring her chewed up, almost rotted belly.

<center>*</center>

Week three and still nothing. Except, maybe yesterday. Yesterday, I saw! Near the reef where the crabs dance, I thought I saw a boat. An old tub, the kind not built anymore, without engine or iron hull, sails hanging slack, rocking left then right, made me so dizzy, I had to sit down to avoid falling. In the end, maybe it was nothing exceptional. Every sea in the world has its shipwrecks.

From the hotel personnel, I could wring no explanation. "It must be the Harmattan trade wind," was all Elvis offered. "That wind will make you see things, can drive you to madness." Told me the story of an old widower who, thinking he'd seen his wife out in the water, plunged into the sea late at night. "The next morning, no body to recover. The sharks must have had a nice feast!"

If I didn't have my senses, I'd think that everyone was lying, that they'd seen it as clearly as I had, an old ship drifting along, scraping against the crab-covered rocks. If I weren't reasonable, I'd go back out there, maybe swim out to see it. Like the women, I'd grab hold of the rope ladder and haul myself aboard.

But I'm not crazy. I stay here. Watch for it out the window. It will reappear at some point. In the end, they will come back.

<div align="center">*</div>

Today, Friday, we went into town. The dugout canoe sang on the lagoon. Three Frenchmen and two Portuguese who had come to do humanitarian work. Silent as a carp, I play dead, dream of being German, Inuit, or cat. I make myself deaf, all lips do is move. A bump. The embankment. Here, our paths diverge. My feet take me off that way, to the former slave market, impossible to locate exactly, but must be here somewhere, for god's sake!

I'm sorry I came, sorry I came, sorryIcame. It's damn hot. Damn it.

"Sounds like you're having fun." The faint voice on my telephone is my mother. Maman who jumps in to tell me about the disaster on everyone's lips. "Tsunami." Pout j'vois pas. I don't get it. "Tsurami." Still don't. In other words, "Things are happening, you should think about coming home."

At this point in the conversation, I hang up the phone and borrow from Duras: "We flee because the only adventure is the one that our mothers foresaw." Period.

Not good. This is not looking good.

The market is not the market. This one has never sold men. Nothing but provisions, fish, *gari*, corn. Monday. Wednesday. Saturday. Thank you. Keep moving.

In the waiting room of the royal palace, where, as a last resort, I made an appointment with a minister who knows history, a couple is deep in a heated argument. "Elle *ne le* aime plus," she no longer loves him, I think, as the government official arrives, inviting me to take a seat on a little bench, where I can follow his lecture.

(General) summary: *"Badagry reminds attention history city. It was a place very peacefull. They are many quarters in Badagry. Baracoon is not so far from the lagoon."* My English is too weak to decipher the rest. My mind soon switches off, I offer the gentleman profuse thanks, then go out in search of some pasta and beer. Seated on a *maquis* terrace, wedged behind a greasy table, I can take my time watching for the occupant. God willing, I'll

catch sight of an ancestor, or else the double of a long-lost friend? Enough! I look away. On the little screen, a fake Yoruba magician picks up a ceramic jar. Magic words, miracle, flash. A beautiful woman appears. The credits roll.

*

"They won't come back." It's the-one-who-flies, really the only survivor, who has appeared in my dream. "The others are no longer," she adds, "Have gone to the sky, like stars that will never fall." I roll on the beach like a wave, rush at the sea, want to destroy it. I got here too late, the sea took everything. Two centuries ago, I could have done something.

Sitting on the sand, I study the map again and deconstruct the sites. Ouidah, Ekpe, Badagry. Some geographers spell it with a "G" instead of a "B."

The coast melts away. Seeds. Ivory. Gold. Slaves. Stop. Right now, I am here, at this tiny point on the globe, where nothing is written in black and white because there is no Black or White.

ALL OVER I walk until the wind erases my steps, and the shadow of the ship hold in my dry eyes. A voice in the daylight finally brings me back. "What can I do for you?" Standing in front of what looks like a snack bar, a woman with white skin is looking at me.

I still remember her hair color, yellow enough to burst the whites of your eyes. The blonde repeated her question and I saw that my hands were suddenly trembling, and I was this close to killing her. I can't really explain why—must we always have a motive?—but I felt a powerful urge to plant my knife in her belly. Let her piss blood, let her pay for them all, so she'd never again dare ask me what she could do for me, in her voice sugary as soda pop.

What could she do besides seat me at a table and rattle through the list of daily specials and desserts? Seizing this moment when we were alone, just the two of us, I grabbed a fork when she turned her back and plunged it into her neck. She grunted, staggered, wheeled toward me, and with an artificial smile, all professional, told me that she'd do her best, that I'd soon be served, satisfied, and on my way.

So, she wasn't dead, she was laughing. Rippling with laughter

like a throat in the sun, her cowardly mane, yellow enough to burst your, etc. Because laughter is a traitor, makes us sympathetic to the most abject being, I set aside my story, ate willingly, and returned to the hotel in silence.

<div align="center">*</div>

In the lobby, strewn with luggage, Carlos was kissing Caroline. So, in the end, she had come to join him against doctor's orders, and despite the extravagantly prominent belly under her skirt. I avoided the main entrance, hoping to walk past them unnoticed, but Caroline hailed me, "What a surprise!" And I had to feign surprise at seeing her. Finding no words to reply, I grudgingly kissed my neighbor on both cheeks, then held my hand out to Carlos who, hovering at his girl's side, seemed to have eyes for no one but her. Awkwardly, I withdrew my hand, slid it into my pocket and just nodded at everything they said.

"My lord it's hot! / You don't look good / I refuse to let them tell me if it's a boy or a girl, it's more exciting that way!"

When she suggested we all go swimming together in the sea, I turned her down and used the arrival of a busload of tourists to slip away. That evening, I made up my mind to leave and called the receptionist to draw up my bill.

"*Is everything ok miss?*" I would have liked to answer, but the man had already hung up. I stood there, alone, the receiver in my hand. Out of nowhere, an old song in my head.

> *I'm worn out. Yeah.*
> *Weary from chasing my story.*
> *I'm worn out. The sap has run dry, who will nourish the tree?*
> *Dry as a snap of the whip. Yeah.*
> *Brittle as a blade.*
> *To keep rowing, I row. Yeah. Yeah. Yeah.*
> *In search of my idols in chains.*

<div align="center">*</div>

As a downpour slapped the sea, I thought with dread of the seamstresses of sorrow. The point where the thread passes through the fabric, the breadth of the needle's eye, the path taken by fingers

struggling at their task, the needle's dance. The hem. The story stitched together, bit by bit, to compose a past.

The rain was falling, confound it, and for the first time, death really was telling me something. And then. Then the heat. Half-heat from which people only returned in a weak, sweaty, feverish state. Step into this heat and it grabbed you. Belly fried. Thighs of caramel. Stench. Made shadows shimmer over there. There, on the sand. An unconcerned, straightforward sun. Flattened wherever you stood. But the man had dozed off, exhausted. Then, there was a sort of pop in the sky. The sky thundered. Let out a cry. Something like "Kuh." "Kuh-kuh-kuh . . . ," one after another, warning the old Black man who was walking-limping-out-there, warning the bewildered old man that something terrible was about to happen. Something terrible.

In the daylight dissolving into irresolute shadow, I waded into the sea with the old man. In the fading daylight, the old man's teeth gleamed. With gold. A large mouth capable of spitting out songs, those blues heard all over the world, telling of death, trouble, pain. Trembling with rage at the memory of a dog that has caught a scent. Let loose.

When darkness fell, the man and I made love. A dry branch in my belly. A stick in the wind. He stayed standing, the old man, that's how he'd learned to do it. He died without knowing it could be done any other way.

*

From the plane climbing into the sky, I gaze down at the sea one last time. The blue-blue of dreams. Down below, someone is smiling at me. It's Caroline, floating like a star, round belly and blond breasts protruding from the water like balloons. She's trying to tell me something. Swam out there for that reason. "*Le Soleil* is here!" she shouts, her eyes turning toward a three-mast ship. My face pressed against the porthole, I peer down at it. One hundred eighty tons. Six cannons. Holds to transport all kinds of goods, and soon to receive residents. Sailing along the coast of Africa, the slave ship will dock in a few days. Following orders, will board three hundred seventy-four Negroes.

Seated at his secretary desk, Louis Mosnier, the captain, studies his map and scribbles some notes.

"*1774. After the calm regions, we are joining the powerful current of Guinea, which should take us farther east. From there, we will proceed to trade for slaves, then will set sail south, toward the Portuguese island of São Tomé. After that port of call* [the end of the sentence is illegible]. *May God protect us.*"

Mosnier is no longer a young man, has been running this route for years. Dreads the middle crossing, the days without wind or sail, when the ship drifts, with hold full, at the mercy of the currents. Counts the knots that separate him from the West Indies. From the inlaid shelf, a woman's eyes never leave him. Through the water stains on the portrait, she seems to be smiling. At least trying. In truth, is worried. Streaked with sweat, the sailors are no less afraid, desperately study the coastline, there where, through the haze, thousands of gleaming eyes seem to be just waiting for the signal to open fire.

Two months after the departure from Nantes, the slave ship has not yet been tested. No illness among the crew, notes the barber surgeon on this day, although knowing it's when they draw near to the tropical coast that fever is most likely to strike. As land draws near, a long shudder runs through the men. Death lies in wait, the squall rumbles, subsides, and despairs.

"*Africa and its mysteries!*" writes the captain before closing his logbook and giving the order to drop anchor.

<p align="center">*</p>

I walked down streets of the city. Paris was hot, the sun beat down. Under a parasol bright as a young girl's skirt, Sylvie was waiting at the little café where we usually met. At this time of day, the languid terrace was quiet. No sound but the owner whistling a tune, keeping one eye on the terrace, one eye on the inside. Inside the low-cut dress of Anne Thewaitress.

Sylvie smiled at me. She was wearing the green pants that looked so good on her, made me think of summer in France. "So, Mule, tell me everything!" That's what Sylvie calls me. Something to do with Zora Neale Hurston who wrote that Black women are the

mules of the world. I started in but couldn't find the words. The language to speak the invisible. The courage to talk about absence. "Did you find it?" she asked again, impatient, as I rose to my feet. "Did you . . . ?" I howled. A Munch-like scream, filled with all the silences. So I wouldn't lose my humanity, go mad.

"You're not going to make yourself sick over this, are you?" How to bury your pain once and for all? Stop seeing it or feeling it? Forget it because the shape of the suffering changes? Until comes the time when you can no longer identify it?

Leave me my ghosts. Give me back my fears. Let me stick my head in a bag. Airtight. Plastic. Die of anguish, for real. As Bettelheim says, the memory saves us. Airtight. Plastic.

As I strode away from the square, I realized I had blood all over my hands. I clenched my fists and decided to take Rue aux Glaces down to the docks. Below me, the Seine was dreaming. Flat, peaceful, under pleats of sunlight that made it tempting to swim, despite the shit and cadavers.

Men whistled when I undressed. I smiled. A policeman grumbled, threatened to stick me with a fine for indecent exposure. You can always run away, I thought, holding my breath.

<p style="text-align:center">*</p>

When I saw Ile de France up ahead, I understood that I'd gone too far. "It's Gosier" said a policeman just like the other one, but Black. I took advantage of the encounter to ask for directions to Pietr's house. Four years since I'd seen the artist.

In his studio papered with white paper, Pedro was painting. "I was hoping you'd come," he said, dipping his brush into a big bucket of black paint.

Silent, trembling, I sat down in the middle of the room. Laid out my papers around me in a circle. Were they the leaves of the tree we'd all had to walk circles around? The-one-who-flies. The mute woman. The little one. The old woman . . . I let the women speak while Pierre pounded his skins.

Who were we in this endless night? But shadows in search of their bodies, feet in a quest for the path, ghosts who know not yet whose ghost they are?

When all had been said, and the walls of the room were covered, we felt inside us a deep silence. Vertigo. Then words. Finally, the cry, too long contained, muffled by the song of the seas and the discourse of men.

"We are the *papa-feuilles,* the healers," Peter whispered to me.

I stood up. Facing the book to come. Facing these walls where the ghosts nestled, ghosts who would soon fade away.

Hear ye good people, Hear ye white lasses
Open your ears to the end of my song
'Tis not very gay, 'tis not all that sad
Perhaps it's the Norman's song

Since he sailed back home from faraway Guinea
Jehan, the old joker, he now laughs no more
Francette, she still tries, but her words fall in vain
Her man listens not, in liquor he drowns

If you ride past a sow farm, just outside of Nantes
And stroll down the Quai de la Fosse
Surely there, you will see him, encounter his shadow,
Facing the river, fists raised with his screams

And a-one and a-two. Oh, Big Jehan of Nantes
And a-three and a-four. Topman, Le Soleil.
Tralala lala. Tralala Lalay.

afterword

Gladys M. Francis

Daughter of the African diaspora, Fabienne Kanor was born in Orléans, France, where she witnessed her Martinican parents' resolute desire to integrate and blend into the Métropole française that relentlessly regarded them as foreigners. At an early age, Kanor thus began to question her sense of belonging at the crossroads of France (where her French citizenship was questioned due to her black skin), the Caribbean (where she was perceived as a *négropolitaine*), and Africa (a point of origin, yet unknown). These violent identity negotiations would nurture the projects she would lead in her career as a journalist (at Radio France Outre-mer, Radio France Internationale, France 3 Télévision, and Radio Nova in Paris, among others). These compound praxes would later become evident in her fiction and cinematic writing. It is through these polycentric avenues that Kanor critically observes and questions colonial history and memory and how they affect relationships to the body, race, gender, place, and borders.

During a visit to the archives in the city of Nantes, France, Kanor found and read the logbook of Louis Mosnier, the captain of the slave ship *Le Soleil,* in which he reports an incident dating from 1774: fourteen unnamed African women (described as goods) jumped overboard into the sea, all together, to escape their enslavement. The report succinctly notes that six of them survived while the others died from shark bites. When Kanor encountered the fourteen women's objectified bodies in the archives, she experienced the captives' "intextuation" (Certeau 140), that is to say, "a bureaucracy of literacy as instruments of [their] control and displacement" (Conquergood 35; Francis, *Odious Caribbean Women*). As the scholar Hershini Bhana Young explains: "Rereading the imperial archive requires immersion into the painful forces that have constituted our strategic communities today. This im-

mersion necessitates not just a resistance to imperialism but a visceral reliving of its trauma" (9). Faced with this imperial archive, Kanor questioned how she could shoulder the legacy of the fourteen women; she struggled with the ways in which she should give voice to their voiceless, intolerable, and unwatchable black experiences. She ultimately decided that the fourteen women would be characters sharing their fictional testimonies from the belly of a slave ship where they are held captive. Fusing her journalistic, literary, and visual virtuosity, Kanor published *Humus,* her second novel, in 2006.

A very interesting aspect of Kanor's preparation for writing the novel is her personal exploration of the role and importance of the slave trade. To gain her own interpretation of this part of history, she sought tangible ways to be a part of it. As a result, she began to trace what the scholar Françoise Lionnet calls "geographies of pain" through meetings with experts and walks in the city of Nantes with a former sea captain and scholar of the slave trade, all the while documenting herself. In addition, Kanor literally performed a physical and transatlantic passage into the spaces that witnessed the slave trade or into the places that continue to reveal the brutalizing and dehumanizing effects of slavery on the inheritors across race, gender, and class (Césaire). Thus, she traveled to Ouidah, Cape Coast, Gorée, and Badagri, where she met the king's historian and visited an old slave market. Convinced that she was developing a framework that would allow her to write the captives' stories "from the heart" (Francis, *Amour, sexe, genre et trauma*), Kanor returned to Saint-Louis, Senegal (where she lived at the time), and started to compose *Humus* by hand. Two years later, during an artist-in-residence program at a former sugarcane plantation in Guadeloupe, Kanor completed the novel's first draft. In an interview, she explains how "Each word was first spoken aloud before being set down in ink. It was important [for her to] restore the words of these voiceless captives. [She] was looking for the right word [and] sometimes it seemed that the women themselves whispered these words to [her]" (Francis, "Fabienne Kanor 'l'Antellaise par excellence'"). It is from the (physical, emotional, and psychological) confining space of slavery that the readers can witness the corpomemorial awakenings, wanderings, and renderings

of the fourteen women, who, until Kanor's novel, were forgotten goods in the colonial archives. Echoing Édouard Glissant, Kanor sees in places of confinement (whether geographical, psychological, emotional, or social) a space that holds embodied "Fermentation, transformation, Creolization, dilution and exchange" (Francis, "Fabienne Kanor 'l'Ante-llaise par excellence'"). Her creative process is embodied through movement, development, and transformation. From Nantes to Guadeloupe, Senegal to Martinique, Cameroon to Louisiana, Spain to Benin, or Haiti to Nigeria (to name but a few), Kanor's cartography of creation marks her own acts of resistance as she refuses to lose sight of her own humanity.

Shortly after its publication, *Humus* was awarded the Réseau France Outre-mer Prize (an annual literary award given to a Francophone work). The same year, Kanor wrote *Homo humus est*, a play based on *Humus*. Staged at the National Theatre of Toulouse (in 2006) and the Théâtre du Rond-Point in Paris (in 2008), *Homo humus est* also received the ETC Caraïbe Playwright Prize. Seemingly inspired by the captives' experience in the slave ship's hold, Kanor wrote her second play, *La grande chambre,* which was staged in 2016 at the National Theatre of Marseille (La Criée) by La Part du Pauvre Company. To date, *Humus* is Kanor's most studied novel, inspiring hundreds of academic works ranging from dissertations, articles, and book chapters (in postcolonial studies, women's sexuality and gender studies, cultural studies, French and Francophone studies, human rights studies, as well as migration and border studies). Since the original publication of *Humus* in 2006, Fabienne Kanor has made her mark as a notable francophone writer, filmmaker, activist, and scholar. Maryse Condé, the illustrious Guadeloupean novelist and recipient of the 2018 Alternative Nobel literature prize, named Fabienne Kanor her "beloved literary daughter." In fact, Kanor is one of the foremost figures of the emerging generation of Caribbean filmmakers and writers after Aimé Césaire, Maryse Condé, Édouard Glissant, Euzhan Palcy, and Derek Walcott. The latter have been influential forces in her body of work, which is revealed through the following shared themes of study: identity formation and "homelessness" (at the crossing of Africa, America, the Caribbean, and Europe); race, colonialism, and its legacy; the notion of roots from different spaces/

cultures; water as a sacred space of passage; the enclosed ship hold as a space with the potential for transformation; the body as memory; and the complexity of love and sexuality in these neocolonial spaces (among others). In 2010, Kanor was named Chevalier de l'Ordre des Arts et des Lettres by the French minister of culture; she is the author of fourteen documentary films, nine novels, eight audio documentaries, two movies, two plays, four short stories, and numerous critical essays and live performances.

In the early spring of 2016, Fabienne Kanor was preparing for an upcoming live performance that would combine a short film she directed, *Le corps de l'histoire* (2015), English excerpts from *Humus,* as well as a new spoken-word essay on police brutality and systemic racism. After the poignant inaugural presentation of the live performance in April 2016 in Atlanta, *Le corps de l'histoire* expanded to a larger body of work meant for larger stages and audiences. As Kanor shared her English translation needs for longer *Humus* excerpts, we began to vigorously discuss the translation of the entire novel. She expounded upon the importance of having this novel translated in English: "In the United States, there is a place for these enslaved women, there is a place to listen to their testimony. There, it is not a time gone by or a settled matter. We must live in the footsteps of this history, for we are its product. Whereas it is a truth that can be told and shared in the United States, however, France continues to proclaim itself as a post-racial Republic, which makes it difficult to have these necessary conversations" (Fabienne Kanor, email message to the author, May 29, 2016). An English translation of *Humus* would hence disseminate the truth of a French colonial past that continues to be subdued. Through *Humus,* Kanor questions the genesis of, memory of, and voids left by traumas resulting from the Middle Passage. She contends that all the heirs of this colonial trauma must contribute to the difficult yet indispensable dialogue.

A few months later, I recommended Dr. Lynn E. Palermo for the translation of *Humus,* and the two arranged a videoconference to feel things out:

> It was in July. A Saturday morning . . . I remember the calm and the intensity in the tone of her voice. She asked me about my time-

line, because she wanted to take the necessary time to complete the translation with attentiveness. She wanted to be careful not to flatten its poetics, hinder any portion of it. I could feel that she was completely moved by the captives' stories, as if something had happened between them, like a mystic dialogue. The conversation we shared was very honest, and we just said, "Let's do it!" She promised to reach out to me as needed. Yet, she did not come back too often. She worked on *Humus* like a soldier fighting against ghosts. (Kanor, Interview)

There were times when Kanor could not respond to Palermo's need for clarification. As she explains:

She would ask me what I meant, and sometimes I could not answer. Maybe it is because I wasn't totally myself when I wrote *Humus;* these women haunted me; I was only channeling their voices. Lynn gave me the opportunity to take my narrative back, to talk about it as its author instead of being at the service of my characters and expressing myself solely through them. This translation project provoked this distance, which forced me to take ownership and to explain myself. (Kanor, Interview)

This English translation of *Humus* is indeed the result of a close and genuine cooperation between Palermo and Kanor. I vividly recall phone and email conversations with Palermo at various stages of this translation project. The most memorable exchange is certainly the one that followed her first reading of *Humus* in 2016. She pointed to the novel's literary virtuosity and to its atemporal uniqueness. As she felt an urgency to make it accessible to a broader audience, she never stopped carrying a profound feeling of responsibility toward the fourteen captives' voicing. She pointed to some challenges: "*Humus* requires constant attention; I must track the countless movements of deracination, displacement, and dislocation for each captive [as each moves through physical and esoteric spaces]" (Lynn Palermo, personal communication with the author, July 2016). As Palermo stressed, in *Humus,* retracing the captives' steps is a complex venture. The process implicates a variety of "passing experiences" through lands (those of the Peuls, the Mossis, the Mandés, the Bambaras, the Yorubas, and the colonial

islands); the spiritual; liquids (the ocean, sweat, menstrual blood [embodying the tactile and haptic passing of months and years in the slave boat and the plantation], snots [symbolizing sickness once on the island], tears that become rivers, and the fluids relating to rape and *jouissance*); and many more. This profusion of spaces makes the reader feel a sense of loss and confusion—the very same feelings the captives are experiencing. In an email conversation we had in 2018, Palermo wrote, "To fully connect and do justice to the original story, I am haunted by the desire to trace Fabienne's journeys to Nantes, Africa, and the Caribbean."

Humus contains textual representations of performance (what the scholar Jeannine Murray-Román calls "ekphrasis representations") that can be easily overlooked by readers unfamiliar with the language, oral traditions (*oralité*), myths, and rituals of the (French) Caribbean and African cultures. This repertoire creates a complex level of reading and contributes to a literary decolonization of the Caribbean francophone novel (Toman in Francis, "Review of *Women Writers*"). Indeed, it is through *oralité* that Kanor provides her female characters with expressions of self-agency and rebellion. As a result, the testimonies, dances, chants, storytelling, Creole proverbs, and all embodied gestures (such as jumping collectively overboard into the ocean) become an embodied record/ trace of the fourteen women's sociopolitical agency signifying their black bodies *becoming* historical archive, landscape, and text (Francis, *Odious Caribbean Women*). Palermo made every effort to render the Afro-Diasporic performances and mnemonic transmissions that bear the fourteen captives' complex experiential negotiations and identity formation. *Humus* is also a polyrhythmic text that reveals the beauty of Creole imagery and rhythmic structures (such as call-response patterns and [folk]tales) that nurture the lived experiences of some of the women as an embodied discursive site (Probyn, "Travels in the Postmodern; Probyn, "Anxious Proximities"). The second challenge for Palermo was to capture, in English, the subtle forms of the creolisms found in the text, which are often noticeable only to native speakers of Creole. To maintain the Creole essence of the original text, the author, the translator, and Carine Gendrey, a professor of Creole based in Martinique (whose research focuses on translatology studies in Creolophone

and francophone settings), worked closely together. Palermo's effort to render a brilliant translation is undisputable.

When Kanor chooses to give voice to the fourteen captives through their oral testimonies, she is able to reveal the heterogeneity of identities and backgrounds that individuals of African descent can possess and negotiate. Kanor, as Palermo understood during this translation project, creates a complexity of identities and a density of textures that prohibit the readers from reducing Africa or blackness to a homogeneous or simplistic entity. Similarly, the reader can hardly draw "victim versus hero" or "good versus bad" portraits of the characters. Kanor creates intricate intersectional spaces that the readers are free to decipher. In fact, Kanor feels very connected to *la vieille* (the old woman), for she is the only one who understands the danger of losing what makes her African once she is in the colonial plantation, and she is also the only one who remembers how joyous and playful life used to be in motherland Africa. Kanor marvels at *la vieille*'s level of consciousness, the depth of her memory, her inability to forget, her resilience (as she keeps moving forward), and her unwillingness to become a Creole woman: "She failed inside the belly of the slave ship and realized that it is the entire continent that will be enslaved and will lose its identity. On the slave ship, she acknowledges more than the people from her own tribe. She is the only one who declares: 'tout partout l'Afrique'" (Kanor, Interview). *L'amazone* (the amazon) also captivates Kanor through her resolute desire to fight the fate of slavery. Kanor admires her complex and fluid idiosyncrasies: "She is man and woman, strong and weak, glorious and disgraced. She is also the king's most devoted soldier and then his fierce enemy. She looks like a bachelor when she falls in love with Makandal. She is the link or what we call in the playwright world 'a utility' since there is no jump, no plot, no novel without her" (Kanor, Interview). Like *The Autobiography of Miss Jane Pitman, Beloved, Island beneath the Sea,* or *For Colored Girls Who Have Considered Suicide When the Rainbow Is Enuf, Humus* puts women at the center. As a French Caribbean woman of African descent, Kanor coins the expression "fanminism" from the French creole word "fanm" (meaning "woman") in order to analyze the effects of patriarchy and sexism in society. *Humus* holds fanminist agency as, despite their violent

objectification, the captives still attempt to create their own intimate and private spaces. Kanor doesn't shy away from unveiling their sexual subjectivities and forbidden desires.

Humus possesses various original features. From its diegesis emanates what has undoubtedly become a signature aesthetic for the author: the difficult "seeing" of black bodies in pain. Indeed, the novel enfolds specific modes of representing "uglified" spaces, transgressive "deglamorified" female bodies in pain and explicit corporeal behaviors:

> It is through the barren and inhospitable setting of the boat's hold that Kanor develops the corporeality of her characters. From their narrative minimalism [or] the compositional bracketing of empty spaces (the slaves' barracks in the colonial plantation)—the black women, just as the spaces that do violence to their bodies, create a space of impropriety. [The] body is environment. We must make the journey of its construction and reflection . . . The transgressive body is to be "seen" as it creates "memory," as it creates sense-driven aesthetic and cognitive perceptions that are palpable. In *Humus,* pain is not located inside the raped body, it is inside every object or being that comes into contact with that pain. (Francis, *Odious Caribbean Women*)

This palpable and transgressive aesthetic of the odious circumvents any simplistic attempt to gain the readers' empathy. Rather, it encourages an engaged witnessing (as opposed to a voyeur posture) and embodied transformative lived experiences that break the distance vis-à-vis the "other" black body. *Humus* is therefore an invitation to engage in an uncomfortable but necessary conversation about invisible or silenced traumas caused by capitalism, imperialism, (neo)colonialism, and (forced) immigration. It is a phenomenology of the transgressive that mobilizes the readers and makes them confront what they might rather dismiss, which conjointly tests their tolerance. This difficult "seeing" of the fourteen captives combines corporality, orality, memory, and history. In fact, *Humus* challenges the Western conventional perception of genres through an interweaving of oral and esoteric practices, the empiric archive, and literary writing.

Humus's impact is manifold. In this novel, Kanor takes on the

imperialist discourse of slavery and shifts the national archive's value as illustrated in *Humus,* where she complicates the context of the archive and changes its significance and meaning. In this instance, she does so by reinterpreting the enduring archive from a March 23, 1774, captain's report focused on justifying the loss of a valuable cargo of fourteen unnamed African women (who escaped from his ship's hold to jump overboard) and by reinvesting them with embodied experiences, identities, and voices as she narrates their own stories. By re-presenting the experiences of the fourteen captives and by naming them, Kanor ritualizes and symbolizes them as embodied recollections—while inscribing them as (noncanonical) historical archives of public records. Through a *Sankofa* process, Kanor invites the daughters and sons of the African diaspora to "go back and fetch" their disremembered African heritage. By critically reassessing the colonial archives, Kanor can holistically engage black history as a contemporary voice in the present and the future. She creates space, knowledge, visibility, and humanity for the black bodies rendered invisible and silent in colonial history. *Humus* examines what can be painful and powerful when black bodies are positioned at the crossroads of dehumanization and self-resilience, just as it represents the complex frameworks that police, politicize, and imagine black bodies. In *Humus,* Kanor presents black bodies as a contested space continuously controlled or challenged by pernicious orthodoxies and racialized bio-logics that hinder their advancement or visibility. It mirrors today's configurations through which politics of power, discipline, surveillance, and mediated representations are carried (Strauss 45; hooks, *Black Look;* hooks, "Transformative Pedagogy"). In fact, the forms of discrimination and oppression visible in *Humus* are not foreign to our twenty-first-century racial nomenclatures, which have a direct impact on our economic, political, sociocultural makeups. Kanor subverts the conventional frames of the colonial archives, allowing the fourteen captives to exercise embodied freedom as they reinstate their identities moving in and out of time and space. Hence, they are able to resist colonial taxonomies by shifting their bodies from passive to active embodied beings. Kanor calls us to be attentive to by what degrees and means our black cultural memory is being institutionalized—for instance,

how museums elect to display our collective memory, preserve black cultures, or reduce complex events to isolated objects made public as an exhibit behind a glass case (Rein 97). Kanor challenges the process by which an object is detached from its original setting for its exhibition in a museum-like manner and environment. This musealization removes "cultural expressions [and functions] from their original context, in order to integrate them into the academic environment of the museum institution" (Rein 97). *Humus* is a call to maintain an emancipatory pedagogy of Black lived experiences, a call to reinvest ownership. *Humus* is a form of maroonage, of extricating oneself from slavery.

In *Humus,* Kanor also judiciously questions the tourists who have become the contemporary explorers of yesteryear. She wonders if the tourists' postcards and cameras function as the captain's logbook, objectifying and consuming the black body. Kanor, in her novel *Humus,* tells us the black bodies must be engaged in the multilayered contexts within which they come to be and create. It is inside these settings, we (just as Kanor and her fourteen captives) experience the humus of life: exertions of community building, power, resistance, and (transgressive) belonging. *Humus* is—as readers will now be able to enjoy through this English translation—ongoing; it is contemporary.

In January 2020, Kanor made her first journey back to Benin since her last visit fifteen years ago. She shares her thoughts: "I have a copy of *Humus* in my suitcase. The pages are yellow, some are missing . . . Books are fragile, but stories are strong" (Kanor, Interview). She plans to revisit the sites that gave birth to *Humus* and prepares for a performance she will do in Ouidah the following month titled *Paroles de revenante:*

> Today, at the Saint-Michel market, I bought a calabash that I will fill with Ouidah's sand-soil-humus. It will be a part of the performance. I do not expect to meet with "my fourteen women" again, but I just want to reconnect with my former self . . . When I had not yet published, did not know about the African American community, when I was just a young French Caribbean woman looking for her ancestors. (Kanor, Interview)

bibliography

Certeau, Michel de. *The Practice of Everyday Life*. Berkeley: University of California Press, 1984.

Césaire, Aimé. 1955. *Discourse on Colonialism*. Translated by Joan Pinkham. New York: Monthly Review Press, 2000.

Conquergood, Dwight. *Cultural Struggles: Performance, Ethnography, Praxis*. Edited by E. Patrick Johnson. Ann Arbor: University of Michigan Press, 2013.

Francis, Gladys M., ed. *Amour, sexe, genre et trauma dans la Caraïbe francophone*. Collection Espaces Littéraires. Paris: L'Harmattan, 2016.

————. "Fabienne Kanor 'l'Ante-llaise par excellence': Sexualité, corporalité, diaspora et créolité." *French Forum* 41, no. 3 (2016): 273–88.

————. *Odious Caribbean Women and the Palpable Aesthetics of Transgression*. Lanham, MD: Lexington, 2017.

————. "Quand l'invisible s'affiche: Entretien avec Fabienne Kanor: Inscrire et réitérer des identités ouvertes, mouvantes et complexes." *Francosphères* 8, no. 1 (2019): 85–100.

————. Review of *Women Writers of Gabon: Literature and Herstory*, by Cheryl Toman. *French Studies* 71, no. 4 (September 18, 2017): 601–2.

hooks, bell. *Black Look: Race and Representation*. Boston: South End Press, 1992.

————. "Transformative Pedagogy and Multiculturalism." In *Freedom's Plow*, edited by T. Perry and J. Fraser, 91–97. New York and London: Routledge, 1993.

Kanor, Fabienne, dir. *Le corps de l'histoire*. Screenplay by Kanor and Yonus Astorga. March 8, 2015.

————. *Le corps de l'histoire*. Live performance at the conference "Islands & Identities: Memory & Trauma in Comparative Perspectives," 260 Student Center East, Georgia State University, Atlanta. April 14, 2016.

————. *La grande chambre*. Play staged in Marseille, France, 2016.

————. *Homo humus est*. Play staged in Toulouse, France, 2006, and Paris, France, 2008.

————. *Humus*. Paris: Gallimard, 2006.

————. Interview by Gladys M. Francis. Cotonou Benin. January 27, 2020.

Lionnet, Françoise. "Geographies of Pain: Captive Bodies and Violent Acts in

the Fictions of Gayl Jones, Bessie Head, and Myriam Warner-Vieyra." In *The Politics of (M)Othering: Womanhood, Identity and Resistance in African Literature*, edited by Obioma Nnaemeka. New York: Routledge, 1997.

Murray-Román, Jeannine. *Performance and Personhood in Caribbean Literature: From Alexis to the Digital Age*. Charlottesville: University of Virginia Press, 2016.

Probyn, Elspeth. "Anxious Proximities: The Space-Time of Concepts." In *Timespace: Geographies of Temporality*, edited by Jon May and N. J. Thrift, 171–207. London and New York: Routledge, 2001.

———. "Travels in the Postmodern: Making Sense of the Local." In *Autobiography and Postmodernism*, edited by Kathleen Ashley, Leigh Gilmore, and Gerald N. Peters, Amherst: University of Massachusetts Press, 1990.

Rein, Anette. "Flee(t)ing Dances! Initiatives for the Preservation and Communication of Intangible World Heritage in Museums." In *Emerging Bodies: The Performance of Worldmaking in Dance and Choreography*, edited by Gabriele Klein and Sandra Noeth. Critical Dance Studies 21. Bielefeld, Germany: Transcript, 2011.

Strauss, David Levi. *Between the Eyes: Essays on Photography and Politics*. New York: Aperture, 2012.

Young, Hershini Bhana. *Haunting Capital: Memory, Text, and the Black Diasporic Body*. Lebanon, N.H.: University Press of New England, 2006.

9 780813 944692